WITHDRAWN

In memory of

DUNCAN GRANT

1885-1978

English Post-Impressionism

SIMON WATNEY

STUDIO VISTA/EASTVIEW EDITIONS INC.

A Studio Vista book
published by Cassell Ltd
35 Red Lion Square,
London WC1R 4SG
and at Sydney, Auckland, Toronto,
Johannesburg,
an affiliate of
Macmillan Publishing Co. Inc., New York

© Simon Watney, 1980
First published in Great Britain 1980
ISBN 0 289 70888 5

First published in the United States by
Eastview Editions Inc.
ISBN 0-89860-039-1
Library of Congress Catalog Card No.
80-80038

Design and production: Roger Davies

Typesetting by TNR Productions
London.

Printed in Great Britain by W.S. Cowell
Ltd.

Contents

Acknowledgements

To begin with I should like to acknowledge my debt to the published work of Dr. Wendy Baron and Mr. Richard Shone, without whose scholarly research this book could not have appeared in its present form.

For permission to read and make use of quotations from unpublished manuscripts I should like to quote Professor and Mrs. Quentin Bell, who have long helped and encouraged me in this field; Mrs. Henrietta Partridge; and Mrs. Angelica Garnett, who has been consistently generous with her time and hospitality. I am also grateful to Mrs. Pamela Diamand for discussing with me the work of her father, Roger Fry, and allowing me to quote from his books and letters.

I wish to thank Penelope Bulloch and the staff of King's College Library, Cambridge; Sarah Fox-Pitt and the staff of the Tate Gallery Archives; Jill Sheppard and the Staff of the Communication School Library of the Polytechnic of Central London; the staff of the Tate Gallery Library; and the staff of the Victoria and Albert Museum Library, London.

I should also like to thank individually Dr. Christopher Greene of the Courtauld Institute; Mr. Richard Shone; Mr. Richard Morphet; Mr. Peter Scott; Mr. Anthony D'Offay; Jeanne Schulkind; Tristram Holland; Judith Collins; my editor Kathy Elgin, who has been a model of good sense and support; and everyone who has in one way or another 'got me through'. I must also thank Mr. Edward Casassa of the Fine Art Society, and Caroline Cuthbert of the Anthony D'Offay Gallery for their invaluable help with illustrations.

Finally, I express my gratitude to the late Mr. Duncan Grant, whose patience and good humour were seemingly endless. His passionate love of painting remains a steady source of inspiration to all who knew and loved him.

Introduction

In February 1912 the critic Frank Rutter described the 'utter confusion and muddled state of thought, prevalent not only among the public, but also among artists', caused 'by the coining of the compound "Post-Impressionist" to cover a variety of different and often contrary movements in modern painting.'[1]

In this book I want to explore and analyse the contradictions implicit in the generic concept of Post-Impressionism invented by Roger Fry in 1910. I want to consider how those contradictions were applied in the First World War period and how they have subsequently affected our picture of the art of the time. I also want to describe a particular moment in English art which has been suppressed by a specific model of English art history, namely the work of the artists of Bloomsbury and the Camden Town Group.

I shall argue that in practice, the concept of Post-Impressionism transforms the familiar nineteenth-century distinction between the perceptual (Naturalism) and the conceptual (Realism) into the form of a new dualism, the related notions of Figurative and Abstract art. Like all dualistic theories, one side is constantly striving to do down the other.

It is in the prolonged context of this dispute that we find a particular version of English art history constructed in the 1960s. In its use of such terms as 'movement', 'progress', 'purity' and so on, we can see that it takes both its methodology – the ways it thinks of art – and its epistemology – what it believes art to be – from the original debates concerning Post-Impressionism. What is at stake here is the hegemony of formalist criticism and the entire philosophy of art which it discloses. In this sense our understanding of those ideas laid down and fixed in the First World War period continue to determine our own artistic discourse and assumptions as we move into the 1980s.

In other words I am concerned with the ways in which the avant-garde of the 1960s, rooted in a set of unquestioned beliefs in the supremacy of Hard Edge Abstract Painting, has effected a specific and highly selective model of history, of which it is seen as both apex and consummation. This is, I think, a major characteristic of Modernist aesthetics which, having established the idea that art is in some important sense an autonomous institution, obedient only unto itself, becomes endlessly involved in a sequence of conflicting versions of how it is to signify this autonomy.

Thus we find a modern historian[2] casually defining Vorticism as a 'stimulating precedent' to the English abstract art of the 1930s, as if there were some actual causal relation between the two groups. This is a history of stylistic resemblances masquerading as a full historical account. We shall see how in 1912 Roger Fry could re-write history in precisely the same way, constructing a kind of transcendent 'inner history' within European art in which, in his version, Cezanne is supreme.

All such avant-gardist approaches to the history of art collude in the active suppression of any 'rival' art practices or theory. In this sense we should note the distortions which most accounts of modern English art exhibit by ignoring the work of artists who either took alternative avant-gardist positions or eschewed the entire debate.

I do not myself intend to appear to be advancing an 'alternative' avant-garde model of English twentieth-century art. Rather, I hope to present an account of the work and ideas of a large group of painters whose reputations have suffered – largely due to the fact that they cannot easily be accommodated to a particular monolithic theory of unilateral artistic 'progress' which turns out to

be little more than a taste for one kind of art presented as a universal prescription.

In fact, as I hope to show, there was never any real question of an absolute rupture between figurative and non-figurative painting in England in the period 1910-1920. The artists of Bloomsbury produced pictures which exemplify Apollinaire's concept of 'peinture pure' as closely as any European equivalents, whilst the work of most of the Vorticists are grounded in an observed nature from which they are rarely totally 'abstracted'. In this sense all acts of artistic recuperation can be seen as challenges to received and over-simplified pictures of history.

This book then, has three primary objectives. Firstly, to examine and clarify those contradictions in early twentieth-century English aesthetics which continue to obscure our sense of the shape of the period. Secondly, I hope to present a body of paintings which have been overlooked as a direct result of the artistic confusions and art politics of their day which have been, as it were, inscribed into the history of art itself. And, thirdly, I want to suggest that there existed a full and largely self-sufficient style of painting in the period 1910-1920 which, in relation to both local and continental sources, we might profitably think of, rejecting ungainly neologisms, as English Post-Impressionism.

English Post-Impressionism

I. The Concept of Post-Impressionism

No account of the concept of Post-Impressionism, first used by Roger Fry in 1910, can be separated from his general position as an Aesthetician, his practice as a painter, and his respective attitudes towards England and France, without doing grave damage to our understand of the term by abstracting it from the rest of his thought. The major ambiguity of the term stems from the fact that it was originally used to refer to the work of two distinctly different groups of European painters, as represented in the two celebrated Post-Impressionist Exhibitions of 1910 and 1912.

Duncan Grant has observed that Fry 'applied pictures to his ideas'[1] and this was certainly the case when, in 1910, Gauguin, Van Gogh and Cezanne were arbitrarily grouped together as examples of an anti-naturalistic tendency which, Fry hoped, would successfully challenge the dominance of what he described as 'literary' painting, or 'pseudo-art'.

In October of that year Fry went to Paris to finalise his selection of paintings for an exhibition to be held in London at the Grafton Galleries. 'The show will be a great affair' he wrote to a friend, 'I am preparing for a huge campaign of outraged British Philistinism.'[2] The First Post-Impressionist Exhibition then, was a calculated attempt to infuriate the British art establishment, of which Fry, as Editor of the *Burlington Magazine*, European Advisor to the Metropolitan Museum New York, and ex-jury member of the New English Art Club, was a prominent member. In the work of these artists Fry perceived a return to what he considered to be the major tradition of European art, a tradition which he believed had been all but extinguished in this country during the course of the nineteenth century. Fry's theories were founded upon a belief in the existence of some essence, or lowest common denominator, shared by all 'great' works of art. This essence, as is readily apparent, is to be equated with the personal taste of Roger Fry. A decade later he wrote to his friend Marie Mauron, 'I know that I was born "classical", which means, for me, not that one likes Corneille, and the art of the Romans, (both of which I detest) but one who enjoys above all pure art without any rhetorical emphasis, art which expresses a sensation without wishing to impose it.'[3]

Purity is a key term here. As early as 1909 he had contrasted the 'pure' art of children to the 'crude' representational criteria of bourgeois art, attacking that equation of aesthetics with morality, explicit in the British tradition from Pugin and Ruskin onwards. As Quentin Bell has observed, 'Like Ruskin he wanted to be an artist, became a critic malgré lui.'[4] In another letter to Marie Mauron[5] he writes as a painter, 'It's all the same to me if I represent a Christ or a saucepan since it's the form, and not the object itself, that interests me.' The concept of Post-Impressionism, then, is intimately informed by Fry's own practice and taste as a painter.

At the same time the original concept embodies a particular view of history, a positivist and semi-religious view, in which art is constantly restoring itself to a state of Edenic 'purity', which is to be identified by a concern with particular internal formal values, as opposed to any issues of subject matter or social usage. The choice is between 'Art' and 'False Art', that which masquerades as Art.

Thus, in an essay of 1912 (revised in 1921) on the subject of 'Art and Socialism', we find him distinguishing between two kinds of taste, one 'consisting in the negative avoidance of all that is ill-considered and discordant' and a positive one, 'which always results from the expression of intense and

disinterested emotion'. The concepts of disinterestedness and formal purity are inseparable in Fry's thought, combining to establish what he thought of as the 'aesthetic emotion'; the essence of good art.

Further on in this essay we are offered a fascinating account of European Art History. The art of the eighteenth century was 'subtly and deliciously flattering and yet always fine' whilst that of the nineteenth is 'coarse, turbulent, clumsy'. This is, of course, an enormous generalisation, covering an equally enormous value judgement. All the complex changes in patronage and the social uses of painting resulted, according to Fry, in a 'new race' of artists, 'A race for whom no name has yet been found, a race of pseudo-artists.' This is Fry's way of dealing with popular art; to that which he dislikes he denies the status of reality.

British art in the nineteenth century was simply 'sugared poison', 'pseudo-art', for 'a population saturated with snobbishness, and regarding art chiefly for its value as a symptom of social distinctions'. This is not far from the aesthetic paternalism of Ruskin, but Fry fails to turn Ruskin's trump card – that the poisoning in question has wider consequences than its effect on the fine arts. Yet he argues at the same time that art is 'the symbolic currency of the world'; hence his need for a two-tiered concept of art itself. On the one hand social and symbolic, and on the other hand instinctive and disinterested. It is this latter kind of art which is most 'real'. The essay ends with an aristocratic vision of the new (Post-Impressionist) artists as 'a new kind of kings', once the rest of art has been 'purified of its present unreality'. This strangely metaphysical aesthetic model constitutes Fry's sociology of art.

In 1917 he wrote rather more succinctly in 'Art and Life': 'In proportion as art becomes purer the number of people to whom it appeals gets less... It appeals only to the aesthetic sensibility and that in most men is comparatively weak.' This theory of innate aesthetic competence is similarly linked to a strongly metaphysical notion of artistic value, which is seen to have nothing to do with representational functions. From this vantage point he could project a critical tradition backwards through the history of European painting, connecting Giotto, Byzantine mosaics, Piero Della Francesca, Poussin, Cezanne and so on, as if subject matter had been as unimportant to them as it was, apparently, to Fry.

Such a view of art had two major shortcomings. Firstly, as is apparent, it required a notion of 'competence' which smacks of a kind of aesthetic eugenics; secondly, it did tremendous violence to those artists selected as its exemplars. It has, for example, ensured that Symbolism be regarded as some kind of alternative tradition, and that the careers of Gauguin and Cezanne should have been grotesquely distorted, the former being cut off from his crucial Symbolist background, and the latter fetishised into an over-simplified figure for anti-naturalistic invective. In both cases the role of subject matter is completely suppressed. Fry's hostility to the dominance of a particular kind of sentimental narrative painting, which he equates with 'Naturalism', thus leads him to depict the generation of 1870 in such a way that they are all reduced to a single polemical unit.

With regard to his own British contemporaries this also meant that he was singularly ill-equipped to distinguish between that which was genuinely vital, and that which was actually moribund, in his own culture. Everything British was 'pseudo-art', all feyness and whimsy. In effect this meant that he could

perceive no design tradition between the art of the Aesthetic Movement and English Post-Impressionism, and that any evidence of iconography in twentieth century art was to be condemned as 'impure', the residue of a corrupt and 'in-artistic' century.

Above all, this original formulation made it virtually impossible to distinguish between say, Cezanne and Van Gogh, since both are reduced to a single function, as the French conceptual stick with which he would beat down the English 'literary' dog. It was this aspect of Fry's work which most enraged contemporaries like Sickert, who, sharing his contempt for the official London art world, nonetheless saw Cezanne and Gauguin as a part of one culture with Degas and the Impressionists. It was the monolithic nature of Fry's distinction that Sickert objected to so strongly.[6]

This very local notion of Post-Impressionism as an anti-literary and anti-naturalistic movement was, however, drastically revised for the Second Exhibition of 1912, which presented a very different group of painters, the generation which had grown up in relation to those of the 1910 Exhibition as they in their turn stood to Manet and Courbet. 'These painters' wrote Fry in his classic re-formulation of the theory of Post-Impressionism, 'do not seek to give what can, after all, be but a pale reflex of actual appearance, but to arouse conviction of a new and definite reality. They do not seek to imitate form, but to create form; not to imitate life, but to find an equivalent for life. By that I mean that they wish to make images which, by the clearness of their logical structure, and by their closely-knit unity of texture, shall appeal to our disinterested and contemplative imagination with something of the same vividness as the things of actual life appeal to our practical activities. In fact, they aim not at illusion, but at reality.'[7] It is however clear that this reworking of his original, much vaguer theories, still derived from his attitude towards French avant-garde painting in the 1880s and 90s, rather than from the Modernists of 1912, Picasso and the Fauves. This staggering of historical references is offset and obscured by the continuity of his key term, Post-Impressionism.

It proved far more easy for Fry to resolve the various painterly objectives of Cezanne, Gauguin and Van Gogh in 1910, than those of Derain, Matisse and Picasso in 1912. He writes of these last two artists in the Catalogue as 'highly civilised and modern men trying to find a pictorial language appropriate to the sensibilities of the modern outlook'. But such wide phrase-making ultimately evades the entire question of how Matisse and Picasso relate to and differ from Gauguin and Cezanne. For they were not trying to find a unified 'pictorial language'; their artistic trajectories were entirely and critically different. It is clear from Fry's impassioned defence of such painters as Friesz and, in particular, Marchand, that his painterly sympathies, if not his intellect, were far from Cubism.

Of Marchand he wrote in a letter that 'he possesses that austerity and that solidity of construction which, for me, are the great qualities of the French tradition from Poussin to Cezanne. These are particularly what we lack in England, where fantasy and lyricism are all in favour...'[8] And in a review in the *Athenaeum*: 'M. Marchand was handicapped in any competition for notoriety by the very normality and sanity of his vision... He never tries to invent what he has not actually seen. Almost any of the ordinary things of life suffice for his theme... They do not become excuses for abstract designs; they retain in his pictures all their bleak everydayness.'[9] Admittedly this was written somewhat

later and undoubtedly forms some kind of personal response to those exhortations to abstraction which are implicit in his 1912 Exhibition Catalogue essay. The problem is one of dating.

The concept of Post-Impressionism as developed by Roger Fry derives neither from the crucial Fauvist period of 1905/6, nor from that of Analytical Cubism but rather from the experimental phase in French painting between these two moments. It derives, in other words, from the period of the ascendancy of Matisse, when Picasso was working in a variety of tentative styles outwards and on from the *Demoiselles d'Avignon* of 1907. In the final analysis Fry was disbarred from any clear view of what was actually happening in Paris (or London) by his constant need to create a universal theory of aesthetics in the context of a crudely social-determinist psychology of visual perception and in response to his own obsessive attitudes towards the values embodied in much late nineteenth-century painting, seen as a remarkably unified whole and requiring in turn an equally over-simplified alternative.

In this situation Fry advances a theory of 'Pure Painting' in 1912 which is in many respects close to that of Apollinaire. He had used the phrase 'pure form' in his 'Essay in Aesthetics' in 1909 to refer to quality perceived in objects once they have been passed through a filter of 'disinterested intensity of observation'. Apollinaire had similarly written, as early as 1908, of 'purity' as 'the forgetfulness that comes after study', which is similarly related to a theory of innate or instinctive aesthetic competence.[10]

Thus, just where Fry seems to be advocating a broadly catholic approach to painting, defending the right of artists to explore the new freedoms opened up in the generic category of Post-Impressionism, he is in fact prescribing a specific and limited kind of representational painting focussed on the middle period of Cezanne.

Fry's importance in stage-managing the introduction of modern French art into this country should not be underestimated. But it would be extremely misleading to regard him as an unequivocal champion of modern English painting. Writing in *The Art News* in 1911 he could describe Sickert as an artist who 'has steadily refused to acknowledge the effect upon the mind of the associated ideas of objects; has considered solely their pictorial value as opposed to their ordinary emotional quality'. Similarly Fry regarded the painters of the Camden Town Group as being 'characterised by their concentration on this purely pictorial and non-romantic attitude'. Despite the expression of 'personal attitude', the work of Gore and Gilman is seen to be approached in an 'objective spirit'.[11]

This extraordinarily inaccurate criticism begins to suggest the measure of Fry's inability to regard painting save through the very narrow terms of his own theory of pictorial 'purity' and aesthetic 'disinterestedness'. What is totally overlooked here again is the role of subject-matter. In the same spirit he was fundamentally unable to apprehend the specifically British qualities in the work of Duncan Grant, whose work he often found 'whimsical', for which term we might understand an emphasis on subject-matter.

It is in this context that it becomes apparent that Fry was totally unable to grasp any of the specific continuities which run through from late Pre-Raphaelite culture into English Post-Impressionism, or the strengths of the English *pleine-aire* tradition. It was this critical short-sightedness which gave him such a curiously distorted view, for example, of Gore or Grant. For he could

never accept that which was specifically local in English art. This need not involve any parochial nationalism, but is simply an acknowledgement of the fact that English art was not perhaps so mechanically determined by French sources as Roger Fry imagined. It is, ironically, Fry's criticism which initiated the totally misleading myth that Grant was no more than a French artist *malgré lui*.

In Fry's theories there was no room for subject-matter, or iconography, or concrete issues of usage. Good art and good design were dependent solely upon transcendent categories of value. All was a matter of form. 'I want to find out what the function of content is and am developing a theory which you will hate very much', he wrote in a letter of 1913,[12] 'viz. that it is merely directive of form and that all the essential aesthetic quality has to do with form... I admit that there is also a queer kind of hybrid art of sense and illustration, but it can only arouse particular and definitely conditioned emotions, whereas the emotions of music and pure painting and poetry, when it approaches purity, are really free, abstract and universal.'

Instead of breaking once for all with the ancient distinction between form and content in the revolutionary manner of Russian contemporary aestheticians like Schklovsky and Eichenbaum, he merely collapses all issues of 'content' into those of 'form', unable to see that each is inescapably a function of the other.[13]

Fry's aim, then, was to encourage a kind of painting in this country based upon a technique of spatial construction learned from Cezanne and deriving from an idea of nature which is at the same time drained of all social meaning. What he sought was a closed rather than an abstract art, a self-referential style in which the conventions of representation stand in an uneasy alliance with the things they represent. Such an art was to operate as a semi-mystical stimulation for visual contemplation in a humanist/materialist age. At this point it is hard not to conclude that in his sense of 'purity', the rebarbative force of the word in its moral sense is rarely far beneath the surface. It is this troubled ambiguity which anticipates, as it helped shape, the similar formalist position adopted some fifty years later in the United States by such critics as Clement Greenberg, often with Fry's name used as sanction.

Nonetheless, one may gauge the tremendous convenience of the term Post-Impressionism from the range and frequency of its application. Yet it was never merely a vogue term. The scope of its reference and the complexity of ideas which it holds have guaranteed it a longevity which has tended to cover over its fundamental contradictions. Principal among those, for any understanding of British art, is its latent but overwhelming Francophilia, which is only the obverse side of Fry's Anglophobia. And, not surprisingly, the more or less unquestioned use of the term as a basic organising category in art history has perpetuated and universalised that occlusion of early twentieth-century English art which remains so widespread today.

Indeed, the principal scholarly historian of the period felt quite happy to apply the concept of Post-Impressionism 'in a broad sense' to cover the entire period in French art from the last Impressionist Exhibition in 1886 to the birth of Cubism some twenty years later, whilst noting that it is 'not a very precise term'.[14] To that extent Fry's own taste has unmistakably shaped our notions of the history of art as a whole in this long period, ensuring a certain critical focus upon the kind of painting he preferred, as prescribed within the

apparently descriptive notion of Post-Impressionism.

One result of this process has been the familiar readiness, particularly on the part of British critics and historians, simply to pair-off English and French painters in a series of what are seen as one-to-one relationships of direct and unmediated influence. Thus Duncan Grant, for example, has been consistently cast in the peculiar role of the British Matisse (he used colour!), with Spencer Gore as the British Cezanne and Ginner and Gilman fighting it out for laurels as the English Van Gogh, and so on. This is deeply unsatisfactory.

To begin with, this relates to a certain myth concerning the First Post-Impressionist Exhibition of 1910. This myth invites us to imagine an entire generation of young English painters, steeped in any amount of dingy Whistlerian tonality and 'impure' literary values, filing into the Grafton Galleries in December 1910, only to emerge full-blooded Post-Impressionists, purged, as it were, of any taint of 'Englishness'. Whilst it would be foolish to deny the importance of the Exhibition, it would be equally foolish to imagine that the impact of the French painters gathered together by Fry could have aroused any response other than outright rejection from young British painters had they not felt able to apply these new ideas in a meaningful way to their own experiences.

Neither the First Post-Impressionist Exhibition nor the concept of Post-Impressionism then were new in any absolute sense. The influence of English art upon France throughout the closing decades of the nineteenth century provides evidence of the ways in which Post-Impressionism itself, in the same sense of a broad anti-natural tendency, was bolstered by the British example. Fry's objections to 'literary' painting were in fact objections to painting related to a specific literature – the culture of late Pre-Raphaelitism. And, even here, there is a contradiction, since the ideas of purity and disinterest so central to his aesthetic position are unimaginable without the context of the British Aesthetic Movement of which, in his youth, he was so much a part. Nonetheless, Fry seems to have been oblivious to the English decorative movement, whose artistic assumptions were so close to those of the French artists he championed.

The aesthetic position within which Fry located late nineteenth-century French painting derives quite as much from the explicitly anti-literary assumptions of the British Aesthetic Movement as from the writings of Maurice Denis. In this respect it is possible to detect a strong *fin-de-siècle* undercurrent in Fry's own thought, an undercurrent which is also apparent in his early painting with its strong linear emphasis. It is in this way that English artists proved so receptive, so immediately, to the new French art; an art which they could recognise, at least in their imaginations, from a host of local sources.

Fry's signal achievement was to summarise, rationalise and generally bring together a wide range of hitherto disparate notions concerning the future of painting in Britain in such a way that it was relatively easy for the young followers of Whistler and the Slade tradition, the 'young lions of the Butter-fly',[15] to recognise their own aims and aspirations in the apparently new culture of Post-Impressionism. But if the concept was already largely soluble in artistic thought, then it was also able to take on broad social implications. For no theory of art can ever be advanced without some notions of its potential (or desired) public being stated, be they never so vague. The relation between aesthetic and social theory is rarely a matter of mere analogy. Thus it was that just

Colour 2
Spencer F. Gore, *Corner of Ampthill Square*, 1913, oil on canvas, 50.8 × 61 cm (20 × 24in). Private Collection.

Colour 3
Spencer F. Gore, *The Cinder Path*, 1912, oil on canvas, 68.6 × 78.8cm (27 × 31in). The Tate Gallery, London.

1 Roger Fry, *Turkish Landscape*, 1912, oil. Provenance unknown.

as French Impressionism had implied political scandal in Paris in the 1870s, so Post-Impressionism seemed to be more than just a generalised attack on the taste and structure of the London art market in the 1910s. For Edwardian middle-class culture remained a remarkably consistent and unified system, such that Ford Madox Ford could see it as a minuet, 'simply because on every possible occasion and in every possible circumstance we knew where to go, where to sit, which table we unanimously should choose.'[16]

Hence a term derived largely from the thought of a French Symbolist,[17] used to attack Symbolism in the context of what amounted to a Gauguin retrospective, became the *dernier cri* of anti-Edwardianism. Again, this process is not simply, as is often pictured, one of displacement from the aesthetic to the social. In the 1870s the 'negative capability' of Impressionism was quite rightly understood as an attack not merely on the antiquated hierarchical system of subject-matter in French art, but also simultaneously upon the society which sanctioned the ossification of such hierarchies.

In the same way the concept of Post-Impressionism challenged the totality of cultural ideology in this country by articulating a sharp denial to the validity of one relatively small part. Perhaps it was this very density, the impacted unity

of aesthetic, moral and political values which characterised the late Victorian and Edwardian era, which led Fry and so many of his contemporaries to such an equally impacted and nugatory alternative. Hence the idea of Post-Impressionism is almost an exact inversion, or mirror-image, of that which it sought to overcome, similarly collapsing moral, political and aesthetic values into a unitary term which, stressing such notions as 'purity' and 'disinterest-edness', remained largely unaware of its larger social contingency. This massive act of theoretical and historical condensation effectively guaranteed the splintering of younger British artists into a bewildering variety of fluctuating froups and identifications.

This problem is exemplified by the Camden Town Group painters. In 1910 Spencer Gore could write[18] that he believed a future generation would find some essential unity behind all the French artists associated with the Impressionist group, including Gauguin, Cezanne, Renoir, Monet, Pisarro – even Degas – whilst another member of the group could find in the concept only a new Academicism 'disguised under a false cloak'.[19]

The actual allegiances and specificities of English painting in this period can only be established by drawing back some little way at least from the troubled concept of Post-Impressionism, in order to trace the trajectories of those younger English painters who were so profoundly and variously moved by the experience of modern French painting. For it is only from within the matrices of the English art world that the full impact and significance of French Modernism may be appreciated.

2. English Impressionism

That Impressionism was never a particularly stable term in the currency of late nineteenth-century English art criticism is generally taken as evidence of some congenital national stupidity on the part of local painters and critics alike. It is therefore important to understand that Impressionism, in its original French formulation, could never have enjoyed any very precise meaning in a country which had some fifty years acquaintance with the principles of open-air painting, established by Constable and extensively described in the 1845 edition of C.R. Leslie's *Memoirs of the Life of John Constable composed chiefly of his letters*. Indeed, it is probable that the Barbizon and Impressionist paintings exhibited annually at Durand-Ruel's London Gallery between 1870 and 1875,[1] looked only too familiar to a public well acquainted with the values of the English watercolour tradition. If the concept of avant-gardism meant anything to this public, it meant Whistler. It is unlikely that the work of Corot or Monet would have appeared particularly revolutionary in the 1870s to anyone accustomed, for example, to the more extravagant colour innovations of Holman Hunt's landscapes. Impressionism was the *ne plus ultra* of a specific tendency in French art. Neither aesthetically nor institutionally did that position obtain in England.

In order to understand the various ways in which the term was used in England it is necessary to consider those institutions and their conflicts, but it is also necessary to consider the way in which Impressionism itself has been consistently used in order seemingly to guarantee the validity of that would-be universal version of European art history discussed in the previous chapter.

The Impressionists had themselves shared many of the basic aesthetic assumptions of their contemporaries. Gautier had, after all, first used the phrase *'l'art pour l'art'* (art for art's sake) in the late 1880s in order to rally together a broad consensus of opinion hostile to the notion of 'ideas' in art. Impressionism began its long career with this same credo – a clear demand that art should not longer exist for the sake of literature, or philosophy, or the State, but rather for its own sake, as a formal method: 'It's only painting that counts.'[2] The roots of Formalist aesthetics can here be seen to lie very deeply within this period, together with a theory of 'purifying' the spectator's perceptive faculties, which was to culminate in various twentieth-century versions, principally in Russia and Germany.[3] Stylistic disputes should not be allowed to obscure the fundamental and widespread appeal of Aestheticism for both Symbolists and Naturalists, the most characteristic single feature of the art of the late nineteenth century.

It is this cultural unity which has been fragmented by later critics and historians who projected the uncertainties and controversies of early twentieth century aesthetics onto this period in their various attempts to create some kind of Great Tradition as a bulwark for Post-Impressionism. This reductive and over-simplified accounting of late nineteenth-century painting, based upon the complex sociology of early Modernist art, continues to suggest that, for example, any European painter in 1890 not working in the manner of Cezanne was either wilfully perverse or merely reactionary. The result is a total flattening out of the period, together with an endless proliferation of 'alternative traditions', required to deal with any artists who cannot simply be accommodated as a fore-runner of Post-Impressionism. This theorisation also guarantees the consignment of most British painting to a kind of historical no-man's land, supressed, together with many other entire national schools, by the

force of an art historical orthodoxy established in the exact likeness of the canonical status of Post-Impressionist aesthetics.

At least three sets of meaning were associated with the term Impressionism in the England of the 1890s. In its most common usage it implied a general sense of cultural radicalism, verging on the modern sense of radical chic, more or less synonymous with the *terrains vagues* of Bohemianism. Thus Lionel Johnson could parody the excesses of his 'decadent' contemporaries in 1891, describing 'the haggard eyes of the absintheur, the pallid faces of "neurotic" sinners' and English attempts to ape cafe society. 'Anyway', he continues, 'beauty includes everything; there's another sweet saying for you from our Impressionist copy-books. Impressions! That is all... we alone know Beauty and Art and Sorrow and Sin. Impressions!'[4] Here the stereotypical characters of Murger's *Scènes de la vie Bohème* are heard to speak with the unmistakable accents of Chelsea and Bedford Park. However, as T.J. Clark has pointed out, we need to be able to distinguish between the genuine counter-cultural values of Bohemia, and the avant-garde's fantasy of it.[5]

In this context the term served to connect, if loosely, the values of Aestheticism to a broader current of social criticism which the Decadents themselves were unable to articulate beyond a certain degree of metaphor – the literature of 'Impressions'. That rejection of the strict hierarchies of genre in official French salon art which had automatically led to an equation in France between Impressionism and political radicalism, lost most of its ideological significance in England. To begin with, the political situation was dramatically different. In England the 1890s were marked by the success of the 'Parliamentary Faction' in British Socialism. Revolutionary dissent was increasingly focussed on the electoral chances of the newly-formed Independent Labour Party.[6] The social purchase of the term in England combined the Utopian other-worldliness of the Aesthetic Movement with vague memories of the Paris Commune, and half-remembered studio gossip concerning the original scandal of Impressionism itself in Paris.

It was Oscar Wilde who most succinctly illustrated this situation. 'Society often forgives the criminal', he wrote, 'it never forgives the dreamer. The beautiful sterile emotions that art excites in us are hateful in its eyes... Contemplation is the gravest sin of which any citizen can be guilty...'[7] For Wilde, the love of art is an *amour fou*, a way of by-passing politics, a means to some ideal aesthetic Utopia: 'Aesthetics are higher than ethics'. Hence his admiration for the Impressionists: 'I like them. Their white keynote, with its variations in lilac, was an era in colour.' But at the same time he dislikes 'their coarse gritty canvasses of their unnecessary selves and their unnecessary opinions'. Art, he argues, is inimical to practical experience, and 'the art that is frankly decorative is the art to live with... mere colour unspoiled by meaning, and unallied with definite form, can speak to the soul in a thousand different ways... In the mere loveliness of the materials employed there are latent elements of culture... By its deliberate rejection of Nature as the ideal of beauty, as well as of the imitative method of the ordinary painter, decorative art not merely prepares the soul for the reception of true Imaginative work, but develops in it that sense of form which is the basis of creative no less than critical achievement. For the real artist is he who proceeds not from feeling to form, but from form to thought and passion.'[8]

Wilde dislikes the 'realism' of the Impressionists which he views as evidence

of artistic impurity. Art is not to be 'expressive' but 'impressive': 'In fact an art by itself, occupying the same relation to creative work that creative work does to the visible world of form and colour, or the unseen world of passion and of thought.' The very close resemblance to Fry's 1912 Introduction to the Second Post-Impressionist Exhibition[9] is only extraordinary in the context of a picture which would present Post-Impressionism as a totally innovatory aesthetic rupture with the immediate past. Wilde champions a decorative art following and quoting Plato's arguments concerning the exemplary influence of one's environment, thus ensuring that Impressionism would be seen in terms of its purely synthetic qualities, its 'disinterestedness', which at the same time connotes a broad criticism of the kind of society which uses art as 'mere' illustration. He had thus already effected that shift from aesthetics into ideology which is so characteristic of early Modernist thought. Impressionism becomes the painting of 'Impressions', more or less exquisite, more or less identified in London with the career of Whistler. Thus French avant-garde culture was annexed to the Cult of Beauty.

Many painters in London, however, including Whistler, had a very thorough and precise knowledge of French Impressionism. When he chose, Sickert could be extremely lucid on the subject: 'The Impressionists have added two things to the language of painting ...enlargement of the possibilities of composition, [and] an enlargement equally extensive and important of the understanding of colour, especially in the shadows'.[10] He writes of the 'pure impressionism' of Sisley and Pissarro in which 'though exquisite places or exquisite groups are sometimes the excuse for the painting, the principal personage is the light'.[11] The history of the New English Art Club, and Sickert's place in it will be described later, but suffice it to say in this context that in the 1890s this precise sense of the word 'impressionism' was hardly useful within the discourse of English art. Thus it was that at the one moment in his career that Sickert defined himself as an 'Impressionist', it was an act of identification with the urban, the anti-Academic and was used in a sense of conscious defiance of both symbolism and naturalism. For him and his colleagues in 1889, Impressionism was 'a belief that for those who live in the most wonderful and complex city in the world, the most fruitful course of study lies in a persistent effort to render the magic and the poetry which they daily see around them.'[12] Here Sickert is emphasising precisely the 'coarse, gritty' aspects of Impressionism which so offended Oscar Wilde. Sickert's use of the term however, as a specific intervention into the situation in London will be explained in the next chapter. He wished to transfer an emphasis away from technique and towards issues of subject matter, since Impressionism was already becoming a commonplace in art education, but a commonplace which implied neither a 'social' attitude towards subject matter and the consumption of works of art, nor a 'scientific' attitude towards light and colour.

Above all else it implied an attitude towards tonality and actual brushwork. Impressionism was not discussed as a 'movement' in French art, but as an approach to painting as such, a technique which might be discovered in all periods of European art. Thus Sir George Clausen in 1904, as President of the Royal Academy, could write of Impressionism as a universal form of 'psychological' expression in all art, a theory of 'form and movement, and not of colour'.[13] At the same time Japanese art is 'frankly impressionist in its disregard of all but the things chosen'. He specifically rejects any attempt to 'confine' the

term 'to a particular group of explorers in colour... as all art is so largely a matter of personal impression'. Thus the entire intellectual importance of Impressionism as a cognitive theory of art is conveniently overlooked. 'The old painters', he writes, carefully refusing to name anyone to whom he might actually be referring, 'gained colour at the expense of light.' With these nameless Old Painters is contrasted the figure of Turner, 'the first and greatest impressionist painter' who 'influenced' Monet to study the 'realisation of actual sunlight'. Yet it is not this 'realisation' which finally matters to Clausen. For it is neither Turner nor Monet who is the hero of this particular account of 'impressionism', but Bastien-Lepage, 'incomparably more able and skilful than Millet'. Lepage does not let 'everything go for the sake of expression', but paints 'for the sake of giving the true effect of people in the open air, with the light and actual colour of nature...' But this sense of light and colour is not the 'prismatic sensibility' of Manet, as described by Jules Lafargue.[14] Bastien-Lepage may paint from the model, but 'avoiding sunlight and effect, and confining himself to an even light'.

This is what matters for Clausen, the uniform tonality of an overcast afternoon, the reduction of Millet to a sentimental pastoralist whose peasants are drained of what little radical significance they might have still possessed in the 1890s. They are restored to more ancient consolatory functions, as figures in a new sense of the picturesque, imbued with a sense of modernity by the transference of the more superficial effects of Impressionist brushwork, which is a measure of the ease with which Impressionism could be assimilated to the Academies, once stripped of its specific associated meanings within French culture.

It is in a similar vein that R.A.M. Stevenson could use the word Impressionism, in his seminal work on Velasquez, to express a particular modus vivendi between decoration and 'impressions of the external world'.[15] In this version of history Velasquez emerges as the key figure, the quintessential example of a painter who conceived his pictures 'rather as an ensemble of tone than as a pattern of lines and tints'. The art of oil painting is defined around a concept of Impressionism which privileges the idea of that which may be seen from any one place at any one time. Like Clausen, Stevenson is using Impressionism to describe an approach to painting which is principally concerned with tonal relations and their relative values, but with far greater intelligence and logic. However, as Clausen looked to Turner and Bastien-Lepage, so Stevenson looked to Carolus-Duran and Whistler, seen as the exemplars of 'direct-painting', the 'cure for namby-pamby modelling which trusts for expression to a red line between the lips, a contour line to the nose, and a careful rigger track round the eyes and eyebrows.' What is important in Stevenson's notion of Impressionism is that images should be built up by planes alone, rather than by secondary drawing, and that surfaces remain distinct and not brushed into one another. It follows that for him Manet, Corot, Courbet, Whistler, Degas and Monet are all 'Impressionists' in this reading of a technical tradition in European art seen to stem from the primary example of Velasquez.

At one point in his argument Stevenson fascinatingly cites the idea of a child's early vision, 'receiving from a field of sight an impression of the value of colour and the forces of definition, utterly unadulterated by knowledge'. Once again, seeing is theoretically distinguished from knowing within a metaphor which was widely used by many of the Impressionists themselves, including

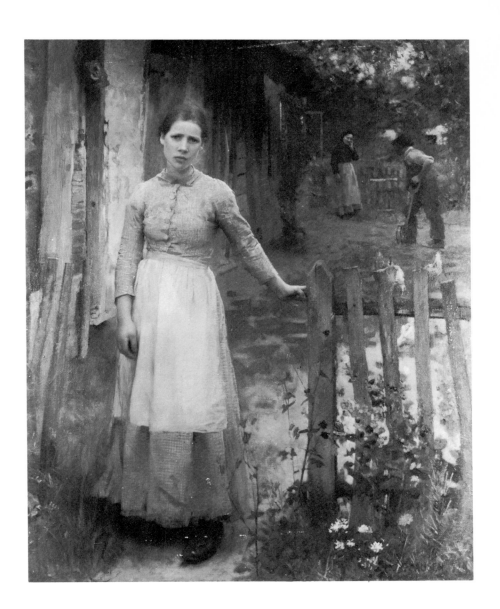

2 Sir George Clausen, *The Girl at the Gate*, 1889, oil, 172 × 138cm (67½ × 54½in). The Tate Gallery, London.

Monet, Pissarro and Cezanne. I do not think there is any point in trying to trace individual precedents here. What should be noted is the availability of a new theory concerning the development of human visual perception and its immediate relevance to a new theory of pictorial space.

Impressionism emerges here as a transcendent theory of 'correct' painterly practice, which is simultaneously a broadside against the 'realism of effect', the 'rude compilations of objects, studied at different focusses', which Stevenson diagnosed as the principal fault of Academic technique. His theory depends upon an ideal of completeness, and unity of impression, which was to become the standard goal for such painters as Harold Gilman and Spencer Gore, who read his book as avidly as the rest of their contemporaries at the Slade School of Art in London at the turn of the century.

Impressionism, as Sickert pointed out, was an elastic term. In crossing the Channel it lost its original meaning and became widely used within fashionable *fin-de-siècle* art jargon. As such it was employed by both Realists and Anti-

Realists to add the same gloss of modernity to their somewhat laboured debates. This should not be read as the 'distortion' of some fundamental and unalterable principle, but rather as an example of the ways in which different cultures communicate with one another, dynamically, modifying new ideas to complex historical traditions as and when they are useful or appropriate. Thus it was that in England Whistler was an 'Impressionist'. Sargent was an 'Impressionist', Velasquez was an 'Impressionist'. At once modish and radical, the term was ideally suited to a situation in which the artist's relation to his or her society was far from clear. It conveniently sanctioned both a move towards 'safe' and seemingly familiar subject matter, conveying the burden of social symbolism to aspects of technique, and a specific iconography of 'modern' urban scenes. And even these two positions could be less exclusive than they might appear. It was Aubrey Beardsley, the master of English decorative art in the 1890s, who could look forward to a London which 'will soon be resplendent with advertisements [which] against a leaden sky will trace their formal arabesques'. This vision, so close to the literary impressionism of Arthur Symons, could equally be defended by either camp.

In this sense, the story of Roger Fry's invention of the term Post-Impressionism in a moment of exasperation before a pressing journalist in 1910, in order to categorise the painters whose work was being shown at the First Post-Impressionist Exhibition, ensured not simply the acknowledgement of a historical break, real or imagined, but also the transference of a wealth of cultural and social associations across from the 1890s and into the twentieth century. But to understand how young English painters came to disentangle the 'Impressionism' of Bastien-Lepage and Carolus-Duran from that of Monet or Sisley, it is necessary to examine the major art institutions in London at the time, and how they defined what was or was not 'acceptable' and, of course, ultimately, saleable. In this context we begin to understand how artists trained in the avant-garde tradition of Whistlerian tonality, found something meaningful and applicable to their own work in the art of Cezanne and Matisse.

3. The New English Art Club and the Slade

As late as 1910 Sickert could observe: 'It is a pitiful thing, and one of the best proofs of the nullity of art criticism in this country, that Sargent's painting is accepted, as it is, as the standard of art, the ne plus ultra and high-water mark of modernity.'[1] One of Saki's characters explains in a short story from 1904 that to 'die before being painted by Sargent is to go to heaven prematurely'.[2] The cult of 'Sargentolatry' was hardly surprising. As an Academician Sargent offered his clients a flattering view of themselves which reveals an intelligent reading of the conventions of English aristocratic portraiture, and in particular the work of Van Dyck and Sir Thomas Lawrence. As a member of the New English Art Club he added a thorough knowledge of Velasquez, Whistler, Manet, and the French Impressionists. This was to prove an ideal recipe, combining an austere tonality with a top-coat of illusionistic devices which were sufficiently dramatic, and 'tasteful', to guarantee him 'a decade of the heaviest artillery of unbroken adulation'.[3]

A student of his at the Royal Academy School wrote to a friend in 1902: 'Sargent is teaching most extraordinarily well at the R.A.... He gives lessons as you said he did... They're chiefly about tone. He insisted upon thick paint and makes one try to get the right tone at once... The one thing he is down upon is when he thinks anyone is trying for an effect regardless of truth.'[4] Looking back in 1934 she recalled: 'I had for long doubted, denied his merits, thought him vulgar, but had at last gone over with vehemence, overcome by what seemed superb painting.'[5] Vanessa Bell writes here as a representative art student at the turn of the century. She had attended the Royal Academy Schools between 1901 and 1904, and then studied briefly at the Slade in 1905. At the time it seemed to her that the New English Art Club was 'the most go ahead group in modern art'. Nonetheless, she describes her own situation, as a woman painter, preparing 'to be silent and afraid' in the face of the exclusively male 'art universe' of the New English. How she and so many of her contemporaries were to come to feel that, as she put it, they had 'lost their way' by 1910, is only explicable in relation to these institutions and their own historical relations.

The 'art universe' to which Vanessa Bell referred consisted of two principal institutions, an exhibiting society formed in 1886 – The New English Art Club – and the Slade School of Fine Art, founded in 1871 as a part of University College, London. The importance of the Slade is apparent from the number of young artists who went on to make their names within the Post-Impressionist period: Vanessa Bell was a student in 1905, David Bomberg from 1911 to 1913, Harold Gilman from 1897 to 1901, F. Spencer Gore from 1896 to 1899, Duncan Grant in 1906, J.D. Innes from 1905 to 1908, Mark Gertler from 1908 to 1912, Augustus John from 1894 to 1898, Derwent Lees from 1905 to 1908, Paul Nash from 1910 to 1911, C.R.W. Nevinson from 1908 to 1912, Sickert in 1881, Stanley Spencer from 1908 to 1912, Percy Wyndham Lewis from 1898 to 1901, Edward Wadsworth from 1908 to 1912, and so on.

The Slade School of Art had been founded in the circumstance of a widely felt dissatisfaction with contemporary teaching methods at the only 'official' art schools in London, those of the Royal Academy, including the 'Schools of Design' at South Kensington. Here the student began with 'elementary design', which consisted, as Fred Brown described it, of 'fudging plant shapes into a geometric framework'. This system mechanically followed the insistence in Owen Jones' *Grammar of Ornament* that all ornamentation should be based upon geometric principles.[6] Teaching at the R.A. Schools consisted then either

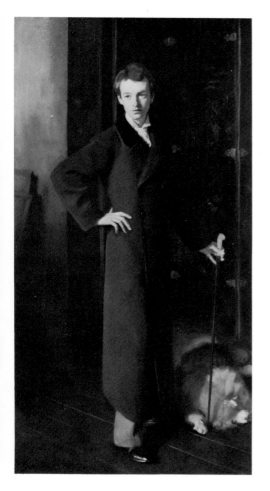

3 J.S. Sargent, *W. Graham Robertson*, 1894, oil, 231 × 119cm (90¾ × 40¾in). The Tate Gallery, London.

of copying such designs, known as 'drawing models', or of copying from the Antique. 'The Antique' consisted of plaster casts of well-known works of Graeco-Roman sculpture, each drawing possibly taking the student months to complete, such were the demands of elaboration and 'finish'. In all essentials this system remained as it had been when Rossetti abandoned his studies there in 1848.

The particular social and cultural alignments which had breathed contemporary political meaning and significance into the historical recreations and facsimiles of the Neo-Classical period, were all but extinct by the middle of the nineteenth century. The extraordinary pluralism of Victorian culture meant that classical antiquity was only one of many symbolic systems available to deal with the complex issues of the day. Antiquity lost the semiotic primacy which it had enjoyed since the Renaissance. Thus it was that the Slade's first professor, Edward Poynter, wanted to impress only one point on his students in his inaugural lecture: 'That constant study from the life-model is the only means we have of arriving at a comprehension of the beauty in nature, and of avoiding its ugliness and deformity, which I take to be the whole end and aim of study.' He goes on to argue against allowing 'ideas' to destroy the 'impressions'. The fundamental tension in the Slade 'tradition' is already implicit here in 1871, between an idea of intuitive naturalism, and an idealising programme which is clearly much more culturally specific. The student is not to be satisfied merely with detail of effect, but neither is he or she to be over-concerned with subject matter, since art itself, the conventions of drawing and painting, are the prime concern. The Slade has never been well known for its social realism.

Poynter's regime clearly derived from his own experience as a student in Paris, caricatured by George du Maurier in *Trilby* as Lorimer, 'who did not share in the amusements of the Quartier Latin, but spent his evenings at home with Handel, Michaelangelo and Dante, on the respectable side of the river.'[7] Poynter left the Slade in 1876 for an eventual and perhaps inevitable baronetcy, having been elected President of the Royal Academy in 1896. And it was from Paris that his successor, Alphonse Legros, had arrived. Legros had exhibited his own rather severe brand of Arcadian Realism at the first Impressionist Group exhibition in 1876, and earlier at the Salon des Refusés in 1863, together with Monet and Cezanne and Whistler, who had persuaded him first to come to London in the same year. However, as Sickert observed many years later: 'Apart from the question of degrees of personal force, Legros was exiled at the wrong moment from subjects and influences that had formed his inspiration. His themes of French country and peasant life could, in London, only become as time went on, fainter and fainter echoes of any living impression. His professorship depleted his creative energy instead of nourishing it. A great teacher is refreshed and inspired not only by his direct but by his indirect creation. Legros had no clearly reasoned philosophy of procedure and did not understand the closely-woven plexus between observation, drawing, composition and colour. The heads he painted in two hours before his classes, with their entire absence of relation between head and background, were almost models of how not to do it.'[8]

As a painter who spent a lifetime attempting to work *away* from nature, Sickert has a personal axe to grind here, and Legros' influence on the 'Newlyn School', in particular Tuke and Gotch, has perhaps been underestimated. Legros established a technique of naturalistic drawing, forbidding any

4

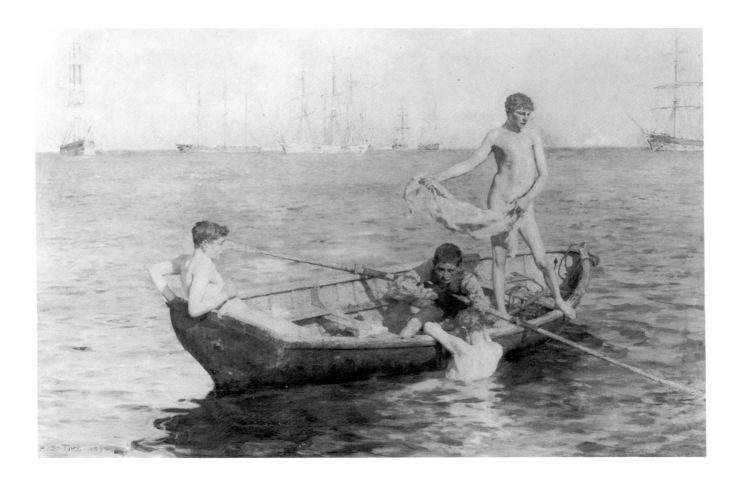

4 H.S. Tuke, *August Blue*, 1893-4, oil,
122 × 183cm (48 × 72in). The Tate
Gallery, London.

alterations or erasures, which Poynter could scarcely have imagined. Legros'
successor was Professor Fred Brown who came to the Slade from the
Westminster School of Art, where he had taught Beardsley and Henry Tonks,
whom he promptly appointed as a teacher of drawing. Between 1892 and 1918
Brown presided over the School, supervising both the 'generation of 1890' –
William Orpen, Ambrose McEvoy, and above all, Augustus John, as well as the
younger Post-Impressionist generation including Harold Gilman, Spencer F.
Gore, Duncan Grant, and many others.

The Slade's educational policy under Brown was summed up in one word,
drawing, and it is important to understand what he and Tonks meant by it. The
reputation and prestige of the Slade throughout this period meant that it could
be a largely self-referential institution. The concept of Art to which it set its
sights was the product of a particular kind of historical consciousness. 'I want
to have an art revival as they do in religion,' wrote Tonks. 'I feel I could go and
weep and rave in Hyde Park and beg people to repent and turn to art before it is
too late.'[9] Obsessive it may have been, but this idea of art was blissfully free of
that positivist concept of progress which invariably informs later theories.
Manet and Courbet stand beside Michaelangelo and Goya. Whistler and Millet
are discussed in the same breath as Rubens and Velasquez. Art was seen as a
pantheon into which the student was invited, often rather brutally, to enter.
Thus a method of instruction was developed which, as John Fothergill
explained, 'should be capable of rational exposition. It must depend upon first

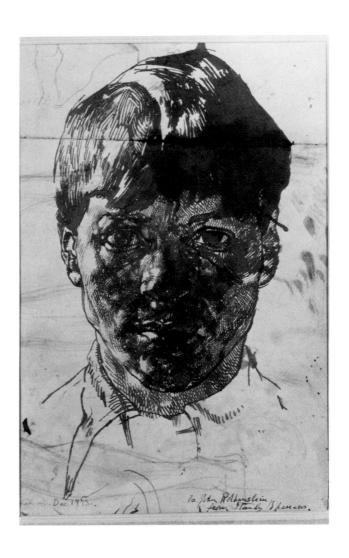

5 Stanley Spencer, *Self-Portrait*, 1913,
pen and ink, 35.6 × 21.6cm (14 × 8½in).
Private Collection.

principles'. First principles at the Slade insisted that form was the prerogative
of drawing, but only via lighting, and not as a thing in itself. At the same time
Fothergill describes the notion of 'Touch'.[10] Touch involves our knowledge of
the visible world in relation to that of the medium being used. Drawing is to
derive from observation, but its object is not photographic verisimilitude.
Indeed, throughout this period, photography served in England to define
negatively what art was not. Good drawing could not simply be linear, since line 5
on its own was not thought to be able to transform one's full knowledge of an
object into adequate visual terms. Like R.A.M. Stevenson, Fothergill used the
analogy of a child's vision to make this point: 'The ideas of touch know no
contour.'[11] Form was a tangible quality, and thus formal ideas could only be
expressed through modelling.

It was from this single-minded education that a 'family likeness' emerges, as
Andrew Forge has described it, between the various Slade students of the
period.[12] This ensured a certain formal and constructive predisposition in
English art. Hence the receptiveness of Slade students to the new French
painting which explored this area which seemed to Brown, Tonks and Steer to
be an absolute break with observed nature. The Slade represented a

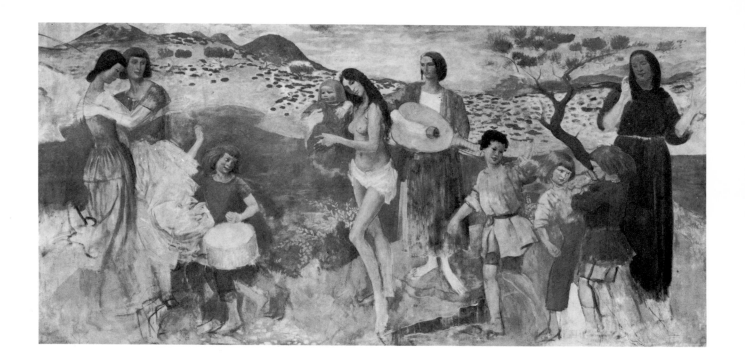

6 Augustus John, *Lyric Fantasy/The Blue Lake*, 1911-15, oil, 234 × 472cm (92 × 185in). The Tate Gallery, London.

passionately held *idea* of art. Thus it was that D.S. MacColl could exclaim of Augustus John's drawings that 'the hour of Rubens had returned.'[13] This was perhaps the highest conceivable praise. It also implies a highly exclusive, connoisseur-oriented approach to art education. John is the supreme example, and victim, of this idea of art. Whereas his contemporaries allowed themselves to be seduced by the compositional devices of Japan and Art Nouveau, or later of Post-Impressionism, John remained caught in the trap of his own much-acclaimed graphic dexterity. As he explained: 'I spent most of my spare time in the National Gallery, the British Museum, and other collections ... loading my mind with a confusion of ideas which a life-time hardly provides time to sort out.'[14] In this context it was apparent to a writer like George Moore, steeped in the values of Tonks' and Steer's circle, that both French and English art had 'grown and flourished in the same aestheticism.'[15] Hence, the contradictions in the work of a painter like Steer, who applied a pointilliste technique of painting, which had been developed by Seurat in the 1880s as an antidote to the formlessness of *plein-airisme*, back to an open air tradition. Like Renoir, Steer found it increasingly difficult to resolve the demands of direct painting with an overwhelming admiration for the draughtsmanship of the Old Masters. This was a direct result of the Slade's attitude towards history. A positivist notion of progress came into inevitable conflict with a transcendent a-historical notion of 'quality'. The result was either the brilliant historicism of an Orpen or John, or attempts to locate the strengths of the Slade's drawing tradition in the here and now. Tonks may have steered his pupils clear of the shallows of Whisterian 'daintiness', but he offered them precious little idea of what to actually do with their robust talents. The younger generation might admire John's bravura feats of economic drawing, but they were equally aware of the doldrums into which that skill had led him, the result of the 'solid

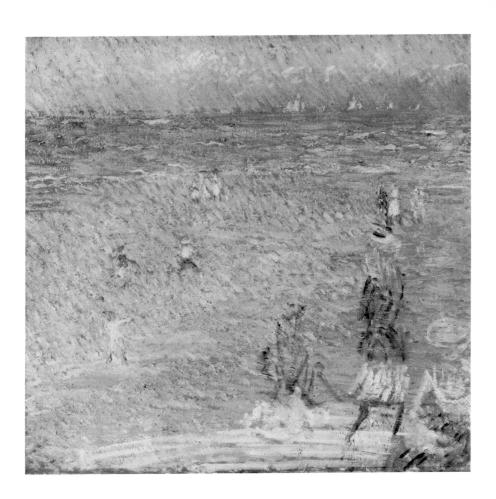

7 P.W. Steer, *Figures on the beach, Walberswick*, c.1889, oil. 61 × 61cm (24 × 24in). The Tate Gallery, London.

unimaginativeness' which William Rothenstein found in Steer but which might be applied to the whole Slade approach.

Tonks wrote in a letter that 'unless a man believe in art he cannot be saved, and *everyone* must as they did when Donatello lived...'.[16] Thus it was that young artists emerged into Gower Street able to draw like angels, committed to an idea of Art which by definition bore no relation whatsoever to the society in which they lived. There was also the straightforward problem of exhibiting. As Vanessa Bell observed: 'Above one were the professors saying "Draw for seven years – learn anatomy and chemistry and the use of the stump" – and in the galleries were their works.'[17] The Galleries in this situation effectively meant the New English Art Club.

Looking back over fifty years of the New English Art Club, Alfred Thornton wrote: 'Into a hothouse of sentimentality in the late 80s it blew again the fresh breath of the open air, of the vitality of the things seen, of reality faced and its beauty sought out.'[18] Now these are strong words. The Club had been formed in 1886 by a group of young painters, mostly trained in France and mostly associated with the Slade, in an attempt to challenge the monopoly held by the Royal Academy on all matters concerning the public showing of works of art. Its constitution was drawn up by Fred Brown and was modelled on that of the Parisian Salon des Refusés, whose function it paralleled in this country. Andrew Forge has written: 'During the 'nineties, the N.E.A.C. became a focal point for all that was most adventurous in English painting. Even so it would be

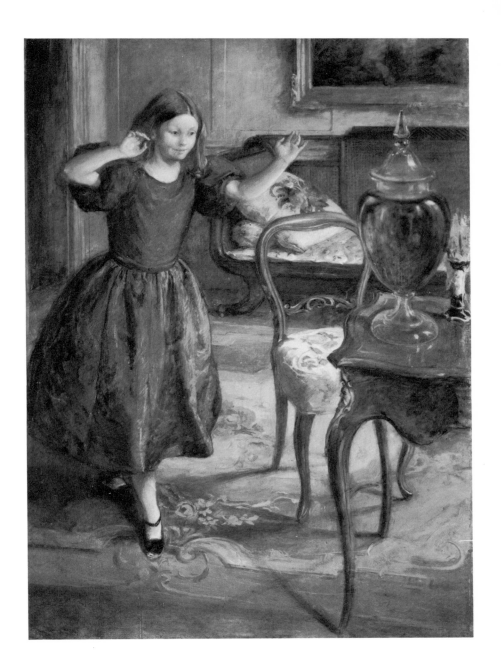

8 H. Tonks, *Rosamund and The Purple Jar*, c.1900, 80.7 × 59.7 cm (31¾ × 23½). The Tate Gallery, London.

hard to define what it stood for aesthetically; perhaps the most that one can say is that to begin with it identified itself with Impressionism, and then, as it became clear that what was happening in France was not merely a technical advance but a revolution of ideas, it devoted itself to a search for patriotic alternatives.'[19] As so often in this period, it is Sickert who provides another clue. 'The born painter,' he writes, 'puzzled and out of joint with the indifference of his times, has, over and over again, sometimes for long periods, or, as wisdom has gained the upper hand, for short ones, stretched his hand out to the mirage of the conquest of society...'.[20] He is talking about Whistler, but the argument applies equally to the origins of the N.E.A.C.

The various names suggested for the Club before its inauguration tell one a great deal about its aims: 'The English Renaissance', 'The New English

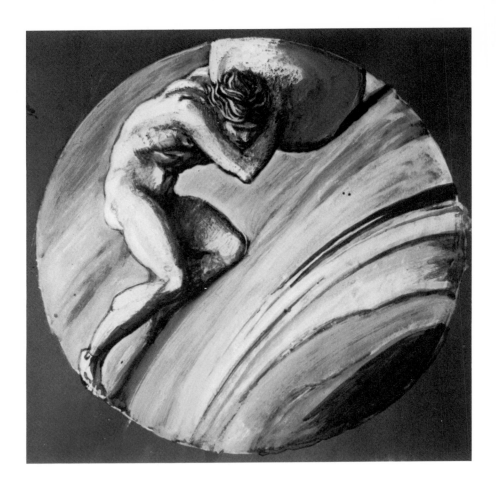

9 Sir Edward Burne-Jones, *Sisyphus*, c.1880, watercolour, 21.8cm (8½in) diameter. The Tate Gallery, London.

facing page
Colour 4
Spencer F. Gore, *The Balcony at the Alhambra*, c.1911-12, oil on canvas, 48.3 × 35.6cm (19 × 14in). By courtesy of Anthony D'Offay, Esq.

Institute', 'The Society of Anglo-French Painters'.[21] From the outset it was divided between at least three factions, firstly the so-called 'Newlyn School', named after the resort in Cornwall where Henry Tuke and his colleagues spent much of their time. Secondly, there was a loose amalgamation of artists like Clausen and La Thangue who had discovered from the examples of Corot and Bastien-Lepage that if everything in a picture is toned downwards, colour and light thus underplayed become extremely effective. This style moved uneasily in and out of a quasi-social realism in the work, for example, of Stanhope Forbes and Frank Bramley. Thirdly, there was the group consisting of Steer, Brown, George Thomson, Theodore Roussel and others who joined together to exhibit as the 'London Impressionists' in December 1889. Here the problem of the term Impressionism becomes particularly acute. In his Introduction to the exhibition catalogue Sickert begins by criticising the decorative tradition of William Morris and Burne-Jones: 'This painting is commonly excused as decorative painting, and it is against the complete misuse of this term that the efforts of serious art criticism should, among other things, be directed. Absence of convincing light and shade, of modelling, of aerial perspective, of sound drawing, of expression, of animation, of all that results from keen and sympathetic observation of life, are not the qualities, although it is at present heresy to say so, which render proper the application to a picture of the term decorative. Surely works constructed to decorate a wall should be so painted as to appeal primarily at the distance at which they are most frequently seen.'[22]

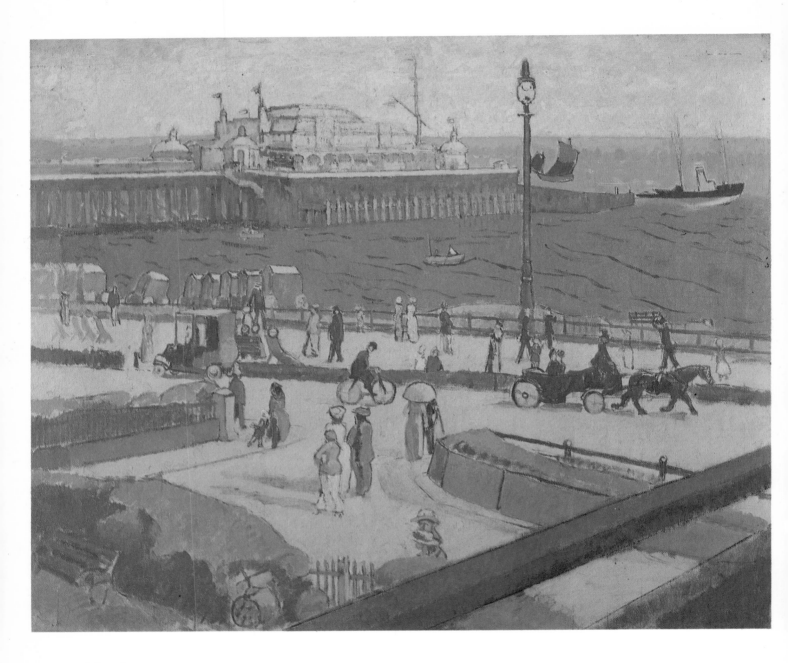

Colour 5
Spencer F. Gore, *The West Pier, Brighton,* 1913, oil on canvas, 63.5 × 76.2cm (25 × 30in). Southampton
City Art Gallery.

facing page
Colour 6
Duncan Grant, *Still Life,* c.1915, oil, 76.2 × 63.5cm (30 × 25in). Private Collection.

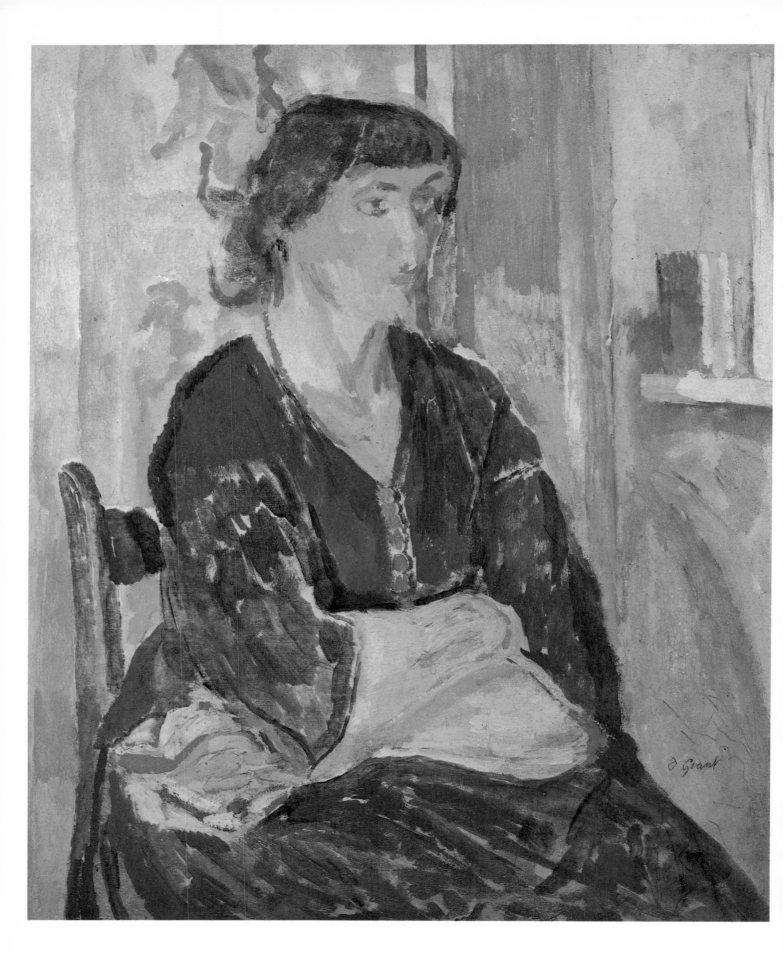

He is particularly critical of those 'who would offer as a substitute on our walls, for an art which is the flower of centuries of European thought and experience, the endless repetition on paper of adapted patterns, printed by machinery in two or three shades of subdued colour.' One can almost hear the derision in his voice. But this has very little to do with Impressionism. What Sickert is doing is to put a fairly simple case in rather muddled terms. He disputes one definition of the decorative, and wishes to replace it with another. He sees Impressionism as being neither Naturalist nor Realist, its function neither 'to record anything merely because it exists', nor 'to make intensely real and solid the sordid or superficial details of the subject it selects'. Rather, Impressionism is to be identified with a particular sense of the Beautiful. It is 'strong in the belief that for those who live in the most wonderful and complex city in the world, the most fruitful course of study lies in the persistent effort to render the magic and the poetry which they daily see around them, by means which [the exhibitors] believe are offered to the student in all their perfection, not so much on the canvasses that yearly line our official and unofficial shows of competitive painting as on the walls of the National Gallery.'

Sickert is appealing to a Great Tradition argument. Impressionism is not to be exhausted as a term in relation to specific artists, or techniques, or even matters of subject, rather it is to combine all three in an assault on the values and power of the Royal Academy and its minions. In effect he is doing precisely what Roger Fry was to do in 1910 – he is selling on a name. For the term Impressionism serves the same role to his attempt to attack Whistler and Burne-Jones in the name of Degas, as the name of Manet was to justify the art of Cezanne, Gauguin and Van Gogh.[23] Thornton and others have argued that Sickert is doing no more than pipe the tune of Whistler's 10 O'Clock Lecture here. On the contrary, however, Sickert's position seems almost defiantly anti-Whistlerian. The sense of Beauty at stake here is not the pedigree aestheticism of his earlier teacher, but Sickert's own vision of an art which is intimately connected to the life of the society in which it is produced. It is not a question of Whistler's much vaunted *valeurs gris* in themselves, rather it is an issue of the meanings which are attached to them, those of an art which is to be the arcane province of a small minority, whose taste seemed to be evidence of their social superiority, or an art which might attract a wider audience, given the caveat that, being so much a matter of conventions, the element of conscious instruction is always present.

Starting out as an annual exhibiting society for members and guests as selected, and using various commercial galleries, the New English settled into an orthodoxy which was to prove at least as uninspiring to the generation of the late 90s as the R.A. had been positively hostile in the 80s. Sickert summed up the situation concisely: 'The N.E.A.C. picture has tended to be a composite product in which an educated colour vision has been applied to themes already long approved and accepted.' Like all Exhibition Societies, it had evolved a particular type of exhibition picture: 'A glance around the walls of any New English Art Club exhibition does certainly not give us the sensation of a page from the book of life. There is an over-insistence on two motifs. The one the august-site motif and the other the smartened-up-young-person motif.'[24] Elsewhere he allows La Thangue's titles to speak for themselves: '*A Brescian Shore, Ligurian Arbutus, Neglected Roses, The Yoke, A Ligurian Shepherdess*'.[25] But by the time this was written in 1914, La Thangue had effortlessly moved

'up market' to the Royal Academy. Such traffic was frequent, and in both directions.

The major problem with the New English was precisely that it lost any sense of 'cause' which it might originally have possessed at the moment it came into existence. It was a self-fulfilling prophecy. Not having set out to proselytise for any particular style, it never developed the kind of identity or organisation which might have allowed it to function as an umbrella for younger and more radical talents. Gore and Gilman and Gertler and Grant might exhibit with them, but principally for the lack of any viable alternative. By 1900 it had become more or less the Slade's unofficial shop window to the world. This was all well and good for Brown and his circle, but it meant the end to any hope of a British Salon des Refusés. And it was in the face of this situation that the various small groups and societies which were to become such a characteristic feature of the First World War period began to emerge. And it was in this vacuum of complacency that men like Sickert, Frank Rutter and Roger Fry moved in their various attempts to solidify English painting by providing the committed sense of identity which neither the Slade nor the New English could begin to offer.

4. The Fitzroy Street Group and Others

In January 1905 Vanessa Bell (née Stephen) made an important decision: 'I have decided not to go back to The Slade at all because I think I should waste my time there either in drawing or painting.' The Slade had nothing to offer her. She detested Tonks' tyrannical regime. She did not want to be 'forever copying'.[1] Returning to London that summer from a painting trip to Cornwall she set about organising a society 'which was to meet every week and... be concerned with the fine arts' – the Friday Club.[2] This was to be the solution to her own sense of isolation as a young painter, and it may also have been a response to her living situation.

On the death of their father in February 1904 the Stephen children had removed themselves from Kensington to number 46, Gordon Square, Bloomsbury. Vanessa's younger sister Virginia has described the impact of 'the extraordinary increase of space,' and how, 'instead of Morris wall-papers with their intricate patterns we decorated the walls with washes of plain distemper.'[3] Vanessa had 'wound up' the old family home at Hyde Park Gate 'once and for all. She had sold; she had burnt; she had sorted; she had torn up.'[4] For the first time in their lives the two sisters were free to do as they chose. They went to hear Frank Rutter lecture on Impressionism at the Grafton Galleries. They entertained. Virginia began to teach adult education classes at Morley College. Most important of all, though, were the Thursday evening 'at home' parties given by their brother Thoby, attended mainly by old friends of his from Cambridge. As far as Virginia was concerned, these were 'the germ from which sprang all that has since come to be called – in newspapers, in novels, in Germany, in France – and I dare say, in Turkey and Timbuctu – by the name of Bloomsbury.'[5]

Certainly the Friday Club looks like a response to the somewhat austere and exclusively male intellectualism of these Thursday evenings. 'From such discussions Vanessa and I got probably much the same pleasure that undergraduates got when they meet friends of theirs for the first time.'[6] Vanessa Bell had also met various independent young British painters in Paris the previous year, and it is scarcely surprising that she should try to create some kind of society which might overcome both the social and the exhibiting problems which she shared with so many of her contemporaries in the first flush of her own newly-found independence. To begin with there were several women involved – Mary Creighton, Gwen Raverat (née Darwin), and Sylvia Milman – as well as J.D. Innes, who had recently left the Slade, Bernard Leach, Clive Bell and others. As a group it quickly expanded to include other ex-Slade students – Duncan Grant, Mark Gertler, Derwent Lees, David Bomberg, and her close friend at this time, Henry Lamb.

The Friday Club survived as an annual exhibiting society until 1916, but was effectively taken over by Roger Fry when he established the Grafton Group. But by this time Bell and Grant were actively involved in the setting up of the Omega Workshops, a far more radical response to the problems besetting the reception of modern art in London. It was the news of such new life in the London art world as was suggested by the Friday Club and other less formal alliances which persuaded Sickert to return to England in 1905 after ten years of what amounted to a self-imposed exile.

One of his later pupils, Marjorie Lilly, has argued: 'If he were famous for no other reason, Sickert would be famous as a teacher... He had two main objects in view. One was to encourage the student to paint without nature in front of

him; the other... was to help him to become independent of the schools as soon as possible and find his level in a wider world.'[7] His gradual estrangement from Whistler during the course of the 1880s left him in an isolated position in London, an isolation reinforced by the failure of the London Impressionists to consolidate into anything even remotely resembling the Parisian art world to which Whistler had introduced him in 1883, the year he met Degas. In his youth Sickert needed and rejoiced in what he once described as 'the Spirit of the hive'.[8] Overwhelmed initially be Whistler's technique and his associations with Courbet and Manet, he came to find that technique to be a system of diminishing aesthetic returns: 'Whistler...was forced by his necessities and a desire to conquer at all costs, a position of success and eminence in a country still unlettered in art, into – the career of an eternal sketcher. The cumulative artist grows in geometric progression greater with age, limited only by the approach of physical disabilities, while the incurable sketcher is compelled, as time goes on, to mint his talent into small change that grows, with failing powers, smaller. And this, in a sentence, is the lesson that the student has to learn from Whistler's life-work.'[9] This criticism has two edges: '[Whistler] painted pictures in which Japanese fans were arranged on English shelves, and English ladies or models were popped into kimonos on Chelsea balconies. He took the art of oil-painting and thinned it into an imitation of the gouache delicacy proper to a *Kakomono*.' These two issues, of subject and technique, were inseparable for Sickert – the results of that 'excessive dose of taste',[10] which led Whistler to so cultish and exclusive an approach to painting, an approach which seemed as limited as the audience for which it was intended. Ultimately it established a new academicism.

Sickert could concede the 'exquisite oneness that gives his work such a rare and beautiful distinction',[11] but found in that lowering of all tonal values which accompanied his lacquer-like procedures only a faint parody of all that he admired most in French (and English) painting, summarised as 'La Peinture'. This, he wrote, 'can be expressed by the clean and frank juxtaposition of pastes..., considered as opaque, rather than as transparent, and related to each other in colour and values by the deliberate and conscious act of the painter'.[12] This was the art of oil-painting which Whistler had renounced, an art in which the painter's technical intelligence is reduced to a slender repertoire of predictable, if luscious effects. 'The staining of a white canvas in the manner of a water-colour is not "La Peinture": nor is the muffling up of the painting in the indecision of universal glaze, "La Peinture" is as fresh and clean in colour as a fresh herring...'.[13] It was as simple as that.

This equal and inseparable emphasis on questions concerning both the source material and the materials themselves of his painting, was a major determining factor throughout Sickert's entire career. It ensured for example, that he could never 'settle down' in the manner of Steer or Fred Brown. However, it was also his deep regard for both the personality and the work of Degas which defined his position in England. 'Le rôle de papillon doit être bien fatigant, allez!' Degas had remarked to him in 1885, 'J'aime mieux, moi, être le vieux boeuf, quoi?'[14] When Degas observed that nature does not pose herself, this implied something very different from Whistler's comment in the 10 O'Clock Lecture: 'To say to the painter that Nature is to be taken as she is, is to say to the player that he may sit on the piano.'[15] Whereas Whistler proceeded to extemporise an increasingly synthetic kind of painting, peeled from a fragile

left
10 Roger Fry, *Self-Portrait*, c.1919,
woodcut,
Victoria and Albert Museum, London.

right
11 W.R. Sickert, *Self-Portrait*, c.1903,
charcoal pen and ink, 40 × 29.3cm
(15 × 11¼in). Ashmolean Museum,
Oxford.

vision of *fin-de-siècle* Picturesque, Degas' message invited on the contrary a far more analytical approach to nature.

Whatever else he may have been, Sickert was a Realist. His lapidary remark that 'painters should not quarrel'[16] was based upon his own experience of Whistler's spectacular egoism. Although Sickert was to manifest a profound distrust of small groups and exclusive movements in later life, there remained an over-riding sense in which he was constantly aware of the responsibility of Degas' mantle about his shoulders. Degas represented 'La Peinture', the art of oil painting which he felt a moral obligation to translate into England. In this sentiment, of course, he closely resembled Roger Fry. Some part of their friendly rivalry resulted from this mutual acknowledgement. For whilst both men championed different French masters, they were of one accord in their diagnosis of the English situation. The particulars of this rivalry will be considered. Returning to London from Venice in 1905, poor, somewhat neglected, it seemed to Sickert that for the second time in his life – he was now forty-five – he was the man to whom was given the task of delivering up the State of English Art. Yet this was initially a tentative return.

After occupying various rented apartments in Dieppe since 1888 for the purposes of painting visits, he had based himself in a house at Neuville, on the outskirts of the port. It was to this house that various young English painters came to visit him in 1904. Most important of these was the young Spencer Frederick Gore, who had left the Slade in 1899. This proved to be perhaps the most important turning point in both men's careers. Sickert had been experimenting for several years with direct painting. His work at this time

12 Spencer F. Gore, *Dancing in the Street*, 1904, ink, 25 × 35.6cm (9⅞ × 14in). The Tate Gallery, London.

ranged widely from the initial expressionism of his Guiseppina portraits,[17] and various nudes,[18] to a much thinner and drier kind of painting, perhaps emulating the effects of Degas' later pastels. In many of these pictures there is 11 a marked return to a dramatic use of colour.

At this time Gore was still a conventional naturalist. His brush-work revealed the influence of Steer, but he lacked any particular sense of direction. 12 He was ripe material. It is impossible to imagine what Gore could have made of Sickert's work in 1904. At the very least he must have been jolted. For here was an English painter, a central figure in the New English Art Club for the better part of two decades, producing pictures which, in the range of their experimentation cannot but have shown up the tame conservatism of the English tonal tradition to which it also related.[19] Thus Sickert enjoyed the advantage of appearing both *enfant terrible* and *maître* at one and the same time. It was this duality which helped him to gather round himself a group of considerably younger painters in the years after his return to London. In this way he escaped being caught in either a narrowly avant-gardist or a distant oracular role.

But in 1905 he was still very much scouting London out. He exhibited at the Salon d'automne in Paris, but not at the N.E.A.C. And although he spent much of that and the following year in France, he retained Whistler's old studio at 8, Fitzroy Street, as well as taking on rooms and studios elsewhere, in the

13 W.R. Sickert, *Hubby and Marie/Home Truths*, c.1912, ink and chalk, 29.8 × 24.2cm (11¾ × 9½in). The Fine Art Society Ltd.

Camden area of London. The return to London, however, also had its own artistic logic. In 1889 he had written of London as 'the most wonderful and complex city in the world'.[20] His fascination with a particular range of subject matter, blending sexuality, violence and urban poverty into a very personal iconography, not surprisingly led him back to the city of Dickens, the Music Hall, Jack the Ripper and so on. In this respect Sickert's London was a European myth, celebrated by Wedekind and many other writers of the time.

Marjorie Lilly has described him looking for a possible new studio in the Warren Street area: 'All he saw was the contre-jour lighting that he loved, stealing in through a small single window, clothing the poor place with light and shadow, losing and finding itself again on the crazy bed and floor. Dirt and gloom did not exist for him; these four walls spoke only of the silent shades of the past... Here, the psychological and the visual aspects of his art came together; here he could transform some incident, a figure at a window, an inscrutable presence, the listless gesture of a hand, the droop of a head, to the universal.'[21]

13

It was in this period, and largely in response to working-class life in North London, that Sickert established his own iconography of intense, complex emotional situations. Time and time again he returns to the relations between men and women, locked in the claustrophobia of small bedrooms in which the minimum of furniture is highly charged with sexual, but rarely sensual, significance, or equally claustrophobic sitting-rooms cluttered with the bric-a-brac of a lifetime. To describe this as a taste for 'low life' is somehow to miss the 14
point. For this is a tragic vision, which closely resembles, for example, the sentiments of John Davidson's *Thirty Bob A Week*, itself a significantly Sickert-like title:

And the Pillar'd Halls is half of it to let –
 Three rooms about the size of travelling trunks.
And we cough, my wife and I, to dislocate a sigh,
 When the noisy little kids are in their bunks.

But you never hear her do a growl or whine,
 For she's made of flint and roses, very odd;
And I've got to cut my meaning rather fine,
 Or I'd blubber, for I'm made of greens and sod:
So p'raps we are in Hell for all that I can tell,
 And lost and damn'd and served up hot to God.

They say it daily up and down the land
 As easy as you take a drink, it's true;
But the difficultest go to understand,
 And the difficultest job a man can do,
Is to come it brave and meek with thirty bob a week,
 And feel that that's the proper thing for you.[22]

I have quoted at length from Davidson's poem because it seems to come so very close to Sickert's sense of the dignity of working-class life, and its appalling difficulties. Hence the increasing significance of Sickert's titles. It is sometimes argued that Sickert's use of titles was more or less arbitrary. Nothing could be further from the truth. The scraps of music-hall song, the newspaper headlines, the fragments of overheard conversation with which he chose to distinguish his pictures, provide us with a vital frame of reference for the way Sickert saw them himself. Sometimes these titles work ironically – *Noctes Ambrosianae*, a view of the gallery audience at the Middlesex Music 16
Hall, also known as the Old Mo, or The Mogul Tavern. Sometimes they are more direct. This process begins to anticipate the more complex relations between canvas and image which will be considered in relations to his Camden Town period work.

Sickert's subject matter then would seem to have been based upon a personal variant of Degas' statement that he wanted 'to look through the keyhole'.[23] Always there is this relation between a watcher and a person watched, whether it involves a man and a woman or whether it involves 13
Sickert's watching over such a scene. In terms of both technique and subject 15
matter we are constantly aware of the painter's presence. 'For all his absorption in the study of light, the quality of paint, these things were merely a means to an end... The influence of Degas on his personal vision was not, I

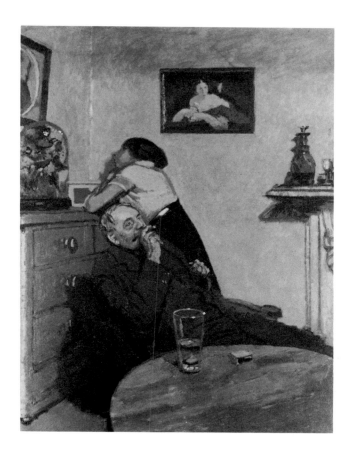

left
14 W.R. Sickert, *Ennui*, 1914, oil, 152 ×
112cm (60 × 44¼in). The Tate Gallery,
London.

right
15 W.R. Sickert, Study for *L'Affaire de
Camden Town*, 1909, chalk, 26 × 21cm
(10¼ × 8¼in). The Fine Art Society Ltd.

think, especially important.'[24] This is a telling observation. Degas provided
Sickert with an almost moral sense concerning the application of paint. He
influenced him in his hands rather than in his eyes.

Nonetheless, Degas' dramatic tonality and use of colour highlighting was to
modify Sickert's own discovery of what he wanted to paint. As I have argued,
these two issues are inseparable in his art. It is Majorie Lilly again who tells us
most about his attitudes towards his own medium: 'Much has been made of his
passion for paint; he spoke and wrote so frequently about surface quality and
the application of paint to canvas that this can prove misleading. Beguiled as
he was by the beautiful quality of paint, much as he hated to see the medium
abused, his main object must not be overlooked, the goal to which he was
striving all the working years of his life. This was to paint without nature in
front of him, everything else, tonal values, brushwork, colour, drawing,
stemmed from that first and final intention... His intellectual calibre was
revealed by his ability to architect large pictures from working notes, to unify
the colour and sustain the vitality of the sketch in the final version.'[25] As for
Bonnard, who was the other major French influence on Sickert's work in this
period, working from memory allowed him a certain indirectness of statement,
a distance from the world which was the condition of those abrasive qualities
which he most valued in art. It was the pre-condition for his particular concern
with the relationship between the empirical and the conventional. Hence
Sickert's attitude towards individual motifs, the delay between the initial
blocking in of a canvas and its eventual execution, the final retouching. This

17

Noctes Ambrosianae Sickert

16 W.R. Sickert, *Noctes Ambrosianae*,
1906, etching and aquatint. P. and D.
Colnaghi and Co. Ltd.

was the approach to oil painting, 'La Peinture', that he wished to pass on to the younger generation in London, proposing a dialectical consideration of all matters concerning subject and technique.

It was from this confidence that Sickert moved back into the London art world. The move took two forms. He began to use his studio at 8, and later 19, Fitzroy Street, as a kind of intimate gallery, from which he and his colleagues might privately sell pictures. And he became closely involved in the establishing of a new public exhibiting society, the Allied Artists' Association – the A.A.A.

Sickert wanted, as he explained in a letter, 'to get together a milieu rich and poor, refined or even to some extent vulgar, which is interested in painting and in the things of the intelligence.'[26] In this respect the Fitzroy Street Group, as it became known, represented an attitude towards the sociology of art as much as to art itself: 'I want to keep up an incessant proselytising agency to accustom people to mine and other painters' work of a modern character. Every week we would put something different on the easels... All the painters interested could keep work there and would have keys and could show anything by appointment to any one at any time...'[27]

One member of the group put this another way: 'Sickert inaugurated...a tradition of Saturday afternoon receptions at which the aristocracy might be lured, perhaps, into buying a picture by a promise of a glimpse of the Vie de Bohème. We also had read our Murger and loyally played our parts of Marcel, Schaunard and Mimi. When, having secured a visit from a peer, he would enquire "who is the lady in the window?" Bevan, knowing his duty and speaking

18

34

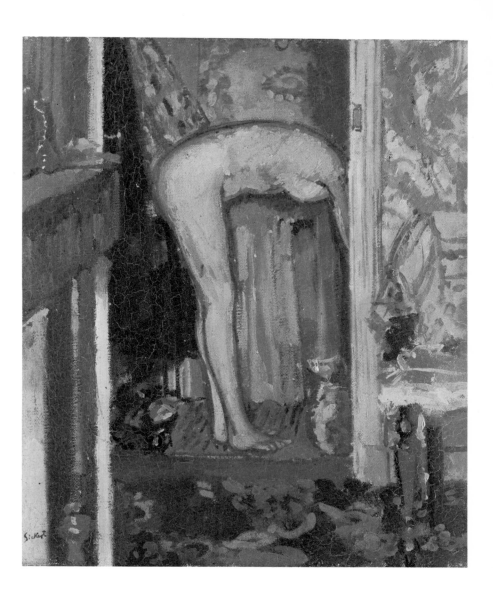

17 W.R. Sickert, *Woman Washing her Hair*, 1906, oil, 45.8 × 38.1cm (18 × 15in). The Tate Gallery, London.

a little behind one hand would answer: "That is the woman who lives with Walter Bayes..."'[28]

At this time, 1907/8, most of the group were still working from nature as if this, as Bayes put it, 'was in some sort an evidence of seriousness, as the working from cumulative knowledge was not'.[29] Bayes was already much closer to Sickert on this point than other members of the group – William and Albert Rothenstein, both of whom had studied at the Slade in the 1880s and were well acquainted with Parisian art, Walter Russell who had been Assistant Professor at the Slade since 1895, Russell's friend and ex-pupil Spencer Gore and his Slade contemporary Harold Gilman, George Thomson who had been with Sickert a member of the London Impressionists group in 1889 and was now teaching, also at the Slade, and Lucien Pissarro, son of Camille Pissarro, a founder member of the original French Impressionist group in the 1860s, and artistic paterfamilias to Seurat, Gauguin and Cezanne.

To these Saturday afternoons came a variety of young painters including Vanessa Bell, Ethel Sands and Mark Gertler, as well as patrons such as Sir

Detail of **24**.

Hugh Lane and Judge William Evans. And not surprisingly, the various painters of the Fitzroy Street Group began to work together around the central axis of Sickert's new interest in the nude, and in subtle *contre-jour* light effects, as seen in Spencer Gore's *Woman in a Hat* (1907), which was also exhibited as *Someone Who Waits*, an alternative title which reveals the impact of Sickert's personality as much as does his actual physical presence, seen obliquely as a figure walking past in the street behind the sitter. Gore's handling in this period involved an extremely careful stippling technique which owed much to the example of Camille Pissarro's later work, with its extraordinary delicacy of touch and colour, which he must have known through his close friendship with Lucien. This modified divisionism provided him with a way of retaining an overall tonal effect without sacrificing either colour or resorting to the type of chiaroscuro favoured by Sickert. Where Gore's lighting is dramatic, as in the early *Mad Pierrot Ballet*, of 1905, this is principally to enable him to make 'naturalistic' sense of Steer's radiant colour contrasts. Hence the contrast in his work between the rather dull observed landscapes, and the brilliant colours of his theatre scenes. He increasingly selected motifs which allowed him to exploit his gifts as a colourist. It must have seemed to him that Steer had 'faked' things. His fascination with the effects of light on form, rooted in an

24

20

19

36

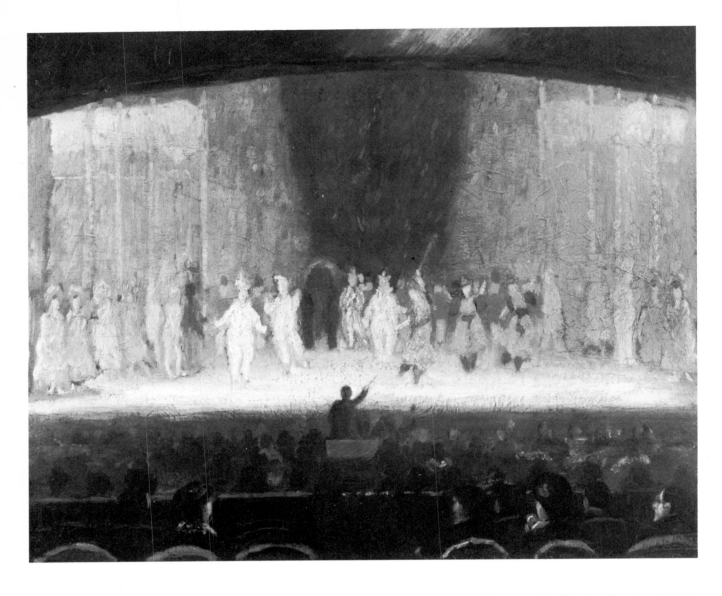

20 Spencer F. Gore, *The Mad Pierrot Ballet*, 1905, oil, 43.2 × 54cm (17 × 21¼). Private Collection.

observed nature, is already apparent in the somewhat Tonks-like sketch in the Tate Gallery, *Dancing in the Street* (1904).[30]

Gore became a member of the New English Art Club in 1909, but told a friend that 'they dislike our kind of painting, and will probably edge us out sooner or later'.[31] It was in this context that he, Sickert and Gilman became involved in the formation of an entirely new exhibiting society, initiated by the critic Frank Rutter, who was to become Director of the Leeds City Art Gallery. In the first issue of *The Art News*, which was soon to become the official journal of the A.A.A., Rutter explained: 'We do not believe that the people of this country are indifferent to art... but we do believe that their artistic yearnings are in need of right direction.'[32] The A.A.A. was established in 1908 as a limited company. Members paid an annual subscription of one guinea and had to purchase a minimum of one ten shilling share. For this sum each member was entitled to exhibit three works at an annual exhibition held in the Albert Hall. But the most important aspect of the A.A.A. was that it was to provide a no-jury system for public exhibitions. It was this aspect which Sickert consistently

championed in the pages of *The Art News* throughout the period. Thus, in 1910, Sickert quoted a speaker at the first Annual General Meeting addressing the Chairman: 'Sir, for the purposes of this Association, there are not good pictures and no bad pictures. There are only pictures by shareholders.' The anonymous speaker may well have been Sickert himself, who in any case went on to argue forcefully that 'yards of horrors would not be too large a price to pay for one beginner's career saved, or one ageing talent consoled and refreshed.'[33]

In the *New Age* Sickert also asked whether, since it was not State aided – unlike the French Indépendents, on which it was largely modelled – it was not in fact 'a working object-lesson of the best elements of Socialism? Is it not a solvent going concern founded by the poor to help themselves?'[34] This was how Sickert viewed it, and it is in this sense that one may appreciate his enthusiasm. What mattered most was the overthrowing of the hated Jury system, and with it the whole tradition of 'Exhibition pictures'. The associated qualitative problems of inclusiveness could not begin to outweigh the benefits of the ending of exclusion. As Gore put this, in another way: 'The incorrigible independent is likely to be an interesting painter.'[35]

The Allied Artists' also proved to be a vital resource for the Fitzroy Street group. It was there that Robert Bevan's work was first noticed by Gore and Gilman, which led to his being invited along to no. 19. Bevan's bright divisionist technique related to the same French origins which interested so many of Sickert's followers. And Bevan possessed the incalculable advantage to many of them of having actually known and worked with Gauguin at Pont Aven in 21
Brittany in 1893-4. Another exhibitor with strong French connections at the A.A.A. in 1908 was Charles Ginner, who was born in Cannes in 1878 of British 22
parents, and who had grown up in France, only turning to painting from architecture in his late twenties. The influence of professional architectural drawing is almost always apparent in his work, though he came to his own brand of naturalism through a personal mixture of Art Nouveau and Post- 23
Impressionism, particularly that of Van Gogh and Maurice Denis.

There were over 3,000 exhibits at the first 'London Salon' of the A.A.A. in July 1908, with a special Russian section of 150 or so works, including

left
22 Charles Ginner, *Paris Cafe*, 1909, ink
and watercolour. The Victoria and Albert
Museum, London.

right
23 Charles Ginner, *The Coliseum,
London*, c.1910, ink and watercolour, 23.7
× 35cm (9⅜ × 13¾). Laing Art Gallery,
Newcastle upon Tyne.

woodcuts by Kandinsky, whose paintings were later to be singled out for much
attention in 1909 and 1910. In this international context the A.A.A. stood in an
historic relation to the French Salon des Indépendents in much the same way
that the new English had stood to the Salon des Refusés in 1886. The Allied
Artists, together with *The Art News*, were the first signs of a broadly-based
revival of British interest in modern European painting. Young painters
returning to England, like Duncan Grant in 1907, or Henry Lamb in 1911,
could now at least find some kind of supportive community in which to work.

At this point it may prove useful to attempt to summarise the range of
painting being produced in London at this time, which Sickert thought of as
'modern'. Here some comparisons might help. Vanessa Bell's *Iceland Poppies* 25
(1908) encapsulates her artistic education. Writing some three years earlier,
she described her own technique as follows: 'My method is the same as
Whistler's – only he used many more layers than I should because he painted
very thinly – which I can't, not at any rate, get myself to do.'[36] Painting thickly
and directly, Vanessa Bell achieves a unity of tone more severe than any
Whistler, since she does not sacrifice form, which is found in her subject matter
itself, in the stark horizontals provided by the stems of the poppies, the edge of
the table or shelf, and the design on the wall behind. At once exhaustively
observed and systematically re-created.

It is not surprising that Sickert, seeing this picture at the N.E.A.C. in 1909,
wrote to her: 'I did not know you were a painter – continuez!'[37] The
extraordinarily subtle tone values of *Iceland Poppies*, together with its
monumental sense of design and colour contrasts – bottle green to the brilliant
red of the poppy – signal the direction she was to take over the course of the
next decade. Another painting from this period, *46 Gordon Square*, surely c16
painted *after* the *Iceland Poppies*, shows her extending her tonal control over a
range of brilliantly modulated greens and ochres.[38] The design of wall, curtains,
balcony and street below, is at once descriptive and starkly abstract, with all

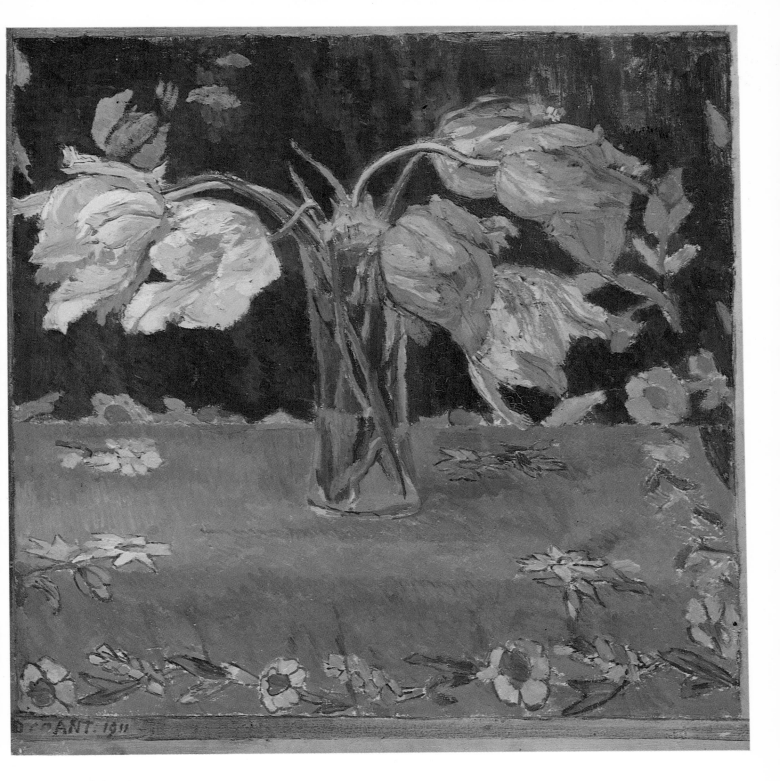

Colour 8
Duncan Grant, *Tulips*, 1911, oil on panel, 52.1 × 50.2cm (20½ × 19¾).
Southampton City Art Gallery.

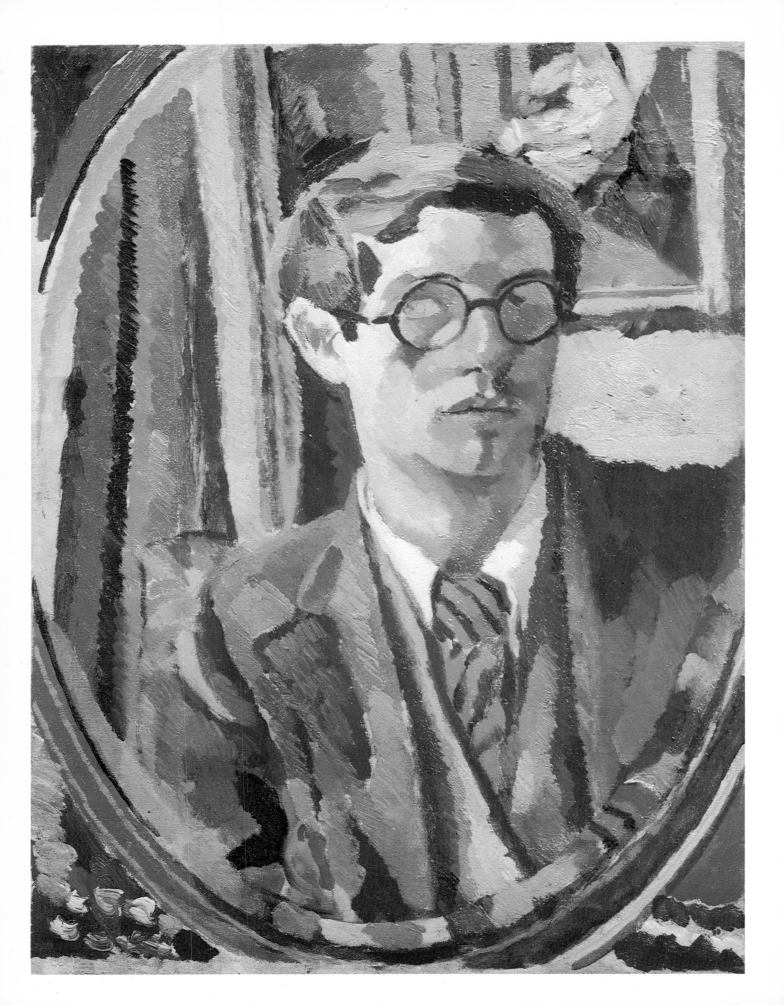

24 Spencer F. Gore, *Woman in a Hat/Someone Who Waits*, c.1907, oil, 50.8 × 40.7cm (20 × 16in). Plymouth City Museum and Art Gallery.

facing page
Colour 9
Duncan Grant, *Self-Portrait*, c.1918, oil on canvas. Private Collection.

the masses pulled together into one unified pictorial space. If we compare this picture with Gore's *Woman in a Hat* (1907) we notice the same play between 24 descriptive and autonomous colour relations, the same candid delight in transforming the grey tonal harmonies of the Slade tradition into an art of colour.

Gilman, moving away from a similar stylistic background, as seen in his 1906 portrait of Gore and the picture of his two young daughters, has also attempted 26, 28 to break away from his earlier Whistlerian facility in *The Breakfast Table* which 27 should probably be dated to 1909. Here the problem of colour is not resolved. He has broken down his individual brush strokes under Gore's influence, but retained a quest for naturalistic detail which is incompatible with this new technique. The result is an uncomfortable fusion of Sickert-like contre-jour, and a divisionist approach to colour which operates against the overall design. Where Gore has learned from Neo-Impressionism, and Vanessa Bell from Cezanne, Gilman is still caught between Whistler and Sickert. If we consider the work of all three only one year later, in 1910, we may appreciate the liberating impact of European painting on the British tradition.

26 Harold Gilman, *Portrait of Spencer Gore*, c.1906, oil, 36.9 × 31.8cm (14½ × 12½in). Leeds City Art Gallery.

27 Harold Gilman, *The Breakfast Table*, c.1909-10, oil, 68.6 × 52.7cm (27 × 20¾in). Southampton City Art Gallery.

opposite
25 Vanessa Bell, *Iceland Poppies*, c.1908, oil, 55.9 × 45.8cm (22 × 18in). Private Collection.

5. The Camden Town Group

In 1930 Louis Fergusson looked back over the period following Sickert's return to London. At 19, Fitzroy Street, there was 'an appetising smell of tea and pigment as you ascended to a glorious afternoon of pictures and of talk. Easels and chairs faced the fireplace with a serried stack of canvasses against the wall. Six works or more of an individual painter were extricated in turn, each Fitzroyalist displaying his quota or having it displayed for him by the untiring Gore.'[1] Something of this rather jolly Edwardian scene survives in Malcolm Drummond's later painting of the same subject. Drummond, another ex-Slade student, had studied etching at the Westminster School of Art under Sickert in 1909 and joined the Fitzroy Street group a year or two later. However, if one considers Derwent Lee's drawing of what is probably another part of the same studio at some time in 1910 or 1911, one may gauge the initial impact of Roger Fry's First Post-Impressionist Exhibition on Sickert's immediate circle. 30 31

Lees was an Australian who had studied in Paris and then at the Slade, where he had remained to teach drawing from 1908 until 1918. He was also involved with Vanessa Bell's Friday Club and the Grafton Group from 1911 to 1916. In this drawing the overwhelming influence is that of Van Gogh's reed-pen and ink studies from the late 1880s, in particular those for the *Night Cafe* and the *Starry Night*. Sickert was equally capable of such a dramatic hatching technique but not, I think, of this Spartan symbolism. All along he had hoped to create a controversial *salon d'automne* atmosphere in London, yet it was Fry who actually effected it.[2] 32

Writing in the early 1930s, Vanessa Bell tried to analyse exactly what the first Post-Impressionist Exhibition had meant to her generation. She argues that: 'In that first show the only possible shocking quality was that of unfamiliarity. To the young that lasts a very short time and there was no affectation in their enthusiasm...No doubt there was much that was silly, things swallowed hastily and ill-understood at first, but all the same to those who had "lost their way" and I think many had or might soon have done so, here was a sudden pointing to a possible path, a sudden liberation and encouragement to feel for oneself which were absolutely overwhelming...it was as if at last one might say things one had always felt instead of trying to say things that other people told one to feel...'[3]. In a telling aside, she recalls noticing on her return to England from a holiday in Turkey in 1911 'how brightly blue all the hats and coats looked compared to the exquisitely dingy many toned blues of the east'.[4]

Here is a complete reversal of the traditional European attitude towards the Arab world and the East, which had been a fundamental tenet of all post-Romantic aesthetics since the time of Delacroix. Now Europe – even London – was the continent of colour. To Vanessa Bell, the work of Sickert and the Camden Town Group 'was sympathetic but for the most part rather timid'. Sickert's own work 'of course always had life and character as well as exquisite taste and colour, but his followers too often seemed to have only taste'.[5] There was in fact a certain delay in the way in which British painters responded to the work of Cezanne and Gauguin and the moderns. In this respect the formation of the Camden Town Group may be viewed as a last ditch attempt on Sickert's behalf to hold together the principles of 'La Peinture' which had so informed the work of the Fitzroy Street Group, in the face of a new avant-gardist position. Sickert's own responses to that 'first show' are very significant: 'Monsieur Matisse obligingly parades before the Grafton Street booth with a c17

28 Harold Gilman, *The Artist's Daughters*, c.1906-07, oil, 61 × 45.7cm (24 × 18in). City of York Art Gallery.

29 Malcolm Drummond, sketch of *19,
Fitzroy Street*. The University of Hull Art
Collection.

string of property sausages trailing from the pocket of his baggy trousers. John
Bull and his lady, who love a joke, walk up and learn a few things, some of which
have been known in Europe for a decade, and some for a quarter of a century...'[6]
Known to Sickert perhaps, but not to his younger followers, whom he had
assiduously 'protected' from the more radical departures in French art. 'Roger
Fry', he writes, 'is nothing if not an educationist and an impressario.' But so, of
course, was Sickert, and they were after the same public. For Sickert, Matisse
'has all the worst art school tricks. Just a hinting dash of anatomy is obtruded;
and you will find a line separating the light from the shade. You know what we
think of that trick.'[7] Yet Sickert must also have known that Matisse was not
using light descriptively, that the relations of light and shade in Matisse were
almost entirely subsumed by the issue of colour. Sickert's criticism is still more
unreasonable when one considers that the Matisses shown in London in 1910
were almost all divisionist paintings from the earliest years of the century, in
which questions of line hardly exist.

Not surprisingly, it is Cezanne for whom Sickert reserves his sharper
criticism. 'Cezanne was fated', he writes, 'as his passion was immense, to be
immensely neglected, immensely misunderstood, and now, I think, immensely
overrated.' What Sickert most objects to is the ascription 'Post-Impressionist'
to a painter who, as far as he was concerned, 'was embedded...in the

32 W.R. Sickert, *Lady of The Chorus*,
c.1913, pencil and ink, 37.5 × 26cm
(14¾ × 10¼in). Southampton City· Art
Gallery.

Impressionist Movement'. He argues, not very convincingly, that it is reductive
to think of Impressionism as a movement concerned more with colour than
composition, and with painting, 'from nature' rather than from preparatory
drawings. If Impressionism was not these things, then what was it: history was
against him. Here we see Sickert, as a man whose sense of 'Impressionism' was
formed in England in the 1880s, coming up against the Art Historical
crystallisation of a style from an entire period. For Cezanne and the
Impressionists did not, as Sickert insists, speak one language. He tries to claim
Cezanne for his own cause, and cannot talk about his actual pictures.

On the whole Sickert is scrupulously fair. Challenged by the idea that Van
Gogh was simply mad, he observes drily that this is like the expression 'the
artistic temperament'. 'Have not some quite dull painters gone mad also?...
Haberdashers have been known to be regrettably irregular in their domestic
and financial relations. Yet I have never heard invectives against the
"Haberdashing temperament".'[8] He execrates Van Gogh's 'treatment of the
instrument I love, these strips of metallic paint that catch the light like so many
coloured straws'. Yet he is still able to find the results, as in *Les Aliscamps*
'interesting and stimulating'. After all, it is not as if he himself had not
experimented with thick paint, and his own drawing was moving in a direction 15, 34
in which the example of Van Gogh could only help him.

Colour 10
Duncan Grant, *Omega
Workshops Shop Sign*, 1913,
oil on board. The Victoria
and Albert Museum.

above **Colour 11** Duncan Grant, *Abstract Kinetic Scroll*, (detail), 1914, gouache, watercolour, ink and painted paper on paper, mounted on canvas, 28 × 450cm (11 × 177¼in). The Tate Gallery, London.

below **Colour 12** Duncan Grant, *The Tub*, c.1940, oil on canvas, (copy after destroyed original c.1918). Private Collection.

Colour 13
Vanessa Bell, *Abstract Painting*, c.1914, oil on canvas, 43.7 × 38.6cm (17¼ × 15¼). The Tate
Gallery, London.

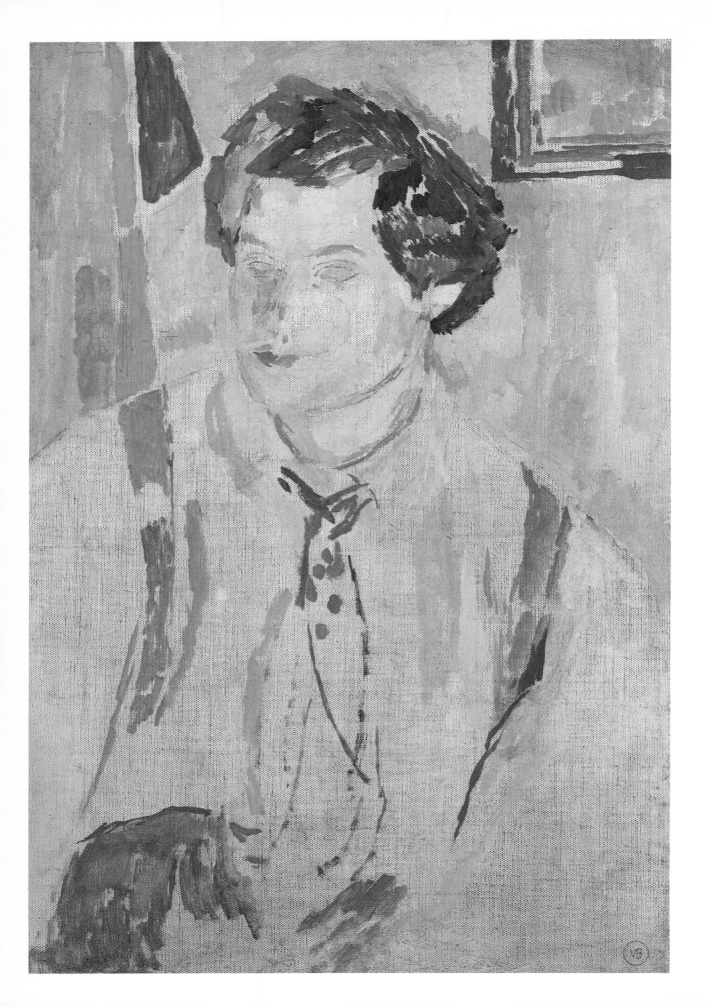

33 Jessie Etchells, *Seated Figures*, c.1912, 30.5 × 45.8cm (12 × 18in). Private Collection.

I suspect that what Sickert recognised in the work of Cezanne and his contemporaries was a new development, as far as his English friends were concerned, along the very path to which he himself was so committed, and which he had done so much to establish in this country. Although he could hardly be expected to sympathise with the more laborious symbolism of Maurice Denis, or even Gauguin, the eventual course of his own careful respones to Post-Impressionism, at first in his drawings, is the measure and evidence of such a recognition. But if, as Vanessa Bell put it in a characteristic image, many painters 'threw their petticoats...over the windmill' in 1910, thinking 'that you could paint like Gauguin or Van Gogh by the simple process of putting a black line round everything, or like Cezanne by putting a blue one,'[9] then as far as Sickert was concerned the time had come to consolidate his own position.

Accounts of the formation of the Camden Town Group in the Spring of 1911, only months after Fry's *coup* at the Grafton Galleries, tend to stress a causal relation to the inadequacies of the N.E.A.C. But these inadequacies had been felt for many years, and besides, there was now the A.A.A. The Camden Town Group arose less from a great burst of confidence – Sickert for one was not much of a 'group' man – than from a certain defensive attitude. This accounts for many contradictions concerning the group, including its actual membership, as well as the ambiguous responses to it from such well-informed contemporaries as Vanessa Bell. One needs, then, to be able to account for the feeling that the Camden Town Group was over almost before it had begun.

According to Ginner, Harold Gilman was the 'prime mover' in the formation of the Group.[10] Stimulated by the rejection of his work by the N.E.A.C., he discussed the situation with Gore, Bevan and Sickert: 'What was to be done? Capture the New English? Form a new Society? Capturing the New English was soon found to be out of the question. Gore for one, was opposed to this idea, and Sickert was of the very decided opinion that it was impossible. The result of these numerous conversations was an intimate meeting over a dinner

facing page
Colour 14
Vanessa Bell, *Duncan Grant* (unfinished), 1915. Private Collection.

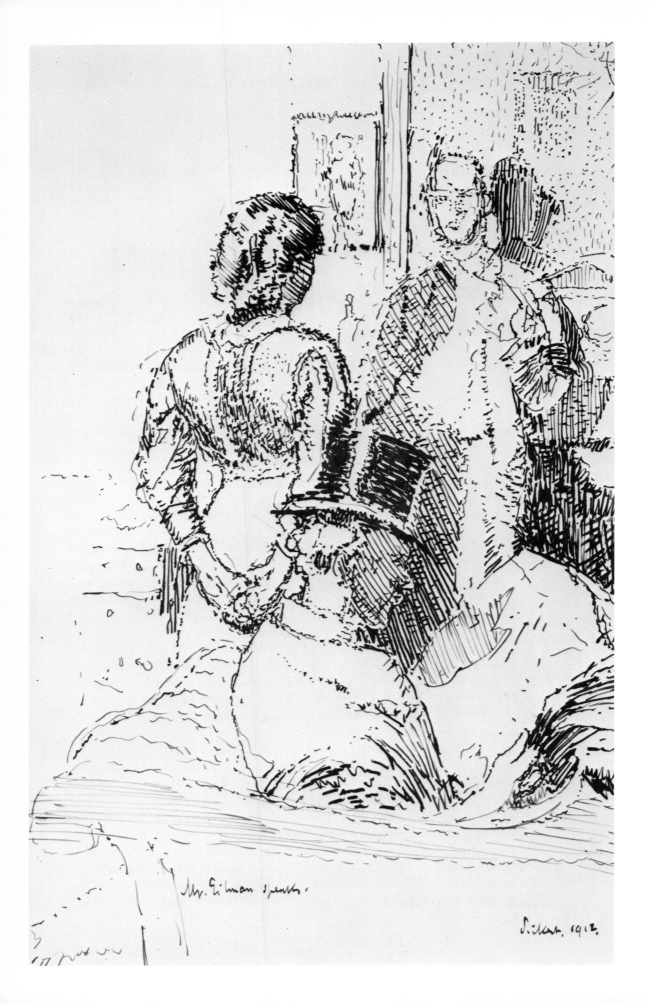

Mr. Gilman speaks.

Sickert. 1912.

at Gatti's, and that evening the decision, after a lengthy discussion was arrived at to form a new society...Sickert, striding out of the restaurant ahead of us, turned and waved his arm, exclaiming, "We have just made history."."[11]

Although both Gilman and Gore were closely involved with the A.A.A. as Committee Members, there was no chance to organise a specific group there due to the total committment to non-selectivity. Both men must have listened enviously to Sickert's accounts of the London Impressionists, as well as to Bevan and Ginner's descriptions of Gauguin's circle in Brittany, and the contemporary Paris art world. Certainly Gore's review of the First Post-Impressionist Exhibition is considerably warmer than Sickert's, but remains couched in terms that show the older man's continued influence. What appealed to Gore was a certain unity of decorative and naturalistic intention: 'The attempt to separate the decorative side of painting from the naturalistic seems to me to be a mistake... Simplification of nature necessitates an exact knowledge of the complications of the forms simplified. This may be done to produce a greater truth to nature as well as for decorative effect.'[12] Which category he asks, decorative or naturalistic, would one use for Gauguin's *Les Aveuses* or *Martinique*? Hence his argument that 'it is equally untrue to say of Pissarro, Sisley, Signac, or Seurat that they cared for nothing but the momentary effects of light on objects as it is to say of Cezanne or Gauguin that they simplified objects to express the emotional significance which lies in things.' As far as Gore was concerned they were all 'equally interested in the character of the thing painted', concluding that: 'If the emotional significance which lies in things can be expressed in painting the way to it must be through the outward character of the object painted'.[13]

It was thus entirely logical for Gore to envisage a future generation which would find some essential unity between Pissarro, Manet, Degas and Renoir, as well as Gauguin, Van Gogh and Cezanne, the essential unity of decorative and naturalistic intent which he understood as Post-Impressionism. Gore's is very much a painter's criticism. This is nowhere more apparent than in his brilliant short analysis, from the same review, of Cezanne as a painter 'who sought above everything else an exact harmony of colour, as exact as Whistler's relations of tone. In attaining this he often lost the drawing, which he would then recover with a line. Hence, incompleteness. The incompleteness not of the shirker, but of the man who has pursued a thing as far as he can go.' He contrasts Cezanne's 'wonderful gravity' with Monet's work, 'pictures "faked" in the studio by a virtuoso of great skill, but without any particular object'. Cezanne is distinguished from the rest of his contemporaries, for Gore, in his use of 'various tints of the same colour instead of the broken colour used by the others...as it suited their purpose at different times, Seurat and Signac... carrying the broken colour method to its furthest point.'

For Gore, then, Post-Impressionism meant an art of colour harmonies in place of the tonal harmonies of the Slade tradition, an art of synthesis which would yet not sacrifice subject-matter to issues of technique. In a little book rushed out in 1910 and dedicated to 'the rebels of either sex all the world over who in any way are fighting for freedom of any kind', Frank Rutter addressed himself to a wider audience and to wider issues. Basing his position squarely on that of Roger Fry, Rutter questions the crudest equation of Art with imitation, stressing the learned conventionality of all modes of representation and, like Fry, pursuing a distinction between Art and non-Art: 'A man who paints

34 W.R. Sickert, *Mr. Gilman Speaks*, 1912, pen and ink, 30.5 × 19.7cm (12 × 7¾in). Victoria and Albert Museum, London.

35 J.D. Innes, *Collioure*, c.1912, oil,
38.1 × 45.8cm (15 × 18in). Southampton
City Art Gallery.

landscapes or portraits is not necessarily an artist. He may be the merest manufacturer of likenesses, and literal verisimilitude to the accepted appearances of places and persons can never by itself be accepted as evidence of high artistic merit. It is the function of art not merely to state a fact, but to communicate an emotion, and the more simply that emotion is conveyed through the sense to which the particular art directly appeals, the purer and higher is the art.'[14] This is precisely what Fry meant by the 'aesthetic emotion' and marks, I think, the measure of the English avant-garde's concensus view of Post-Impressionism at this time.

It is in this context that Monet was rejected: too close to Whistler in his love of pictorial effect for its own sake, too abstract to satisfy either the demands for a residual realism, which proved to be Sickert's most enduring gift to the Group, or the taste for formal design which characterised Roger Fry's circle. It was the methodological rigour of the modern French school which initially attracted this very disparate set of painters, enabling them to 'make sense' of the same qualities of drawing and tonality which had so dominated their common training.

The actual membership of the Camden Town Group testifies to the breadth of the appeal of a new consolidation among English artists. The Fitzroy Street Group, of Gore, Gilman, Bevan, Drummond, Lucien Pissarro and William Ratcliffe – lately introduced by Gilman – were all there, together with Sickert and his old friend Walter Bayes, and J.D. Turner, an independent pupil of Gore. Another friend of Gore's from the Slade with whom he had visited Spain in 1902, was Percy Wyndham Lewis, already closely involved in the polemics of Cubism and Futurism. Other newcomers were Henry Lamb, who had been an occasional exhibitor at Fitzroy Street where he also rented a studio, and Maxwell Gordon Lightfoot who had only left the Slade in 1909, and whose Symbolist-oriented work was markedly at odds with that of the other members. Both men had been involved with The Friday Club. Another fringe member who, like Lightfoot, resigned after the first Group Exhibition in June 1911, was Lucien Pissarro's protégé, J.B. Manson, the Group's first Honorary Secretary. Lastly, and in some ways most significantly, there was Augustus John and his ex-pupil cum acolyte, J.D. Innes.

35

Together with William Orpen, his friend and rival prodigy at the Slade in the late 1890s, John had been co-principal of their private art school in Chelsea from 1903 to 1907. Always a tremendous eclectic, John had settled by 1910 into a manner which was frankly sentimental, a kind of reconstituted and mildly Fauvist style of fancy painting, which played safe between Sargent's Salon style and the Salon d'automne in Paris. Sickert's contemporary criticism of Picasso's Blue and Rose Period work, which so influenced John at this time, might well have referred to him with equal accuracy, as 'a quite accomplished sort of minor international painter [who] has annexed Whistler's empty background without annexing the one quality by which Whistler made his empty backgrounds interesting, the relation of colour and tone.' Describing a picture by Picasso, Sickert wrote: 'The child looks a little like a sawdust doll, but a very animated and very chic little sawdust doll.'[15]

6

There are countless John portraits (and other works) of this period, from that of W.B. Yeats in 1907 to all the intolerably pretty little Johns, which exhibit this same formula of generalised facial modelling against a completely arbitrary and usually monochrome background. Neither Innes nor John, nor his other pupil Derwent Lees, were ever to be short on animation or chic. What is puzzling is why John was elected to the Group in the first place. Belonging nowhere in particular, John seems to have been seeking some kind of temporary home within Sickert's alliance. Certainly both Gore, the same age as John, and Gilman, two years older at thirty-five, must have been aware of their new colleague's potential public drawing-power at a time when they themselves remained almost completely unknown. In any case, John only contributed pictures to the first of the three official Group Exhibitions, and he could scarcely have found the aesthetic lay of that land very congenial to his own brand of modish fantasy art. Still less was he at home with the First Post-Impressionist Exhibition, which he described, somewhat hypocritically given his own strong debts to contemporary French painting, as 'a bloody show',[16] refusing in the following year to contribute to the Second Exhibition when invited by Clive Bell. Presumably, like Sickert, Bell and Fry must have looked to John as a respectable sanction to their aims much as they had looked to Manet in 1910. But John's momentary alignment with the Camden Town Group in 1911 marked his first and last attempt to involve himself publicly

36 Robert Bevan, *Belsize Park*, c.1917, oil, 61.6 × 90.2cm (24½ × 35½in). The Museum of London.

with the struggles for a new attitude to art in this country. Unlike Picasso, or Duncan Grant in England, he was never able to re-function his late pre-Raphaelite origins into any single positive new direction.

In Paris his sister Gwen was beginning to abandon the technique of using thin layers of transparent paint which she had learned from Whistler and at the Slade, in favour of a much drier and thicker technique, developing a form of tonal realism which strongly resembles some aspects of Camden Town School painting which remain to be considered. Yet she exhibited nothing in London between contributions to the N.E.A.C. in 1911 and 1925.

From its very name, then, the Camden Town Group sought to resolve some twenty years of inchoate activities across a broad spectrum of English art. Discussions concerning the exact origins and the precise significance of the Group's title tend to lose sight of the particulars of social symbolism which were attached to the name of this large area of central North London. Camden Town was, and is, an area of social extremes, stretching away north from the grand Georgian squares of Bloomsbury to the sedate tree-lined avenues of Belsize Park and Hampstead, with a densely populated sprawl of dingy run-down Victorian terraces in between. With its careful class segregation, and characteristic sense of local community, Camden Town must have seemed a dynamically positive and at the same time expressly 'English' name for a group

36

of painters, contrasting ironically with the various schools and groups of Chatou, Argenteuil, Puteaux and so on, redolent with the connotations of a very different suburban avant-garde.

The one obvious link between these two avant-gardes, the English and the French, was Lucien Pissarro. Sickert, for one, saw Lucien Pissarro together with himself, as the major influence on the modern English movement, with Pissarro 'holding the exceptional position at once of an original talent, and of the pupil of his father, the authoritative repository of a mass of inherited knowledge and experience...a dictionary of theory and practice on the road we have elected to travel.'[17] He had been sent to England in 1883 by his father, Camille Pissarro, who together with Degas, represented to Sickert the most progressive tendency in late nineteenth-century French art: 'For the dark-and-light chiaroscuro of the past was substituted a new prismatic chiaroscuro. An intensified observation of colour was called in...to get the effect of light and shade without rendering the shade so dark as to be undecorative.'[18] In a letter of 1883 Camille wrote to his son: 'The bourgeoisie, frightened, astonished by the immense clamour of the disinherited masses...feels that it is necessary to restore to the people their superstitious beliefs... The Impressionists have the *true* position, they stand for a robust art based on sensation, and that is an honest stand.'[19]

In 1884 Lucien returned to France, introducing his father to his friends Seurat and Signac. Never a doctrinaire painter, divisionism proved a tremendously liberating technique for the older man who, like his other Impressionist colleagues, had more or less exhausted the cul-de-sac of direct painting. Lucien returned to London in 1889 in order to marry an English woman, and soon moved into the Art Nouveau circle of Ricketts and Shannon, much to his

37

37 Lucien Pissaro, *The Railway Bridge, Acton*, 1907, oil, 45.8 × 54.6cm (18 × 21½in). The City of Leeds Art Gallery, Temple Newsam House.

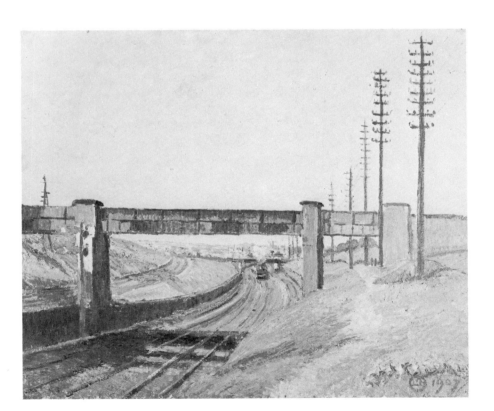

father's displeasure. But was this really such a surprising move? The decorative style associated with the English woodcut revival and the 'Book Beautiful' cannot have seemed terribly unfamiliar to a young artist acquainted with Seurat's *La Parade* (1887), or *Le Chahut* (1889), both of which derive, like so much of Seurat's work, from popular graphic sources – circus posters, advertisements, and so on. Yet in Camille Pissarro's hands, divisionism was prevented from its tendency towards a technique-oriented abstraction, an increasingly self-referential approach to art itself, which was inherent in the history of Neo-Impressionism.

Thus, when French critics noted only the influence of Kate Greenaway in Seurat's *Grande Jatte* (1885), they were curiously, if obliquely, perceptive. Derain realised this a quarter of a century later when he observed of Matisse's divisionism that it was 'a world which destroys itself when pushed to its furthest point'. But long before Matisse, the Pissarros, father and son, were using Seurat's and Signac's technique of separating out their brushstrokes and breaking up their colours in order to prevent their subject-matter from dissolving away altogether – the logical consequence of that 'pure' Impressionism which Monet was to continue to pursue so single-mindedly. It was in this respect that Lucien Pissarro's influence was to prove so important to both Gore and Gilman. For the one man divisionism meant a step forward from the influences of Corot and Sisley, and for the other it meant an art of pure colour in which his forms could not slide away into the beautiful seductive brush marks of Whistler and his followers, a tendency always present in Gilman's early work. 28

It seems likely then, that Camille Pissarro's concern for his son's career in England was less related to aspects of technique than of that robustness, the quality of life observed, of which he had written. What is significant is the ease with which a mainstream French avant-gardist could settle into a culture which we are so often led to believe had little or nothing in common with France. Lucien's move to Bedford Park in the 1890s was not the betrayal of some absolute patrimony, but the recognition of its nearest English equivalent. This is precisely the measure of the shared Anglo-French legacy of Aestheticism.

In the case of Gore, Pissarro's influence followed on sensibly from that of Steer. The transition from the *Mad Pierrot Ballet* of 1905, to *Inez and Taki* of 20, 1910 is one of straightforward pictorial development. This technique, of building up one colour at a time from a variety of tints, is typical of Gore's work from 1908 to 1910, both in his landscapes and theatre pictures, using only tube colour as his son has pointed out, with no added medium and no black.[20] 'What Gore possessed and developed to an astonishing degree was a divine beauty of touch. He used thick paint, without obtruding it. He had the secret of letting his touches descend upon canvas with innumerable and expressive variety.'[21] It was Sickert's personal recognition of the force of Gore's work which led him, only three years after the Group's formation, to spell out the hitherto unstated distance between what he described as the 'realists' and the followers of Augustus John.[22] 'The Burne-Jones attitude is almost intolerable to the present generation' he writes. 'Augustus John's intensity and virtuosity have 6 endowed his particular world of women, half gypsy, half model, with a life of their own. But his whole make-up is personal to himself, and the last thing a wary young man had better do is to imitate John... The realist is incessantly provisioning himself from the inexhaustible and comfortable cupboard of

facing page
Colour 15
Vanessa Bell, *Portrait of Mary Hutchinson*, 1915, oil on board, 73.7 × 57.7cm (29 × 22¾in). The Tate Gallery, London.

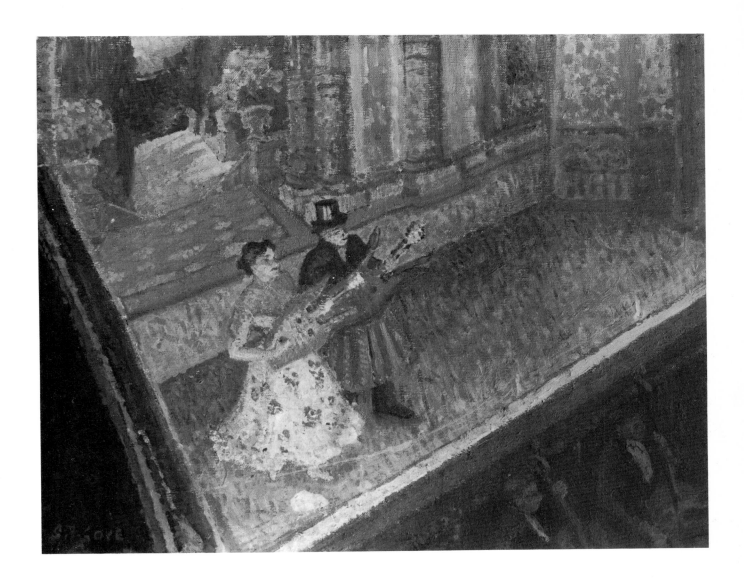

38a Spencer F. Gore, *Inez and Taki*,
1910, oil, 40.7 × 50.8cm (16 × 20in).
The Tate Gallery, London.

38b Spencer F. Gore, *Study for Inez and
Taki*, 1910, chalk and ink. Ashmolean
Museum, Oxford.

facing page
Colour 16
Vanessa Bell, *46, Gordon Square*, 1909-10, oil on
canvas, 73.7 × 50.8cm (29 × 20in).
Private Collection.

39 W.R. Sickert, *Harold Gilman*, c.1912, oil 61 × 45.8cm (24 × 18in). The Tate Gallery, London.

nature. The derivative romantic...can hardly expect such varied and nutritious fare if he restricts himself to the mummies he can find in another man's Blue-Beard closet.'[23]

As usual Sickert is using the term realism in his own idiosyncratic way, to signify that inseparable relation of subject and method which should be seen as the basic lowest common denominator attitude towards painting of the Camden Town Group as a whole. Frederick Gore has described Sickert's influence as the encouragement 'to draw as a direct notation of visual experience and when painting from drawings to stand by the vitality of the marks made on the spot.'[24] This last point is very important. The issue of pictorial authenticity, so dear to Sickert, involved a complete fidelity between sketch and finished canvas. This notion of fidelity came increasingly to determine his own style, thus guaranteeing an effect of immediacy without recourse to the pettifogging demands of either pure Impressionism or classic realist art. The full development of this philosophy may be seen by comparing almost any Sickert drawing from around 1909 onwards with the finished painting. It may also be regarded as the essentially expressionist element in his art, culminating in such works as the 1912 drawing *Mr. Gilman Speaks* and the related portrait of Gilman. Here the sombre flesh mauves and browns allow one clearly to envisage the original, perhaps thumb-nail, sketch. 34, 39

Throughout the period from 1908 Sickert's work relies increasingly upon *c18*
this kind of double-articulation, from life to sketch and from sketch to canvas,
which enabled him to 'gear down' reality into the particular economy of brush-
marks. This is the procedure which gives his work such extraordinary
conviction. It was entirely consistent for a man like Gilman to pursue this
fragmenting procedure as much from Sickert's example as from any other. His
Portrait of Mrs. Whelan (1911-1912), perhaps the *Portrait* shown at the Second *c26*
Camden Town Group Exhibition, held in December 1911, once more at the
Carfax Gallery, is almost unimaginable without the experience of Sickert's
portraits of Mrs. Barrett, especially *Le Collier de Perles*. In the meantime,
however, Gilman had visited Paris with Ginner, being particularly impressed
by the work of Van Gogh.

Wyndham Lewis described how, 'if you went into his room you would find
Van Gogh's letters on his table: you would see post-cards of Van Gogh's
paintings beside the favourites of his own hand. When he felt pleased with a
painting, he would hang it up in the neighbourhood of a photograph of a
painting by Van Gogh.'[25] In a note on technique in relation to Velasquez in *The
Art News* in 1910, Gilman himself contrasts the traditional monochromatic
tonal method of building up the picture surface so that the paint actually
thickens from dark to light, to the modern method of juxtaposing small pieces
of paint, in order to be able to work either from dark to light *or* from light to
dark. 'Edges of paint do not matter' Gilman concludes, 'for the painting is all 40
edges as a tree is made of leaves.'[26]

In contradistinction to Gore, Gilman emerges from contemporary descriptions
as a somewhat dour man: 'Endowed by nature with a serious mind and a thirst
for knowledge, Gilman had begun life with that becoming respect for authority
which it is the mission of our great public schools to inculcate.'[27] Frank Rutter's
description is typical of many. Lewis wrote of 'a parsonic honesty in his

40 Harold Gilman, *Canal Bridge
Flekkefjord*, c.1912-13, oil, 45.7 × 61cm
18 × 24in). The Tate Gallery, London.

painting, a moral rectitude in his pursuit of pictorial truth'[28] – Gilman was born
the second son of an Anglican priest. 'He was proud of a pompous drollery,
which he flavoured with every resource of an abundantly nourished country
rectory, as he was proud of his parsonic stock. He was proud of his
reverberating pulpit voice: he was proud of the eccentricities of his figure. He
was also proud of a certain fleeting resemblance, observed by the ribald, to
George Robey, the priceless ape. But, above all, he was proud to be a man who
could sometimes hang his pictures in the neighbourhood of a picture post-card
of the great modern master, Van Gogh.'[29]

This was the contradiction of Gilman's character, an intensely private man
who was yet 'a socialist with a profound dread and disgust of society'.[30] A family
man, disillusioned by an unhappy first marriage, he was at the same time the
most adamant spokesman for the exclusion of women at the Group's inception.
For him the Camden Town period was marked by a steady and confident
working through and out from the contradictions seen in the earlier *Breakfast
Table*. The two *Nudes* of 1910/11 reveal an enormous psychological distance
from the quiet Sickert-like drawing in The Ashmolean Museum, (c. 1908).
Both painted *Nudes* confront the spectator-cum-painter quite directly.
Sickert's iconography of indirection is turned on its head. This, I think, more
than anything else, denotes the influence of Van Gogh, a closing up of the
painter with his subject-matter, a closure allowed by the new tighter brush
work which seems almost to have acted as a kind of personal shield for Gilman,
the irridescent *fracture* of his new-found colours. In its total commitment to the
use of colour as light I suspect that the reclining *Nude* is later than the York

27

41, 43

42

picture, which still bears traces of his earlier style, especially in the use of highlights which, of course, become redundant in pure colour painting.

At the same time Gore was also applying a rigorous divisionist technique to Sickert's chosen themes. A whole series of music-hall pictures explores the effects of strong artificial lighting on figures who are themselves usually fantastical in the extreme, jugglers, dancers and so on, chosen more for their spectacular costumes – *Rinaldo, The Mad Violinist*, the Danish ballerina Brita as the Spirit of the Flag in *Our Flag, Inez and Taki* – than for those more earthy 19, 38 qualities which drew Sickert to such popular entertainers as George Robey, Little Tich, and the various *soubrettes* of the day.

In 1910/11 Gore came as close to Gilman as he was ever to do, in the broken colour technique of several nudes, in which he daringly transforms the familiar Sickert bed-head into a far more abstract framing device. In the *Nude on a Bed*, 44 an *homage* to Sickert, Gore was already turning his back on the light divisionist technique of the previous two or three years, seen at its most exquisite in his *View from a Window*. If this picture is contrasted to the 1911/12 music-hall 45 scene *At The Alhambra*, the full impact of Gauguin and Cezanne becomes c4 apparent. Yet this was a logical development. For the pointillist technique had itself led to a certain flattening out of planes in Gore's hands, and an emphasis on the picture-surface as an object in itself, uniformly treated, as in much of

43 Harold Gilman, *The Model – Reclining Nude*, c.1911, oil, 45.7 × 61cm (18 × 24in). The Arts Council of Great Britain.

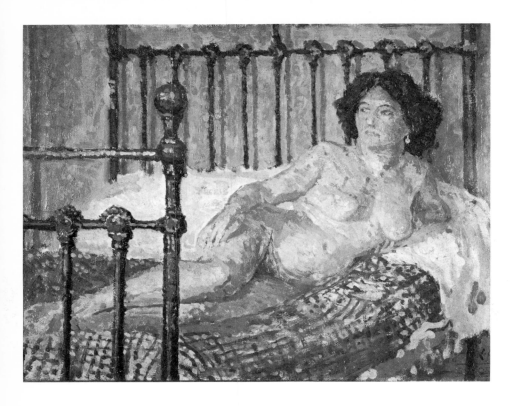

44 Spencer F. Gore, *Nude on Bed*, 1910,
oil, 30.5 × 40.7cm (12 × 16in). Bristol
City Art Gallery.

45 Spencer F. Gore, *View From a
Window*, c.1908-09, oil, 63.5 × 76.2cm
(25 × 30in). Southampton City Art
Gallery.

Signac's work – *The Breakfast* of 1886/7 for example, which he much admired. In the 'Alhambra' picture however, the influence is that of Gauguin's work from the late 1880s. Indeed, Gore's work *At the Alhambra* is inconceivable without the example of Gauguin's *Women at Arles* and the *Vision of The Sermon*. As in the *Vision*, a receding pathway, in this case the balcony staircase, is tilted up to become a solid mass of colour. As his son has written: 'Grasping attitude rather than method, he assimilated Cezanne's monumental design and realisation of space and solid by planes of colour.'[31]

Thus, in 1911, Gore was working in two different, if related styles: the flat decorative Gauguin approach of the *Alhambra* and *Gauguin and Connoisseurs at the Stafford Gallery*, which actually shows the *Vision of The Sermon*, and a much more painterly technique when working more directly from nature. In this respect Gore's scenes of the garden at Rowlandson House, where Sickert ran a private art school from 1910 to 1914, and a few local Camden town-scapes show him working towards the kind of all-over design which he was to establish fully in the following years. In these paintings his brushwork is fuller and looser than at any other time in his career, using characteristically modulated greens and purples and already turning more evidently towards Cezanne, building up his images in a variety of related block-forms.

At the same time Robert Bevan was also tightening up the overall design of his pictures, employing a uniform technique of small brush-strokes, as in the *Cab-Yard at Night* and a series of related pictures of a cab-yard in Ormonde Place, St. John's Wood, not far from his own home in Belsize Park. These very flat, dessicative pictures, mark an alternative resolution from that of Gilman or Gore to the relation of the realistic and the decorative, so often described by Sickert. Of all the Camden Town Group painters, Bevan was the most

46
47

c2

48

46 Spencer F. Gore, *Mornington Crescent*, c.1911, oil, 50.8 × 61 cm (20 × 24 in). The British Council, London.

47 Spencer F. Gore, *The Garden of Rowlandson House*, c.1911, oil, 38.1 × 45.8cm (15 × 18in). The University of Hull Art Collection.

48 Robert Bevan, *The Cab-Yard at Night*, c.1910, 63.5 × 69.9cm (25 × 27½in). The Royal Pavilion, Art Gallery and Museums, Brighton.

consistently serial in his attitude towards subject-matter, rarely straying from 49
equine subjects between 1910 and 1913. His work is principally distinguished
by a unique sensitivity towards close tonal values, as is apparent in much of his
lithographic work from the 1890s. Bevan's career, like that of Gore, involved a 21
more or less steady development towards a synthesis of clear, strong colour
and bold, formal design, mediated at all times by a concern for tonal harmony.
For both men the techniques of Neo-Impressionism had meant a certain loss of
colour or of form. For this reason their work from this period loses much in
monochrome reproduction. In spite of the differences in subject-matter, it was
Bevan's work which actually most closely resembled the French Intimiste
school, especially Vuillard.

The tightening up of Bevan's technique cannot have been unrelated to his
awareness of Ginner's work in 1911. In two pictures of Dieppe, Ginner had 50, 51
already established the basic technique which was to sustain him for the next
forty years. The entire picture surface is worked up into a petit-point effect of
small, heavily-loaded brush strokes, in which the paint itself is almost
architectured. In 1911 this is never laboured and shows the measure of
Ginner's painterly intelligence in his very personal translation of the quality of
Van Gogh's paint surface into a British context. It was perfectly logical for him
to extend this technique to the kind of London street-scene painting which c28
related more specifically to the work of his colleagues. Looking back so
evidently to his early training in architecture, Ginner's preparatory drawings

49 Robert Bevan, *Horse Sale at The Barbican*, 1913, oil, 78.8 × 122cm (31 × 48in). The Tate Gallery, London.

show how his original pictorial conception could be expressed in strictly linear terms, which stand in a curious relation to the densely painterly qualities of the final paintings. This, above all, was what Gilman learned from Ginner. Gilman's various studies for the *Canal Bridge, Flekkerfjord*, (c. 1913) and *Leeds Market*, though painted some years later, stand to their finished paintings just as Ginner's studies for *Leicester Square*[32] and *The Forecourt, Victoria Station* of 1912, stand to theirs. This is the whole point of Gilman's observation in 1910 that a painting 'is all edges'.[33] Drawing did not need to be recovered since it had become completely sublimated at the final stage of blocking-in. In Gilman's case this technique seems to have assumed an almost Pre-Raphaelite literalness at times, as in the *Eating House* pictures of 1912/13. Here the original grid of the drawing being transferred to canvas is itself preserved in the procedure of painting, probably one square at a time, as an important feature of the finished work. Gore also was later to pursue this pictorial logic, which would appear to be an equivalent of sorts to Sickert's careful retention of drawing qualities, in the interests of an altogether new idea of pictorial authenticity, as in his 1911 portrait of Gilman.

c22, 1
53
c23
39

Only once did Ginner give way wholeheartedly to his direct passion for Van Gogh, and the result was not successful.[34] Hence, perhaps, the rigour of his technique, described by Rutter as 'treating paint as pieces of mosaic to inlay on a canvas instead of so much butter to be smeared...'[35] Working increasingly

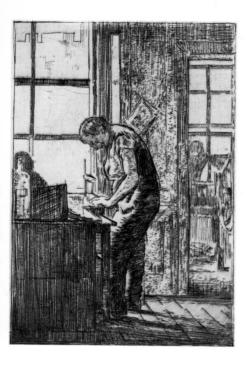

52 Malcolm Drummond, *Sickert Etching*,
c.1909, etching. P. and D. Colnaghi and
Co. Ltd.

away from nature, it is not surprising to learn that Ginner constructed his
drawings through a simple home-made view-finder, an alternative to photo-
graphy which Sickert, from similar motives, was increasingly to exploit.[36] 51

Malcolm Drummond's *Portrait of Ginner* (c. 1911) shows him 'still looking c19
wickedly French' as Wendy Baron puts it.[37] Drummond's work at this time
amounts to a paradigm of Camden Town painting. Here he is busily
assimilating a variety of influences, particularly the open mosaic technique of
Gilman's *Mrs. Whelan* portrait, through the luminous tonality of Bevan's *Cab-* c26
Yard at Night. The result is a curious tribute to Sickert – the very formula of a 48
Sickert portrait such as *The New Home* – yet filtered through Cezanne and a c18
personal taste for a very abstract overall design. This is also apparent in his
painting of *Brompton Oratory* (1910), which again looks to Sickert's music-hall 54
interiors as a source of inspiration, but treats the subject-matter in a far more
abstract tonal manner which anticipates the later style of Sylvia Gosse and
Thérèse Lessore and Sickert himself. The very uncompromising tonality of
Drummond's work, coupled with his generally thin use of paint – the *Portrait of*
Ginner is very much an exception here – seems to have attracted Sickert's
curiosity at several times in later years, e.g. *In the Wonderful Month of May*[38]
which shows him at his most abstract.

Drummond's most personal work from this period however, was his view of
St. James' Park, shown at the third and final Camden Town Group exhibition c21
in December 1912, which was praised when shown at the 1913 Salon des
Indépendants in Paris. Once more Drummond seems to have anticipated the
later direction of his colleagues, just as between 1912 and 1914 he was to
produce a small series of interiors which, from similar sources, arrive at c20 55
pictorial conclusions which are remarkably similar to those of Duncan Grant
and Vanessa Bell at the same time.

William Ratcliffe was also eclectic in his use of sources but generally lacked

53 Charles Ginner, *The Forecourt,*
Victoria Station, c.1912, ink, 25.4 ×
29.1cm (10 × 11½in). Ashmolean
Museum, Oxford.

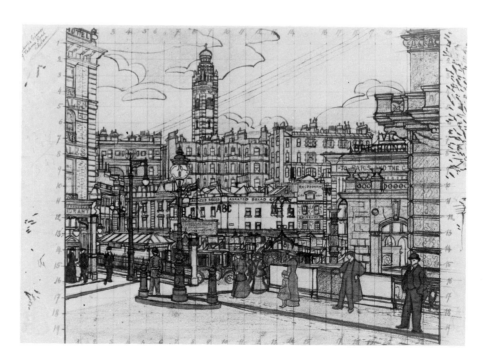

the coherence which enabled Drummond, for instance, to assimilate them into an individual and recognisable idiom. All too often Ratcliffe swung from one member of the Group to another for momentary inspiration. The results are often little more than gifted pastiche, but pastiche which tells one a considerable amount about the strengths of the original artists. Thus, Ratcliffe's *Coffee House* (1914) becomes a rather fussy *homage* to Gilman's 56 *Eating House*, whilst his *Landscape with a Cow* (1912/13) looks respectively to 57 Gore and Drummond. Only rarely did he establish his own gifts as a long-established designer and this was in a tiny town-scape of *Clarence Gardens* (c. 59 1912).

In this picture it is almost as if he had recognised the stylistic contradictions implicit in an exactly contemporary painting by Gilman, his closest friend and introducer to the Fitzroy Street Group. There is an immediately noticeable disparity in Gilman's view of an island of trees and plants in the middles of the 58 gardens,[39] between the highly dramatic bravura brush-work of lawns, very much looking back to his earlier career, and the impacted pinks over blues in the central flower-bed. Painting from a much higher view-point, reminiscent of Gore's *Street Scene Viewed from a Window* (1911), Ratcliffe uses the single vertical line of a street-lamp to divide his canvas, which is far more closely and evenly worked, achieving a low-key tonality and a vigour of paint texture which perfectly fuses the generally variant aims of Gilman and Gore. This division of the canvas was a frequently-used device among the Camden Group.

As was earlier described, Lightfoot left the Group almost as soon as he joined it, and Duncan Grant was invited to take his place, partly to establish some degree of contact with Roger Fry's circle and partly to maintain a younger element within the Group itself.[40] He did, however, exhibit one picture at the Second Exhibition and I think this is an important picture in so far as he consciously attempted to paint something which would 'fit in'.[41] Whether or not he succeeded is another matter. Given the markedly experimental nature of much of his work in this period, *Tulips* appears as a highly serious example of c8 decorative painting, taking the ostensibly conservative genre of the still-life into an entirely new direction for this country. Yet, for all its acknowledgement of Cezanne, it does, I think, suggest that Grant was trying to find a happy medium which would compromise neither the demands of naturalism nor of decoration. Relating as much to Manet as to Matisse, Grant's work must clearly have belonged to a different historical axis from that of the other members, save perhaps Wyndham Lewis, whose work in all three Camden 60 Town Group shows must have jarred awkwardly with that of his colleagues.[42]

Any hope that Sickert, for one, may have had of uniting the whole range of contemporary English art in 1911, from John to Grant, must have been effectively shattered by Fry's Second Post-Impressionist Exhibition, which 61 coincided with the Second Camden Town Group Exhibition. Whereas there had previously been room to manoeuvre between the first generation of French Post-Impressionists and Sickert's general position, Fry now appeared to be launching an all-out attack on what Sickert understood as figurative art itself. The Camden Town Group could, and, it is apparent, did, manage to incorporate Gauguin, Van Gogh and Cezanne. It could not incorporate Matisse and Piccasso and still retain its identity. Even *The Art News* was printing Kandinsky's theories.[43] And in a catalogue note to an exhibition he had organised in Manchester for the Contemporary Art Society,[44] in December

54 Malcolm Drummond, *Brompton Oratory*, c. 1910, oil, 20.3 × 53.4cm (8 × 21in). The Arts Council of Great Britain.

55 Malcolm Drummond, *The Doorway*, c.1914, oil, 50.8 × 61cm (20 × 24in). Private Collection.

56 William Ratcliffe, *The Coffee House, East Finchley*, 1914, oil, 50.8 × 61cm (20 × 24in). Southampton City Art Gallery.

57 William Ratcliffe, *Landscape with a Cow*, 1912-14, oil, 50.8 × 61cm (20 × 24in). City of Leeds Art Gallery, Temple Newsam House.

58 Harold Gilman, *Clarence Gardens N.W.1.*, 1912, oil, 50.8 × 61cm (20 × 24in). Ferens Art Gallery, Kingston Upon Hull.

59 William Ratcliffe, *Clarence Gardens*, 1912, oil, 26.7 × 50.2cm (10½ × 19¾in). Private Collection.

1911, Fry showed how little he understood the Camden Town Group position: 'Sickert was always a somewhat solitary figure. Alone of English artists, he has steadily refused to acknowledge the effect upon the mind of the associated ideas of objects; he has considered solely their pictorial value as opposed to their ordinary emotional quality.'[45] In fact almost the reverse was the case, and it was Fry who was most consistently and polemically representative of the position he attributes to Sickert. He nonetheless remarks upon the 'objective spirit' of Camden Town painting, and it was this spirit which survived the Group's gradual dissolution in 1912.

The Group's name appears for the last time in the title of an exhibition held in Brighton in December 1913 under two names, an 'Exhibition by the Camden Town Group and others' in the publicity, and 'An Exhibition of the Work of English Post-Impressionists, Cubists and others' in the catalogue. The Director of the Public Art Galleries described in a 'Notice' how 'It has been somewhat difficult to find a title for this exhibition...as there are many works exhibited which do not come under either of these titles.'[46] In an Introduction to the first two rooms of the Exhibition, J.B. Manson, the Camden Town Group's first Secretary, referred to Sickert's position in all this as the 'innocent progenitor' of the new generation of Post-Impressionists: 'Mr. Sickert may not have foreseen the Camden Town Group as the outcome of his early experiment, but he did then realise the necessity of providing some scope for the free expression of newer artistic thought.' Manson carries on to argue that: 'The right of free speech in art has been a particularly unsatisfied need in England, where art has meant for the public the sentimental anecdote

63

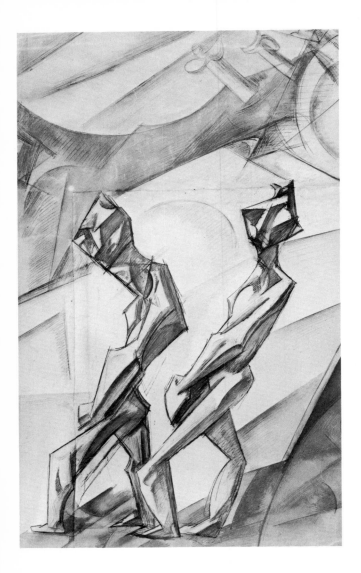

60 P. Wyndham Lewis, *Two Mechanics*, 1912, ink, 55.9 × 33.7cm (22 × 13¼in). The Tate Gallery, London.

right
61 Duncan Grant, Cover of Catalogue to The Second Post-Impressionist Exhibition, 1912.

facing page
Colour 17
Vanessa Bell, *Portrait of a Model*, 1913, oil on canvas, 68.6 × 55.9cm (27 × 22in). Private Collection.

produced according to the best recipes evolved to suit the taste of institutions eminently British.'[47]

Thus, two hitherto distinct discourses are united – the Fitzroy Street, Allied Artists, Camden Town plea for a new open market of ideas, and Roger Fry's generally millenial account of the rise of modernism from the wastes of non-art. Manson's position was sturdily inclusive: 'There is no limit in art to development or to new ideas. New modes of expression, whatever their value, must and will be heard.' Wyndham Lewis wrote a separate Introduction to the third 'Cubist' room of the exhibition, and in so doing decisively represented a major split in the ranks of the avant-garde. Or, perhaps, one should say that at this point a clear and self-defined avant-garde tendency emerged from a broad movement of artistic reassessment which contained within itself the seeds of its own, eventual, atomisation. Manson argues that in 1911 the Camden Town Group had represented 'a coherent homogeneous school of expression; differing in degree as to the work of individual members, but with the unity of a common aim'. By 1912 his tone was already clearly retrospective.

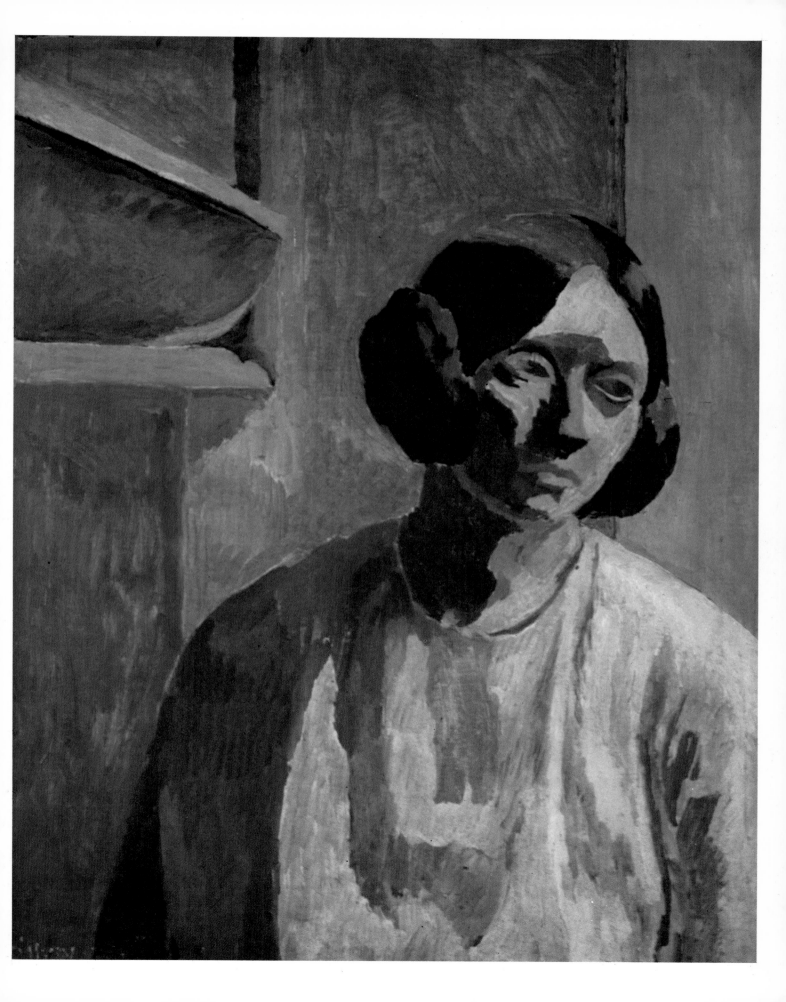

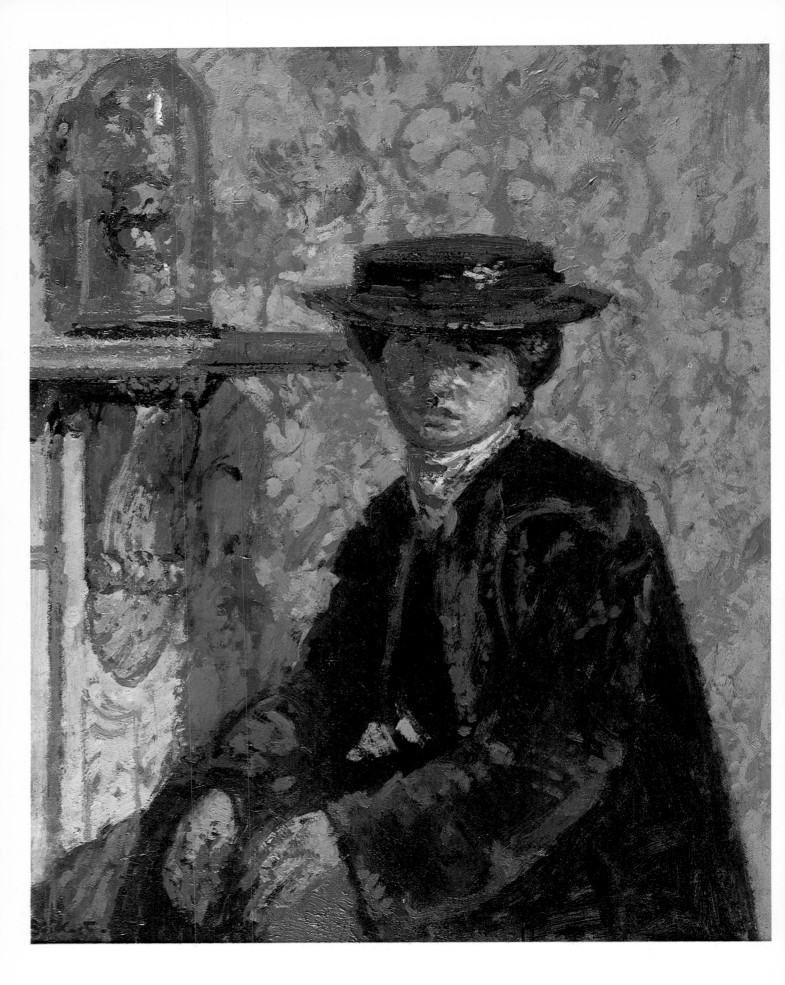

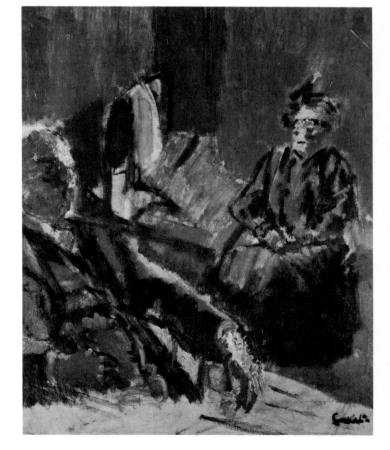

62 Spencer F. Gore, *At The Alhambra*,
c.1910, chalk and ink. Private Collection.

63 W.R. Sickert, *That Boy Will Be the
Death of Me*, c.1912, oil, 40.7 × 30.5 cm
(16 × 12in). The Fine Art Society Ltd.

facing page
Colour 18
W.R.Sickert, *The New Home*,1908, oil on canvas,
50.8 × 40.7cm (20 × 16in). The Fine Art Society.

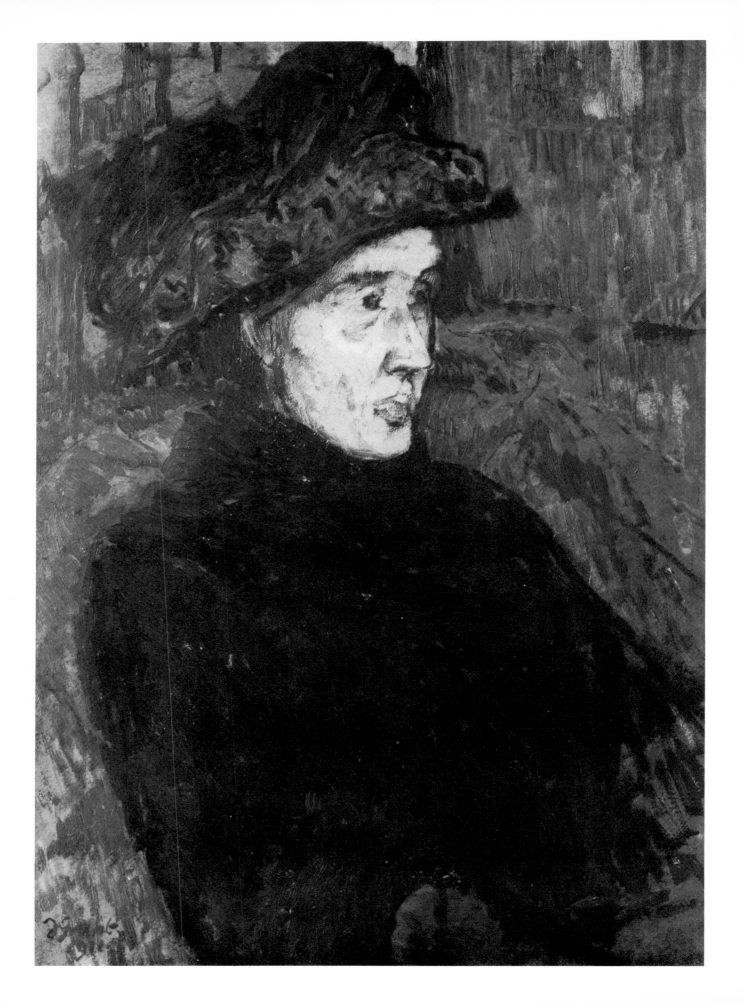

6. Bloomsbury

'Sickert and Fry had known each other all their lives; Fry had lived for a time with old Mrs. Sickert[1] and her sons. The relationship between them was a curious one. Sickert had been a steady support when Fry was passing through a tragic phase; they always rallied to each other in moments of crisis but they could hardly be described as intimates. If they had been constantly together they could never have hit it off...'[2] By 1910 both men were firmly established in rival pedagogic roles, polarised and defined by the First Post-Impressionist Exhibition. Both men defended their respective positions with forceful appeals to convention and history. In this sense neither of them can properly be described as avant-gardists, since in this early modernist period the term became characterised by a hostility to history per se. 'You and I', Sickert once declared, 'live in the firm belief that one or the other of us is destined to do one of us in, and, that being the only thing that keeps us both alive, we should not do it as we should both have lost our motive for living.'[3]

Fry had become involved with members of the subsequent Bloomsbury Group early in the century. Vanessa Bell was familiar with his reputation as an art historian and lecturer in 1902 or 1903, and got to know him through her association with the N.E.A.C. in 1904. He was a selecting Jury member until his resignation in 1908. She had also met Duncan Grant in Paris in 1907 on her honeymoon, and they became friends in the course of the following year when he was sharing rooms in Fitzroy Square with Maynard Keynes.[4] But it was not until 1910 that these friendships merged into a more formal alliance. To understand this alliance it is necessary to consider the individual careers of Fry, Bell and Grant in the immediately preceding years.

Roger Fry had studied Natural Sciences at Cambridge, but made up his mind to become a painter in 1888, at the age of twenty-two, working in the following year as a studio assistant to Francis Bate, the Honorary Secretary of the New English Art Club. He also studied for a short time at the Académie Julian in Paris in 1892, before settling down in London as a regular N.E.A.C. contributor, much influenced by the Aestheticism of the Ricketts and Shannon Circle in Chelsea, as well as by Sickert, whose evening classes he attended at The Vale in 1893. Fry's 1894 portrait of Edward Carpenter[5] is a fine example of N.E.A.C. painting at its best, looking intelligently if cautiously at Degas from its raised view-point, whilst employing the careful glazing technique of Whistler's followers. Had Fry continued in this style there seems little doubt that he would have gone on to join the company of Orpen and Lavery in a prestigious Academic career. This possibility, however, was radically undercut in the course of the 1890s by Fry's increasing enthusiasm for early Quattrocento painting, stimulated by the research for his first book, *Giovanni Bellini*, published in 1899.

In 1897 he wrote of a visit to the then practically unknown frescoes of the History of the Holy Cross by Piero della Francesca in the church of S. Francesco at Arezzo: 'Extraordinarily beautiful...we both [he and his wife] admire him almost more than any other Italian,' And he adds, as a significant afterthought, 'he certainly comes nearer to the Greeks than any other Italian'.[6] By 'the Greeks' we are to understand a particular sympathy for aspects of geometric design and formal simplification over and against issues of tonality or colour. At the same time Fry was also involved in various projects as a furniture designer and decorator.[7] As early as 1885 he had made friends with the English Arts and Crafts designer and theorist C.R. Ashbee, who founded

65

64 Duncan Grant, *Portrait of Virginia Woolf*, 1911, oil, 55.9 × 40.7cm (22 × 16in). Private Collection.

the Guild and School of Handicrafts in the East End of London in 1888. This was effectively a workers' co-operative which pursued William Morris's belief that a revival of individual crafts and manufacturing skills could actively challenge the effects of the division of labour established in all Capitalist modes of production.[8] At the age of twenty, Fry could write to Ashbee that he doubted whether sufficient stress had been placed on the functional role of 'pure aesthetics' as opposed to 'emotional ends' in art, raising the whole issue of the relation between art and morality. He tentatively concludes that 'art should be moral but should regard morality from the point of view of its intrinsic beauty...'[9] From this it is clear that his belief in the *imminent* moral influence of art which so informed his concept of Post-Impressionism, had been worked out gradually over two decades.

What is at stake here is Fry's own relation to the Arts and Crafts movement. Quentin Bell has pointed out that the products of the Omega Workshops were often judged at the time in terms of a craft ideal which derives from Morris, and were found wanting.[10] Modern critics have also tended to regard this side of Fry's work from this same misleading point of view.[11] What should be noted is that the Morris tradition sought on the whole to resolve the Victorian dualism between Art and Design by elevating the latter to the status of the former. Fry, on the contrary, in the concept (and practice) of Post-Impressionism, attempted to call into question the validity of the dualism itself, on the grounds that the formal qualities which he designated as 'pure form' simply transcended the entire issue. In the most direct and pragmatic way possible, 'Fry's calculation was that people who would not buy Fauve pictures would buy Fauve hats or Fauve lampshades...'[12] There is a certain danger however, of over-simplification here. There is all the difference in the world between Morris's proposition in the 1880s that artists were out of touch with everyday life, and Fry's diagnosis of that same aesthetic rootlessness. 'I do not want art for a few,' wrote Morris, 'any more than I want education for a few, or freedom for a few... What business have we with art unless all can share it?'[13] As I have argued in Chapter One, Fry was much more concerned with the capacity for aesthetic 'appreciation', which he believed to be innate and hence beyond the effects of education.[14]

As far as Fry was concerned, Morris's attempts to reconcile the conflicting demands of art and industry were vitiated by his absorption 'in the study of natural appearances' as opposed to 'abstract design'[15] Hence the entire problematic of Post-Impressionism could at times be seen by Fry as a matter of bringing the artist 'back to the problems of design', not in relation to any specific socio-political programme, but 'so that he is once more in a position to grasp sympathetically the conditions of applied art'.[16] In short, Fry's concept of 'Design' attempted to resolve the contradictory relations between Fine and Applied Art by shifting the entire debate onto a transcendant level of innate aesthetic capacity and intrinsic moral worth. Whilst this prevented him from falling into the trap of Morris's stubborn archaicism, it also held him back from any active sociological analysis of the very art which he so fervently advocated.

These problems, associated with the concept of Post-Impressionism, were already built in to Fry's outlook as early as the 1890s. His work as an art historian and painter led him increasingly towards the idea of a 'classical' tradition in European art, the predominantly formal qualities of which also

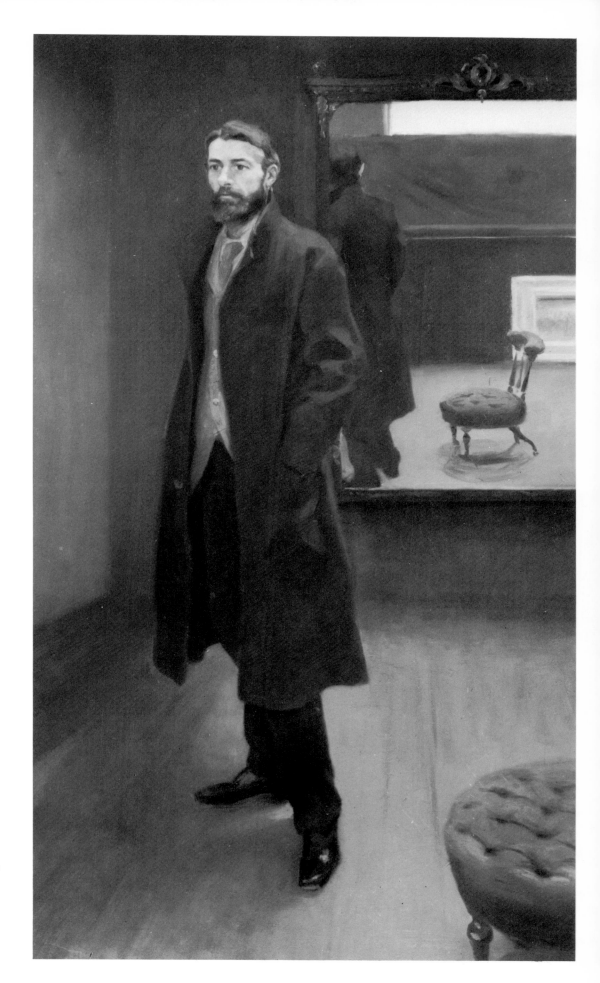

65 Roger Fry, *Edward Carpenter*, 1894, oil, 74.9 × 43.8 cm (29½ × 17½ in). The National Portrait Gallery, London.

raised the issue of the relation between art and design, together with their possible social functions, as well as an overall view of art as an intrinsically 'improving' moral instrument, rather than a merely illustrative conveyor of moralistic anecdote. Hence the inseparable contingency of aesthetics and morality within the notion of 'pure form'. The bitterness of Fry's later invectives against Victorianism should not, therefore, be allowed to obscure the genesis of so much of his own thought in the values and assumptions of the Aesthetic Movement in a decade which, as Richard Le Gallienne pointed out, was 'not so much the ending of a century as the beginning of a new one'.[17]

Indeed, the figure of Cezanne who emerges in Fry's writings from 1906 onwards might in many respects be seen as the cultural and intellectual ideal of a generation of English artists and aestheticians for whom the Whistler-v-Ruskin case had dealt a mortal blow to any idea of a progressive realist school of painting in Britain. This, in one sense, was Fry's initial advantage over Sickert. For however far Whistler's own work may have been from Fry's model of formal purity, it nonetheless spoke for an art which, in rejecting traditional representational values, had opened up a new space for a kind of painting which would stand in inverse ratio to either naturalism or prescriptive realism. This is what Fry meant by disinterestedness.

Although he had written about Cezanne, whose work he had seen at an exhibition held by the International Society at the New Gallery in 1906, it was not until 1908 that the various strands of his earlier interests and ideas began to tie together into a coherent argument. In a letter to *The Burlington Magazine* entitled 'The Last Phase of Impressionism', he protested against what he saw as an editorial policy 'to treat modern art in a less serious and sympathetic spirit than that which you adopt towards the work of the older masters'.[18] In this letter the distinctive outline of his first theory of Post-Impressionism is rehearsed more or less in full: 'Impressionism accepts the totality of appearances...but thus to say everything amounts to saying nothing – there is left no power to express the personal attitude and emotional conviction. The organs of expression – line, mass, colour – have become so fused together, so lost in the flux of appearance, that they cease to deliver any intelligible meaning.' This is the point of an earlier distinction in the same letter between the naturalism of the Quattrocento, which 'was concerned with form', and that of the Impressionists, 'in which separate forms are lost in the whole continuum of sensation'. Cezanne is thus seen, together with Gauguin and Signac, as a pioneer in the restoration of formal qualities to naturalistic painting.

Yet Fry is not at all sure how actually to deal with this 'new' painting, and he concludes that if it is neither Impressionist or neo-Impressionist then perhaps it might be considered 'proto-Byzantine'. By means of this ungainly neologism he asserts the restoration, as he saw it, of drawing and design. His argument, though, is somewhat confused. English art is accused of constantly attempting to revert 'to some imagined pristine purity', whereas neither Cezanne nor Gauguin is seen as 'archaizer' – despite his own new category. Fry was always to critizise any tendency to evaluate art in terms of social symbolism, yet this is already what he is actually doing himself. The values of purity and the aesthetic emotion connote an aristocratic aesthetic quite as clearly as the art of the Royal Academy connoted the ideology of the middle class. In an important sense the later ramifications of the theory of Post-Impressionism were attempts to lift art altogether beyond any possibility of social meaning which

might sully its desired disinterestedness. There is an ironic parallel here to
Marcel Duchamp's eventual concept of aesthetic 'indifference'. Fry might well
have employed the phrase himself. The model of Byzantine art was to prove a
powerful force in Fry's thought in the following decade. It was the breadth of
his historical vision which ennabled him to suggest the mosaics of Constan-
tinople and Ravenna as an antidote to the sometime fussiness of pointillisme.
At the same time the art of the courts of Byzantium was wholly in keeping with
his own theory of a contemporary artistic élite.

In 1909 he became editor of the extremely prestigious *Burlington Magazine*,
having been dismissed from his position as an advisor to the Metropolitan
Museum in New York after disagreements with Pierpoint Morgan, the
President of the Board of Trustees, though he continued to work as a buyer for
H.C. Frick on an informal basis. The *Burlington* gave Fry a new public platform.
In January 1910 he wrote an Introductory Note to the first of two articles on
Cezanne by Maurice Denis which he also translated. 'He is the pure painter'
wrote Denis, quoting Gauguin's pupil Paul Serusier: 'His style is a pure style;
his poetry is a painter's poetry... One thing must be noted...that is the absence
of subjects.' For Denis as surely as for Fry, Cezanne is 'a primitive who returns
to the sources of his art, respects its first postulates and necessities, limits
himself by its essential elements, by what constitutes exclusively the art of
painting.' This is all very far from Spencer Gore's pragmatic criticism. And
strangely enough it takes us back to William Morris. For whilst there is no
question of a direct *stylistic* revivalism, it is hard not to notice the overriding
aesthetic atavism, however abstract the language may be in which it is posited.
E.P. Thompson has described Morris's 'devotion to pre-capitalist achievements
in the visual and architectural arts' and his Utopian vision in a world of Beauty
degraded.[19] For Fry, Cezanne serves a similar function – a figure with whom to
combat the corruption of some absolute ideal of formal purity, as exemplified
by Piero della Francesca and 'the Greeks'. At the same time his 'modernity' is a
pre-emptive defence against any such analysis. As the Church of England
seemed to restore the state of religion to a condition of 'primitive integrity' for
Sir Thomas Browne in the *Religio Medici*, so Cezanne is to renovate and at the
same time advance the State of art.

In this same period Fry's designs for his own house in Surrey were being
realized, combining Italian and French Renaissance sources with the influence
of Philip Webb, in a monumental style which looks back to The Red House as
well as to the work of contemporary European architects such as Loos and
Berlage. Fry may even have been aware of Frank Lloyd Wright's early brick
buildings, since Ashbee had visited Wright as early as 1901.[20] He was confident
and secure, and by 1909 had formulated all his basic ideas concerning the
possibility and indeed the desirability of a new 'pure' art, as set out in the
'Essay in Aesthetics'.[21] It was in the course of that and the following year that it
appeared increasingly clear to him that Cezanne and his followers represented
precisely the kind of art for which his theories had so completely prepared him.
It may well have been the 'shock of recognition' at this actual discovery of what
his own thought had, as it were, anticipated, which encouraged the increasingly
evangelical tone of both his writing and his life.

In 1910 he also re-made his earlier acquaintance with Vanessa Bell and,
through her, her husband Clive Bell, and their friend Duncan Grant. Fry found
out that there were other painters in England who either shared his general

outlook, or whose work at least fitted in with this general thesis. It was in this new confidence that he set out to publicise his arguments as dramatically as he could. Sickert had announced his intention to create 'a titillating scandal for the public' before the London Impressionists exhibition of 1889; now it was Fry's turn.

That Vanessa Bell was also familiar with the paintings of Cezanne and Gauguin may be seen in her *46, Gordon Square* (1909) in which the view of the *c16* Square below the window is remarkably similar to the view from a window in Gore's *Woman in a Hat* (1907), which she may well have seen at a N.E.A.C. 24 Exhibition. What is more important, however, is the way in which both painters were able to respond to French art before 1910. Like Fry she had also come across Cezanne for the first time at the New Gallery in 1906, where she also noticed 'a lovely little Van Gogh of flowers in a jug'.[22] At the same time such pictures were not in themselves sufficient to inspire her to make a decisive break with the overwhelming stylistic orthodoxy of the N.E.A.C.

For her as for so many other English painters, 1911 proved to be a watershed. This is particularly apparent in a series of paintings of Studland Beach, the first of which shows a number of standing and seated figures which, with their strong outlines and flatly filled in forms, show a wide acquaintance with contemporary French painting. In two subsequent versions, however, the whole scene is drastically pared down, with the canvas divided diagonally into two major areas of uncompromisingly flat colour, a 'sea' of deep indigo painted 66 over a red ground, and a 'beach' of various cream and ochre tints. Even Matisse does not prepare one for these extremely simplified forms before his Moroccan paintings of 1913/14. It is as if the myriad random touches of Steer's Walberswick beach scenes have been violently shaken into an entirely new and 7 solid pictorial convention. Like Gore, but in a very different idiom, Vanessa Bell's paintings from 1911/12 explore the possibilities of transforming a

66 Vanessa Bell, *Studland Beach*, 1911-12, oil, 76.2 × 101.6cm (30 × 40in). The Tate Gallery, London.

67 Henry Lamb, *Phantasy, The White Horse*, 1912, oil, 61 × 86.4cm (24 × 34in). Public Collection, Australia.

tradition of monochrome tonality into an art in which colour is built up from related tints. Having emptied her pictures of superfluous information, she was free to concentrate on the exciting potentialities of colour relationships explored for their own sake. It is significant that here, for one of the few times in her life, she painted *away* from nature, gaining a confidence which fed back over the next decade into all her work. *Studland Beach* stands to her work very much as the *Balcony at the Alhambra* stood to Gore's. Both painters took from French painting only what could be assimilated to a strong local tonal tradition, namely, colour.

c4

The only picture Vanessa Bell singled out for praise at the Friday Club exhibition in 1911 was Henry Lamb's *The White Horse* and this certainly makes sense in the context of her own work, since Lamb was also experimenting with large areas of flat colour and very formal design, albeit far more closely derived from Picasso's 1906 studies for 'The Watering Place', which was never finally painted. Much British painting from this period resembles Picasso's work in the years leading up to the *Demoiselles d'Avignon*, not simply in terms

67

6

of direct derivation but as the result of a common stylistic heritage shared by Picasso himself – Whistler and Burne-Jones, Puvis de Chavannes and Gauguin, Velasquez and Cezanne.[23] This new configuration of sources tended to encourage the survival of late nineteenth-century allegorical scenes, but drained of their original Symbolist meanings. In this 'empty' state they became perfect vehicles for the formal and colouristic exercises which were so much in the air. At the same time the old convention of matching low-keyed colour values continued to subdue the possibilities of direct colour painting. Hence the often strained relationship in so much Fauvist art between technical innovation and the demands of a residual Symbolist iconography, as in much of Matisse's decorative work prior to 1910. And hence the enthusiasm of painters like Gilman and Ginner for the work of Gauguin and Van Gogh and Cezanne, rather than Picasso, who, from his pre-Cubist standing at the First Post-Impressionist Exhibition, must have looked somewhat old-fashioned, as Sickert went half-way to saying.[24]

What is most surprising is the startling originality of Vanessa Bell's response to Post-Impressionism. In a series of Italian landscapes and views of her sister's house in Sussex, she developed a style in 1911/12 which perfectly amalgamated the new freedom of colour with her own austere sense of geometric design. In many of these paintings she builds up the picture space in horizontal tiers, which relate far more closely to the background areas in Matisse's *Bathers with a Turtle* and *Game of Boules* of 1908, than to either version of *The Dance*, which so inspired Duncan Grant. This is seen at its most abstract in the broad bands of white, green and orange which comprise the background to *Frederick and Jessie Etchells in the Studio* of 1912, as well as in the construction of her *Conversation Piece* from the same year. The same approach is also taken by Jessie Etchells herself in a small painting, *Seated Figures* (1912/13), with its brilliant blue tree trunks and drastic simplification. More dramatic still is the tiny *Bedroom, Gordon Square*, which is a radical solution to the question of how to deal with contre-jour interior painting. This picture might almost be seen as a reply to Sickert's *Mornington Crescent Nude* (Baron 213) of 1906/8, in which he simplified his favourite motif at this time down to its most basic elements. Vanessa Bell takes the logic of this procedure to a completely new pictorial conclusion, balancing areas of saturated colour, greens and deep reds, with a rich variety of loosely scrumbled and broadly hatched lighter tones. As in the Italian scenes, paint is used quite thickly and to an even texture across the canvas. Light no longer threatens form. It creates it through colour.

At the same time the isolated figure on the bed only serves to stress the desuetude of her situation. It is a desolate painting, and its sense of desolation springs less from the kind of technical expressionism preferred by Sickert, than from its refusal to specify expression at all. The monumental blankness of this single featureless women, dwarfed by the severe geometry of the surrounding furniture, initiates a series of other featureless portraits, at least one of which is of her sister. If, as Virginia Woolf suggested, art is a world 'where no stories are told'[25] then meaning must derive from the relations between areas of colour, lines, marks, 'geared down' from reality in that manner which is such a major characteristic of English Post-Impressionism.

This is the process which Virginia Woolf also analyses so succinctly in the person and work of Lily Briscoe in *To The Lighthouse*; Lily, who constantly 'tried to make of the moment something permanent'.[26] This is exactly the aim of

68

70
71
33

72

73

left
68 Vanessa Bell, *Italian Landscape*, 1912, oil. Private Collection.

right
69 Vanessa Bell, *Still Life with Beer Bottle*, 1913, oil, 48.3 × 33.1cm (19 × 13in). Private Collection.

the Camden Town painters from 1912 onwards; how to achieve Cezanne's sense of 'duration' in the image, without losing sight of that lived social experience which so profoundly nourished their art. It is at this point that a definite local Post-Impressionist style clearly emerges. By the time Fry's Second Post-Impressionist Exhibition opened in London in October 1912, including pictures by Gore, Bell and Grant, this style was already firmly established.

Vanessa Bell's artistic education was largely defined by the influence of Whistler. Duncan Grant's earliest influence was Burne-Jones, and the strength of the Bell-Grant alliance as painters gives the lie to any impression, based on the Ruskin-v-Whistler trial, at which Burne-Jones spoke on Ruskin's behalf, that he and Whistler should somehow be seen as opposed figures. What was far more important in the early twentieth century was the way in which artists were free to move between the influences of the various major figures of late nineteenth-century painting whilst still remaining firmly within the larger territory of Aestheticism.

An unusually large body of early work by Duncan Grant remains from the 1890s. On the one hand there are lively observed studies of farm-yard animals – ducks, sheep and so on – and on the other a number of equally lively pen and ink drawings which introduces us to a world of rococo fantasy in which pierrots

9

70 Vanessa Bell, *Frederick and Jessie Etchells Painting*, 1912, oil on board, 51.1 × 52.9cm (20⅛ × 20⅞in). The Tate Gallery, London.

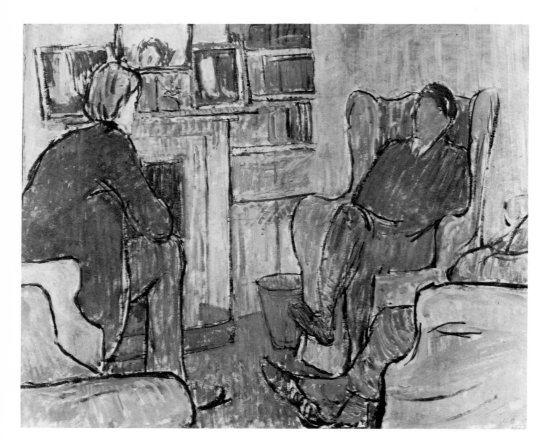

71 Vanessa Bell, *Conversation Piece*, 1912, oil. The University of Hull Art Collection.

 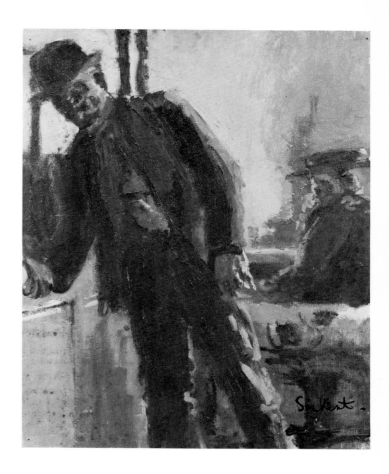

74

75

76

left
72 Vanessa Bell, *The Bedroom, Gordon Square*, 1912, oil, 54.7 × 44.5cm 21½ × 17½in). Private Collection.

right
73 W.R. Sickert, *Off to the Pub*, c.1911, oil, 50.8 × 40.6cm (20 × 16in). The Tate Gallery, London.

spring from wedding cakes before astonished brides, and clowns spell out semaphore messages with their sleeves. These drawings possess a marked iconography of fantastical hats and hair-styles, which owe something to both Burne-Jones and Beardsley, but which is already noticeably Grant's own. In a sense these flights of fancy, with their strong formal inventiveness, counter-posed against the studies from nature, predict the shape of his subsequent career.

Grant's art education, at the Westminster School of Art from 1902 to 1905 and later at Jaques-Emile Blanche's Paris school, La Palette, and at the Slade, affected only the naturalistic side of his talent. His *Memoir of Paris* in 1906 and 1907 is memorable principally for its picture of life for the average British student in Paris at this time. It is an acute record of how easily a young painter could miss what was happening around him. Bonnard and Vuillard were supposed to come to La Palette to teach but never actually turned up. Far more important for him at this time was the memory of the frescoes of Masaccio in Florence and of Piero della Francesca in Arezzo, which he had seen whilst on holiday in Italy with his mother at the age of nineteen. These remained a life-long influence, and were the pre-condition of his own responses to Post-Impressionism. Whilst he almost certainly saw Picasso's *Demoiselles d'Avignon* at the Bateau Lavoir in 1907, there was no real way in which Picasso's legendary masterpiece could have meant very much to him at that moment in his career.

His own work remained in a careful naturalistic idiom, with a strong emphasis, as in Vanessa Bell's work, on geometric design. By 1909 he had

74 Duncan Grant, *Tea*, 1899, ink, 15.2 × 17.8cm (6 × 7in). Private Collection.

taken this style to its limits, and already in the *Portrait of James Strachey* the 77 possibility of a much more abstract art is apparent in the flooded colour of the carpet and the relation of the screen behind the sitter to the shape of the actual canvas. In this same year he also saw the collections of both Gertrude and Michael Stein, with their studies by Picasso for the violently hatched *Nude with Drapery* of 1908, which Gertrude Stein explained was related to Giorgione's Dresden *Venus*.[27] Like Vanessa Bell, Duncan Grant experimented with a variety of styles throughout 1910, working his own way through the various currents available to him. Thus *The Lemon Gatherers* fuses the monumental simplicity of Piero della Francesca's Arezzo frescoes with a clear knowledge of Picasso's 1905 *Saltimbanques*, whilst *The Dancers* of 1910 re- 78 works the classical theme of dancing Graces in a style which also relates to Picasso's pre-Cubist nudes, but still more so to the work of Maurice Denis. Most important of all in this picture is the relative independence of colour from any narrow descriptive function, especially in the loosely painted ground on which the dancers move.

In 1909 Duncan Grant also visited Matisse at his suburban Paris home in

75 Duncan Grant, *The Queen of Sheba*,
1912, oil on plywood, 120 × 120cm
(47¼ × 47¼in). The Tate Gallery,
London

Issy-les-Moulineaux, where he saw the first version of *La Dance*, as well as
various still-lives. Unfortunately Matisse seemed rather more eager to discuss
his conservatory than his studio. Grant had been given a letter of introduction
from Matisse's old friend and ex-colleague from the Beaux-Arts, Simon Bussy,
who had first recommended him to La Palette.[28] Bussy's own work, mostly in
pastels, was also a major influence, and in a rare early review Grant described
how the individual elements in Bussy's pictures 'exist...only for the sake of
their relationship to one another...only that portion of the aspect of an object is
chosen which plays its part with other forms, tones and colours to complete a
whole...this deliberate suppression of certain natural details in order to convey
a sustained and essential impression...'[29] Such criticism looks back to the
Nineties, but at the same time is clearly conversant with many aspects of Post-
Impressionist aesthetics.

By 1910 Duncan Grant has mastered three complementary manners in his
desire to establish a type of lyrical genre painting which would nonetheless be
resolutely 'modern': the tight hatching techniques of Cezanne, a loose
pointillisme which relates closely to Denis and early Matisse, and a highly
personal technique which was referred to as 'mobbling',[30] which was the result
of his own responses to Byzantine and Renaissance decorative art.[31] These
techniques were still held within the larger framework of naturalistic space. He
was at the same time, however, beginning to take a very different approach to

79, 81
c10

76 Duncan Grant, *The Kitchen*, 1902, oil, 40.7 × 50.8cm (16 × 20in). The Tate Gallery, London.

facing page
Colour 19
Malcolm Drummond, *Portrait of Charles Ginner*, c.1911, oil on canvas, 60.3 × 48.3cm (23¾ × 19in). Southampton City Art Gallery.

his medium, as is apparent from the sketches for a series of wall decorations in Cambridge, begun in 1910. Here Grant responds to both Matisse and Picasso 80 simultaneously, rejecting any question of choice between matters of colour and formal construction.[32] His figures become increasingly geometric, and at the same time his individual brush marks are separated out in a markedly caligraphic fashion, using strong colour contrasts. This is the beginning of the technique which Vanessa Bell referred to as his 'leopard manner', which was used to such effect in his portrait of Pamela Fry, and a number of pictures in 79 1911 and 1912.[33]

It is significant that the *Red Sea* is already described as a 'decoration'. In this 81 picture he organises broad formal masses through individual paint marks whose direction alone defines the pictorial space. The effect is one of mosaic within mosaic, an early example of his lifelong interest in highly-schematised representational devices for the representation of water, a concern taken up some fifty years later by David Hockney. This interest is most clearly apparent

77 Duncan Grant, *Portrait of James Strachey*, 1909, oil, 63 × 76.2cm (25 × 30in). The Tate Gallery, London.

78 Duncan Grant, *The Dancers*, 1910, oil, 53.4 × 66cm (21 × 26in). The Tate Gallery, London.

facing page
Colour 20
Malcolm Drummond, *The Artist's Desk*, c.1914, oil on canvas, 50.8 × 40.7cm (20 × 16in). Sheffield City Art Gallery.

81 Duncan Grant, *The Red Sea*, 1911-12, oil, 123 × 150cm (48 × 59¼in). Ferens Art Gallery, Kingston Upon Hull.

82

66

83

opposite above
79 Duncan Grant, *Portrait of Pamela Fry*, 1911, oil, 51.4 × 76.2cm (20⅛ × 30in). Private Collection.

opposite below
80 Duncan Grant, Study for Murals for Maynard Keynes room at Cambridge, 1910-11, oil on board. Anthony D'Offay Gallery.

in the large painted decorations which he did in 1911 for the Borough Polytechnic in London.

Fry had been invited to assemble a group of young artists to decorate the students' Refectory at the Polytechnic in Southwark. Six artists took part – Frederick Etchells, Bernard Adeney, Max Gill, Albert Rutherston, Duncan Grant and Fry himself. Vanessa Bell was too ill to take part in the scheme, following a dangerous miscarriage early in the year. As critics pointed out at the time, the *Bathing* mural owes as much to Signorelli's Orvieto frescoes as it does to Matisse.[34] Which is only to note that both Grant and Matisse were influenced at formative moments in their careers by Sienese and Florentine Quattrocento art.[35] The mural follows the development of what is essentially one figure in a continuous movement – diving, swimming, and clambering up into a boat.[36] This movement finds its formal equivalent in the bands of undulating colour which make up this highly conventionalised flat sea-scape. The result is as uncompromisingly two-dimensional as Vanessa Bell's *Studland Beach*, but as the result of a much more diverse approach to the handling of paint itself. Similarly, the ground to the *Football* mural consists of waving ribbons of colour against which the figures are severely modelled. In both cases it is the second version of Matisse's *La Danse* which is used as a platform from which to explore the dialectic of representation and abstraction implicit in the original.

For Duncan Grant, Post-Impressionism involved a recognition of the possibility of a serious decorative art, in which the aims of decoration and of painting were no longer felt to be mutually exclusive, being seen instead as two aspects of the same thing – what Roger Fry meant by 'Design'.[37]

Fry's own painting at this time remained more closely tied to his earlier work than that of either Bell or Grant. It must have been as a result of the stimulation provided by their experimentation in 1911 that he was able to work his way to the theory of Pure Painting which was such an important determining factor on both the selection and the theorisation of the Second Post-Impressionist Exhibition.

1

61

82 Duncan Grant, *Bathing*, 1911, oil on casein on canvas, 230 × 320cm (90 × 120½in). The Tate Gallery, London.

83 Duncan Grant, *Football*, 1911, oil on casein on canvas, 228 × 197cm (89½ × 77½in). The Tate Gallery, London.

7. Bloomsbury Abstraction

In his Introduction to the Second Post-Impressionist Exhibition, Fry had described a new generation of artists who 'do not seek to imitate form, but seek to create form; not to imitate life, but to find an equivalent for life...they wish to make images which, by the clearness of their logical structure and by their closely-knit unity of texture, shall appeal to our disinterestedness and contemplative imagination... In fact they aim not at illusion but at reality.'[1] Fry himself immediately observes that 'the logical extreme of such a method would undoubtedly be the attempt to give up all resemblance to natural form, and to create a purely abstract language of form – a visual magic; and the later works of Picasso show this clearly enough.'[2] Strangely, the *Head of a Man* to which he actually refers is one of the 1906 studies for the *Demoiselles d'Avignon* and not, as one might suppose, a Hermetic Cubist painting. However, it is the general argument which is important. It was perfectly consistent for Fry to read Picasso's work in its entirety as an exemplification of his new concept of 'visual music'. It was equally consistent to contrast 'such extreme abstraction' with something else, in this case the work of Matisse, in which, Fry argues, 'it is an equivalence, not a likeness, of nature that is sought'.

This, then, is the second stage of Fry's theory of Post-Impressionism. From a theory of 'equivalence' and 'disinterestedness' is derived the notion of a self-sufficient and fully autonomous abstract art, analogous to music within a metaphor which still relates it to the discourse of European Aestheticism. Thus Post-Impressionism is extended as a critical concept from 'the more general tradition of the Post-Impressionist movement', as exemplified by Doucet[3] and others, to the extreme 'simplification' practised by Picasso, Derain and so on: 'Between these two extremes we may find ranged almost all the remaining artists.' Yet all are seen equally 'to derive in some measure from the great originator of the whole idea, Cezanne.' Hence, the significance of a photographic section in the Exhibition which documented the careers of Gauguin, Van Gogh and Cezanne.

Fry concludes his Introduction by returning to the idea of 'classic' art, by which he does not mean 'dull, pedantic, traditional, reserved or any of those similar things which the word is often used to imply... I mean that they do not rely for their effect upon associated ideas, as I believe Romantic and Realist artists invariably do...classic art...records a positive and disinterestedly passionate state of mind. It communicates a new and otherwise unattainable experience.' At this point Post-Impressionism ceases to be a stylistic term, a point which was not appreciated by his contemporaries.[4] This was no doubt a contributory factor to the immediate success of Clive Bell's *Art*, first published in 1914, which set out to expand and clarify Fry's general position as 'a complete theory of visual art'.[5]

Bell's initial argument is deliciously simple: 'Either all works of visual art have some common quality, or when we speak of "works of art" we gibber.' This argument, which suppresses all questions of cultural and historical specificity, has continued to dominate Western aesthetics throughout the twentieth century. The lowest form of common denominator shared by 'the windows at Chartres, Mexican sculpture, a Persian bowl, Chinese carpets, Giotto's frescoes at Padua, and the masterpieces of Poussin, Piero della Francesca and Cezanne' is described by Bell as 'significant form' – 'the one quality common to all works of visual art'. This is, however, a completely circular argument. What is significant form? 'These relations and combinations of lines and colours'

replies Mr. Bell. What, we continue, do these possess in common? 'Significant form'.

Art appeals to an 'aesthetic emotion' for Bell, and like Roger Fry he distinguishes between 'Art', which is 'above morals', and 'mere illustration'. Thus the work of Delaunay or the Futurists is condemned, for example, as 'descriptive painting'. The Futurists are compared with Royal Academicians – they are all using form 'not to provide aesthetic emotions, but to convey information and ideas'. Thus he is able to avoid the issue of representation altogether, which is seen to have value only 'as form, not as representation. The representational element in a work of art may or may not be harmful; always it is irrelevant.' In other words, the one thing that the theory of Significant Form cannot cope with is the actual process of signification.

For Clive Bell, Post-Impressionism is initially an opposition to the aesthetics of mimesis, but also a social opposition to what he calls the 'gross herd'.[6] Thus his theory of Aesthetic Emotion also requires a model of history consisting of heroic individuals (like himself?) who are forever 'against' their times.[7] Bell also takes up Fry's implicit aesthetic atavism, seeing Post-Impressionism as 'nothing more than a return to first principles', the principles of primitive art which, according to Bell, was produced 'with no other motive than a passionate desire to express...form'. Once again all questions of function or sociology are conveniently ignored. In his explicit attacks on history per se, Bell often sounds ironically like the very Futurists he so disliked.

In this account of Post-Impressionism, 'simplification' is seen as the major criterion of the modern movement and in this respect Bell is simply following any number of contemporary French aestheticians. When he describes Cezanne as 'the Christopher Columbus of a new continent of form' he is practically translating Apollinaire word for word.[8] It is not in the least surprising to find him violently hostile to William Morris.[9] Thus we discover the strange paradox of a theory of art which challenges Victorian aesthetics in terms which would have been only too familiar to Matthew Arnold.[10] However, what was at stake here was a theoretical position which could advocate an art of total abstraction from a line of argument which had nothing to do with the critical framework of Futurism or German Expressionism.[11]

This line of argument is particularly interesting in relation to a small body of completely non-figurative paintings by Duncan Grant, Vanessa Bell and Roger Fry from precisely this period, which would seem to exemplify a practical consequence at least of Fry's new notion of art of 'visual music'. In all of these pictures a strategy of mixing and combining a variety of different space-filling techniques in a single picture-space may be observed. They serve to summarise the entire experimentational period from 1910 to 1914, and provide a unique insight into the technical vocabulary of a group whose styles mediated such disparate sources as Byzantine mosaics, Quattrocento frescoes, British Aestheticism and the early school of Paris. The two most important single techniques in these pictures were the centuries-old practice of illusionistic marbling, and the modern use of collage.

Grant's fascination with the effects of marbling was closely related to his own style of pointillisme, as seen in *The Red Sea* and *The Dancers*. By further impacting his brush-strokes, as in *The Queen of Sheba*, he was able to regain a new density of surface, albeit at the expense of combining two seemingly contradictory approaches to pictorial construction, with more or less traditional

81, 78

75

84 Duncan Grant, *The Mantlepiece*, 1914,
oil and collage on board, 45.8 × 39.4cm
(18 × 15½in). The Tate Gallery, London.

draughtsmanship used to recover meaning lost through open colour painting.
The ensuing richness of pictorial effect led him to experiment far more boldly
with marbling itself, a practical extension of this kind of painting. It is also
likely that he saw the earliest of Juan Gris' pictures employing areas of marbled
paper, one of which was already in Gertrude Stein's collection, on his visits to
Paris during the Summer of 1913, in connection with the production of *Twelfth
Night* on which he was working at Jacques Copeau's Théatre du Vieux
Colombier. Certainly Grant used this techique on the sign-board made for the
Omega Workshops in 1913,[12] and in a still more imaginative way, in a host of c10
decorative screens, fabrics and other objects for the Omega Workshops, as
well as the dado of the 'Antechamber', illustrated in the original Omega sales
catalogue.

Marbled paper appears in his 1914 *Mantlepiece* still-life as a collaged 84
element which provided him with one more means of breaking down the
continuous picture-space of his earlier work. However, this held certain
implications for his mixed-media work. Collage may fracture the illusionism of
conventional naturalistic picture space and yet reinforce, as in the work of

85 Duncan Grant, *Still-Life with Paper Hats*, 1914-15, oil and collage on canvas, 75 × 62.3cm (29½ × 24½in). Anthony D'Offay Gallery.

right
86 Vanessa Bell, *Still Life on Corner of a Mantlepiece*, 1914, oil, 55.9 × 45.8cm (22 × 18in). The Tate Gallery, London.

Picasso and Braque, analogically, the identity of the original subject-matter, which may have seemed threatened. But Grant does not appear to have approached Cubism from this point of view at all. Often his collaged pieces of painted paper literally 'float' on the surface of otherwise straightforward Post-Impressionist still-lives, as in *Still Life with Paper Hats*. In such pictures the 85 technique seems almost at odds with the overall pictorial intention, producing an effect strongly reminiscent of biomorphic Surrealism. In this respect it is constructive to compare Vanessa Bell's *Still Life* with Grant's, since both were 86 done from nature at the same time. It is clear that Grant was far more interested in the qualities of surface texture than in design.

1914 seems to have been marked by a recognition of this apparent contradiction and, characteristically, Grant proceeded to explore two radically alternative solutions. In a whole series of portraits of Vanessa Bell, he introduced actual pieces of the fabric in which she was sitting to him, so that the collage takes on a powerful iconic function, whilst in a collaged version of the *Interior, Gordon Square* the technique is used in precisely the opposite direction, to emphasise the autonomy of the elements of collage in themselves.

None of Grant's abstract work is dated. We do know, however, that the *Abstract Kinetic Scroll* was made in the Autumn of 1914, that an abstract *c11* picture known as *In Memoriam, Rupert Brooke* dates from the Spring of 1915, and that he was involved in various exercises in abstract design at the Omega Workshops from 1913 onwards.

Much of Grant's experimentation in the previous years had been leading up to this point. Although he had met Leger through the Steins, he did not know either Sonya or Robert Delaunay, or any of the other Section d'Or painters. In

this respect his use of geometric designs around 1914 did not signify any particular allegiance to a specific French avant-garde tendency. Rather, it relates to the British decorative tradition of Whistler and Godwin as much as to Picasso. What is striking is how rich Grant's work from 1914 appears compared to these stylistic complexes to which it relates. In these paintings Grant isolates and dramatizes a number of formal elements from his contemporary painting. There is a real sense in which Grant is looking at himself as a painter here in these few abstracts. They may thus be seen as a curiously direct moment of artistic autobiography, a stepping back to take the measure of his own growth since 1910.

It seems probable that the musical aspects of the *Abstract Kinetic Scroll* have been over-emphasised.[13] What is significant is that the Scroll itself was made, whilst the viewing box through which it was originally intended to be viewed, was not. The 'Scroll' is in fact less a painting which moves, than an analysis of movement itself, a development from the theme of the progress of a single incident, which has already been noticed in the 1911 *Bathing*. In the course of its fifteen or so feet, seventeen configurations of six basic colour untis tumble their way from right to left, in the manner of Oriental scroll painting, one of Roger Fry's many enthusiasms. The colours are two tones of orange, red, green, blue and purple. The first seven groupings are entirely collaged onto their paper support, and the final four groupings are entirely painted onto the paper. The rest are a mixture of collage and direct paint. There is nothing in the least mechanical about the movement of the configurations, nor is the sequence of the six coloured elements constant from grouping to grouping. The structure of the scroll allows the artist to play, in an astonishing variety of techniques, with the possibilities of formal relationships between the six colours, these colours and the supporting ground, and between the different kinds of ground.

The ground itself is closely marbled ('mobbled') in blue and white in some places, but opens out for the greater part of its length into an elegant calligraphy of individual, swirling brush-strokes. This extremely open use of marbling reinforces the features of the ground, whilst at the same time it celebrates the qualities of the actual marks themselves. The artist has also stippled many of the edges of the coloured elements with black paint, in yet another range of techniques, from tiny dots to loose blobs and thinly-hatched lines. These markings seems to relate directly to many of Picasso's Cubist studies from 1914, which at times serve a similarly ambiguous function, simultaneously two or three-dimensional. They thus increase the sense of movement whilst establishing a tentative unity between ground and elements.

It would certainly be unwise to attempt to place Grant's work from this period in relation to any single intellectual influence. He undoubtedly stands within the large framework of contemporary Bergsonian thought, with its emphasis on form as an aspect of the durational concept of 'transition', according to which discrete moments only possess meaning in their relational sequence. There is no evidence however, that he was interested in Etienne-Jules Marey's cinematic desire to reconstitute the appearance of movement in objects into geometric equivalents. Indeed, there is no question of any such equivalence deriving from nature in the scroll. Grant's objectives are equally far from the Futurists whom he detested, although traces of their influence made its way into some of his decorative work.[14] But unlike the Futurists he is

82

not working *away* from any objects in nature. On the contrary, he is exploring a purely pictorial territory of formal transformations. It is possible that he had heard Picasso discussing the possibility of moving pictures,[15] but this should not obscure the fact that the scroll examines movement within the picture space itself, and that the projected view-finder would only have facilitated the viewer's apprehension of that process. Certain aspects of the scroll do call to mind the early abstract films made by Hans Richter in the 1920s, but this is finally only to observe that both men were operating within a common range of cultural reference.

The only other close parallel to the scroll was the collaboration between Sonya Delaunay and Blaise Cendrars on *La Prose du Transsiberien et de la Petite Jehanne de France* of 1913, described by Grant's friend André Salmon in *Gil Blas* in October, and widely elsewhere. Here again it is the differences between the French and English works which are functional. Grant's picture stands in no relation to any text or object in nature. Even the concept of a musical accompaniment was precisely that, an accompaniment to the priority of the visual. There is no trace or suggestion of illustration in the scroll, unlike Sonia Delaunay's epic fusion of poetry and Orphism.[16]

In the Spring of 1915 Grant produced a panel, *In Memoriam, Rupert Brooke*, in which the elements of the scroll reappear, in a structure which is reminiscent of a Greek 'Stele'. Its very relation to a tragic event gives it a range of symbolic reference which his other abstracts scrupulously avoid, a function suggested in the collaged central area of silvered paper, reflective of the real world and, as it were, a source of light in itself.[17] It is, however, the *Interior, Gordon Square* 87 which exemplifies Grant's tendency, like Fry, to treat Cubism in the general abstract terms of Apollinaire's 1912 criticism.[18] There is, in fact, a close relation between this picture and Picasso's *Man With a Guitar* (1913), again from the collection of Gertrude Stein, a picture which was also very important for Malevich. Grant's *Interior*, like Picasso's painting, is hand-painted, without any collage, whilst he also made another version, this time entirely collaged. I think this is important. It marks a recognition of the confusion between techniques and pictorial intentions which is so apparent in the *Paper Hats*. It 85 was precisely this new separation of techniques which was one of the most vital lessons of the scroll.

Grant was clearly uninterested in the portraitive aspects of the *Man With a Guitar*. What appealed to him – and what informs the *Interior, Gordon Square* – was both the colour, sombre and densely rich, and the immensely strong underlying structure. In this picture he comes to grips with a much more sensuous and densely-worked paint surface, using deep crimson scrumbled over dark blues in the marbled section of the bottom left, with a thick yellow line of paint dragged down the upper right hand side. The range of colours used – olive greens, vermillion, ochres – is again close to Picasso. In this small painting Grant may be seen to have produced a paradigmatic example of 'pure painting' along the lines of Fry's concept of art as 'visual music'. He is working, unusually, away from nature, and it is typical of him that he should thus turn art historical orthodoxy on its head by proceeding from an almost unique adventure with the possibilities of *peinture pure*, to the kind of abstraction-by-simplification-from-nature which is usually assumed to precede the former. This picture proved to be the *ne plus ultra* of Grant's brief abstract period. The division of techniques, oil paint and collage, in two separate versions, marks a

87 Duncan Grant, *Interior at Gordon Square*, c.1915, oil on panel, 40 × 31.9cm (15¾ × 12⅝in). The Tate Gallery, London.

new distinction in his work, one in which oil painting is increasingly reserved for naturalistic painting, with abstraction and collage used for decorative schemes.

We have seen how, in her 1911 version of *Studland Beach*, Vanessa Bell was far more interested in Matisse's colour than in his draughtmanship. It is also interesting to note that the colour layering of blue over red in the sea is exactly reversed in the reds over blues of the two foreground figures. As in Grant's work, we may distinguish two distinct styles of painting in this period, the one hatched, open, Post-Impressionist technique of her *Conversation Piece* (1911), and the other, working her pictures together far more closely, as in *Studland Beach* and the still-life *Corner of a Mantlepiece.* Vanessa Bell's abstract work in this period seems to possess a prismatic quality, like that of Duncan Grant, which enabled her to take stock of her position in the fateful year of 1914. It is through these works that her two earlier styles converge into the practice of thinly-used yet tightly organised brush-marks which characterises her finest Post-Impressionist work in the First World War period.

66

71

119

The abstract screen (or wall decoration) seen behind *Mrs St. John* c15 *Hutchinson* seems very close in construction and colour range to the Tate Gallery's *Abstract*, which must therefore date from c. 1914/15. The dominant c13 colours are yellow, pink, olive-green, sky-blue and indigo. It is also possible that the background area to the 1913 *Portrait of a Model* shows a section of an c17 early abstract picture, though it seems far more likely that this is a section of decorated wall. What is significant is precisely this ambiguity. For a brief and seminal moment in both her own and Duncan Grant's careers, it made little difference whether they were decorating a screen, a wall or a table-top – or painting on canvas. There is all the difference in the world between this indifference to what material was being painted on, and Roger Fry's indifference to what subject-matter was being painted. The former position signifies the extent to which the issue of design for Grant and Bell transcended traditional categories of 'Fine' and 'Decorative' art. This, in essence, was what Bloomsbury painting was all about. Neither painter would ever have confused Christ with a sauce-pan.

Already her 1913 'Nursery' decorations, painted at 33, Fitzroy Square for an 89 Omega Workshop exhibition, show an astonishing freedom in both colour and overall conception, practically anticipating Matisse's *papiers collés* of some forty years later. A large and highly schematised elephant bounces along one wall past trees and a rocky horizon, whilst at the far end of the room a lake full of fish stands before a clump of trees, the tops of which fold out across the ceiling, which was painted bright blue, with large white clouds on it. The entire style of this room derives from her experience of working with cut-out pieces of paper.[19] In this respect Vanessa Bell's designs for the Omega Workshop stock-pile, 91 usually severely geometric and traversed by diagonals, relate directly to her abstract paintings. Hence the totality of the original effect of Grant and Bell's decorations at Charleston, with its unique integration of screens, paintings, and wall decorations, all of which are treated with equal seriousness.[20] The wall of Clive Bell's bedroom at Charleston, which is visible behind an early photograph of *The Tub* is designed in almost exactly the same way as these 92 abstract paintings. Hence the confusion as to what one is actually looking at in the backgrounds of several portraits, as mentioned earlier.

The Tate Gallery's early *Abstract* is much the finest of Bell's surviving works c13 in this style. Her preferred colour range is explored here discreetly yet with immense confidence, in a series of relationships between colour areas and rectilinear forms. The altogether monolithic effect of this canvas totally belies its small size. Like Grant's *Scroll*, this painting is in no sense derived from nature. As such it is a perfect analogue for the concept of *peinture pure*. It cannot be said to symbolise anything beyond its own presence as a set of colour relationships, and the significance of such relationships to an audience acquainted with the values of contemporary Parisian aesthetics. This brief Minamalist phase was probably necessary for Vanessa Bell: certainly it lends to much of her earlier work a quality of self-fulfilling prophecy. With hindsight her entire career bears down relentlessly on this point of technical and conceptual sophistication. It also firmly marks her allegiance to a *European* avant-garde.[21] It is important to notice, however, that such pictures were never an exclusive interest, although they should properly be seen at the very heart of her Post-Impressionist style, mid-way between her decorative and descriptive work, a sign of her refusal to give priority to one over or against the other. This

88 Vanessa Bell, Design for woodcut, c.1918-19, ink. Private Collection.

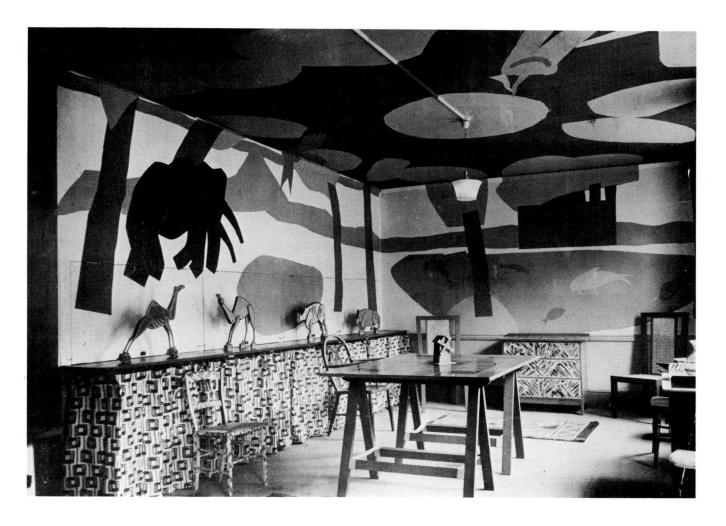

89 Vanessa Bell, Omega Workshops Nursery Installation, 1913, murals and ceiling. Curtains and rug by Frederick Etchells, toy animals by Duncan Grant, cane chairs by Fry.

again would seem to be a major characteristic of English Post-Impressionism – its refusal to accept the validity of any absolute distinction between decorative and naturalistic concerns. It is significant that Ginner and Gore were also involved with decorative work in this period, although they seem to have developed radically different approaches to it.[22] Only in the careers of the Bloomsbury painters does one find this full modernist continuum of painterly practice, a point which neither Fry nor Bell seems fully to have appreciated.

In 1914/15 Vanessa Bell also produced a number of mixed-media pictures,[23] which point away from the decisive abstracts. To this extent it is clear that abstraction per se had little interest for her. This is not to say that the Tate Gallery's *Abstract* is a *tabula rasa*. On the contrary it is a work profoundly saturated with ideas concerning the nature and status of painting itself, ideas which remained to be worked through in the following years. She undoubtedly preferred to work directly from a motif, however slender that may have been, and her boldest pictorial inventions, be they portraits or still-lives, remain determinedly figurative.

The pictorial problems of abstraction were not put to one side then, or simply dismissed, but were allowed to feed into her subsequent work, particularly after her removal to Charleston in 1916.[24] It is, however, undeniable that the profound level of psychological intensity which is always

90

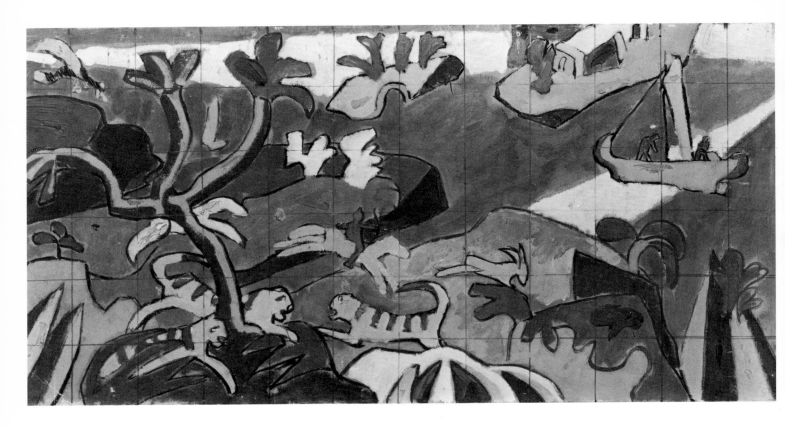

90 Spencer F. Gore, Sketch for a Mural
Decoration for 'The Cave of The Golden
Calf', 1912, oil on paper, 28 × 61cm
(11 × 24in). The Tate Gallery, London.

91 Vanessa Bell, Omega Workshops
Fabric, 'Pamela', c.1914. The Victoria
and Albert Museum, London.

present in her finest work could not be contained in purely abstract terms. At the same time the elegance and formal seriousness of her work, from 1914 onwards, was intrinsically informed by the experience of non-figurative design, in whatever medium it was practised. In *The Tub* (1917) we find a picture which 92 looks back, within a figurative tradition, over her entire career. The Omega Workshop woodcut to which it relates combines an expressionistic use of the 93 medium, which may well relate to the woodcuts of Kandinsky, in whom she took a great interest, with that harmonious design associated so much with Matisse.

The Tub has the effect of a large field of related tones of yellow and ochre, with an interest in brush-strokes themselves which, though entirely different in technical terms, seems to match Gilman's work at this time. A strangely *c27* disquieting nude woman playing with a pig-tail of hair, stands filling up the right-hand side of the canvas, beside a large bathing tub, such as was used at Charleston at that time – the picture having been painted for a specific room in the house.[25] The numerous pentimenti in this large painting seem to reinforce the significance of the act of undressing before us, a curiously apt metaphor for this further paring down of her pictorial vocabulary, allowing her to pursue that distinctive dramatisation of the qualities of related brush-marks in the context of an extremely personal iconography which abstraction could never have allowed. Duncan Grant's painting of a similar subject, which also relates *c12* closely to an Omega Workshop woodcut, becomes at once a far more playful work than that of Vanessa Bell. Yet his version of *The Tub* is equally informed 94 by the experience of abstract design, an influence which leads him, as so often, to treat the human body in an extremely free and decorative manner.[26]

Bloomsbury abstraction does not present us with a single unified style. For Roger Fry abstract art was a logical consequence of his previous theoretical positions, its appeal remaining largely intellectual. Indeed, his own work in this vein is singularly weak. By 1917 he was in any case more or less disenchanted 95, 96 with the whole idea, partly as a result of the siege-mentality of the war years, in which he was cut off from all his friends in France, and partly because his painterly sympathies had always lain with the more conservative wing of the Parisian avant-garde. At the same time abstraction must have appeared hopelessly bound up with the optimism of pre-war cultural life, together with connotations of Futurism and Vorticism which could never be accommodated to his vision of aesthetic disinterestedness. He found increasingly that this quality could only be realised through representational means.[27]

In its total commitment to autonomous abstraction, Grant and Bell's non-figurative work looked forward with almost uncanny historical accuracy to the kind of American painting celebrated half a century later by Clement Greenburg. Its very personal role in their own careers also meant that it was rarely exhibited at the time, and hence has remained almost completely unknown. These works, however, functioning on and between a number of formal and technical levels, fully realise the early modernist concept of the work of art as 'an ensemble of means'.[28] This is not to say that either Bell or Grant ever envisaged an exclusively non-figurative style for themselves: in no way did they signify a reaction against what has been described as 'the tyranny of the image'.[29] There was never any question in Bloomsbury painting of making an absolute choice between figurative or non-figurative art. The aesthetic position of the painters themselves precisely rejected just that kind

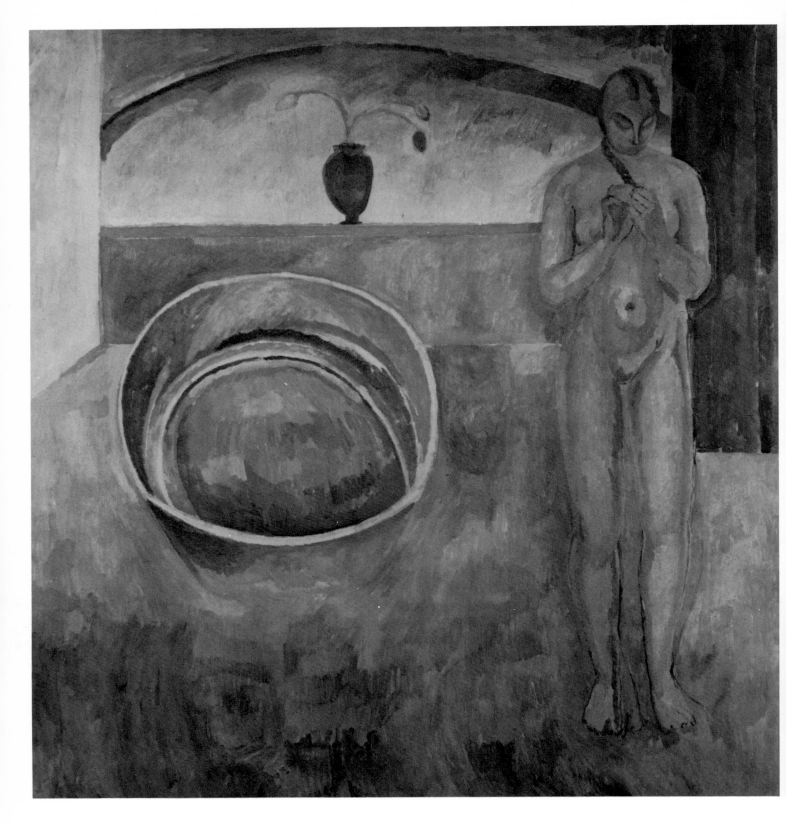

92 Vanessa Bell, *The Tub*, 1917, oil,
181 × 168cm (71 × 66in). The Tate
Gallery, London.

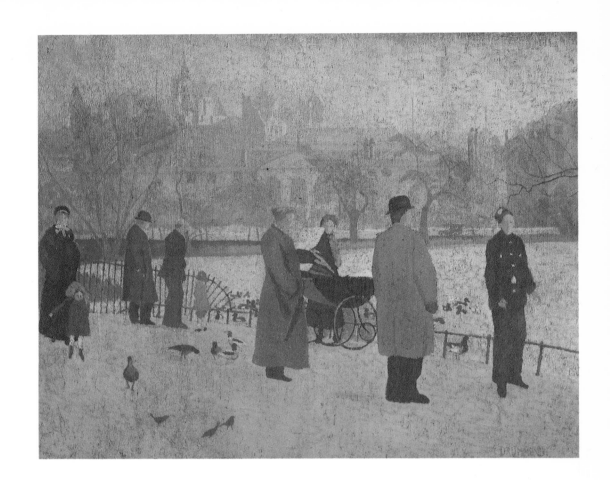

Colour 21
Malcolm Drummond, *In the Park (St James' Park)*, c.1912, oil on canvas, 71.2 × 90.2cm (28 × 35½in). Southampton City Art Gallery.

Colour 22
Harold Gilman, *Leeds Market*, c.1913, oil on canvas 50.8 × 61cm (20 × 24in). The Tate Gallery, London.

Colour 23
Harold Gilman, *The Eating House*, c.1913, oil on canvas, 56.5 × 75cm (22½ × 29½in). The Graves Art Gallery, Sheffield.

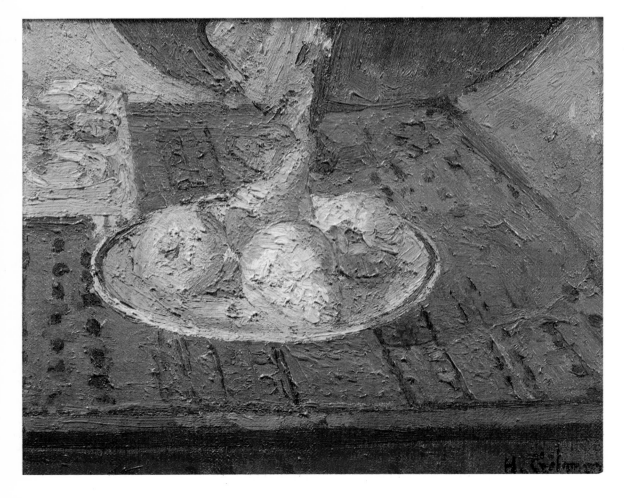

Colour 24
Harold Gilman, *Still Life, Pears on a Plate*, c.1914, oil on canvas, 25.4 × 30.5cm (10 × 12in). The Fine Art Society.

93 Vanessa Bell, *The Tub*, 1919, Omega Workshops woodcut. The Victoria and Albert Museum, London.

of narrowly dichotomous formulation. It is in this sense that Bloomsbury abstraction may be seen to typify a hostility to rigid dogmatism of all kinds, which was the one determining characteristic of the Bloomsbury Group as a whole.

It would, therefore, be simply unhistorical to expect a school of abstract painting to have emerged from these experiments made between 1913 and 1916. But if we are to detect a fairly massive condensation and dramatisation of formal issues in these works, then it is reasonable to ask what such experiments achieved. Certainly these are paintings which allowed both artists to clarify their thoughts on art at a crucial moment in their respective careers. As a result of this collaboration they subsequently drew closer together than ever before, in the establishment of an extraordinary lyrical English Post-Impressionist style. But more important still, we can detect an eventual return to a kind of conceptual division of artistic labour which ensured that they increasingly retained the abstract mode for traditional decorative purposes –

c6, c9,
c15

right
94 Duncan Grant, *The Tub*, 1919,
woodcut, 10.8 × 18.4cm (4¼ × 7¼in).
The Victoria and Albert Museum, London.

below left
95 Roger Fry, *Essay in Abstract Design*,
c.1914, oil and collage, 36.2 × 26.8cm
(14¼ × 10½in). The Tate Gallery,
London.

below right
96 Roger Fry, *Still-Life with Coffee Pot*,
c.1915, oil and painted paper, 49.6 ×
36.8cm (19½ × 14½in). Courtauld
Institute of Art.

walls, ceramics, fabrics and so on, whilst developing their easel paintings towards an ever more painterly naturalism. This new concern with volume and more sombre colouration, grew logically from what must have been a gradual recognition that the full Post-Impressionist style of the years 1914 to 1917 had specific limitations; a certain thinness of paint, and a tendency to prettify. It was this same logic which led Grant to re-paint an earlier work in 1918, adding a lemon and a jug to what had been a typical geometric abstract picture.[30]

The experience of painting the walls and furniture at Charleston and elsewhere during these years may also have suggested a new sense of what was to become respectively specific to their decorative and easel work. In many pictures from this period we may note the presence of elements which they had separated out in their abstract works. In Grant's 1919 *Venus and Adonis* the individual motifs – clouds, curtains, bedding, the body of Venus herself – are used as means to accommodate an explosive concern with pure colour, design and paint textures. But this is the swan-song of Bloomsbury Post-Impressionist painting. Both painters were henceforth to reserve the clear unadulterated primary colours and flat forms of their work since 1910, for their various decorational projects, whilst their paintings witnessed a total stylistic transformation, an English equivalent of that *'rappel a l'ordre'* which was simultaneously occurring throughout Europe.

97 Duncan Grant, *Venus and Adonis*, 1919, oil, 63.5 × 94cm (25 × 37in). The Tate Gallery, London.

8.The London Group

In his catalogue Introduction to 'An Exhibition of the Work of English Post-Impressionists, Cubists and Others', held in Brighton at the end of 1913, J.B. Manson described the gradual genesis of The London Group following the disintegration of the Camden Town Group: 'It was...felt to be desirable to extend the means of free expression thus won to other artists who were experimenting with new methods, who were seeking or who had found means of expressing their ideas, their visions, their conceptions in their own way. For this reason the London Group is being formed. More eclectic in its construction, it will no longer limit itself to the cultivation of one single school of thought, but will offer hospitality to all manner of artistic expression provided it has the quality of sincere personal conviction. The Group promises to become one of the most influential and most significant of art movements in England.'[1]

The somewhat ragged conviction of this statement tells one a good deal about the origins of the London Group, which set out, as Manson implies, to scoop together the scattered remnants of Sickert's earlier groupings, together with the ascendant stars of Roger Fry's circle. Sincerity, as Stravinsky once remarked, is the *sine qua non* which yet guarantees nothing, and in 1912-13 the Modern Movement in England, as it became known, was sharply divided. For reasons that are not entirely clear, Gilman had severed his friendship with Sickert. Wyndham Lewis, whose role in this business was less than impartial, described how 'Sickert's obstinacy in not adopting the Signac palette' was 'a source of great perplexity to Gilman':[2] 'He would look over in the direction of Sickert's studio and a slight shudder would convulse him as he thought of the little brown worm of paint that was possibly, even at that moment, wriggling out onto the palette that held no golden chromes, emerald greens, vermillions, ONLY, as it of course, should do. Sickert's commerce with these condemned browns was as compromising as intercourse with a proscribed vagrant.'[2] Gilman, we are told, simply saw Sickert's work as 'dirty'.[3]

This criticism is less than fair to either artist. Sickert had always been a colourist, though his own colour sense was tempered by his concern for draughtsmanship. It seems likely in the circumstances that Lewis had been attempting to corral Gilman into a new grouping, together with their old friend Spencer Gore. Gore was certainly used rather shamelessly by Lewis as a pawn in his own dealings with Roger Fry at this time. Fry had opened his Omega Workshops in London in July 1913, with the aim of extending the principles of Post-Impressionism to applied art. The Workshops had scarcely opened when Lewis issued a round-robin, signed by Frederick Etchells, C.J. Harrison, Edward Wadsworth and himself, all of whom had been working at the Omega Workshops, charging that Fry had 'secured the decoration of the Post-Impressionist room at the Ideal Home Exhibition by a shabby trick and at the expense of one of their members, and an outside artist – Mr. Spencer Gore.' Quentin Bell and Stephen Chaplin have explored this 'rumpus' in some considerable detail.[4] It seems reasonably clear in retrospect that the Daily Mail, who organised the Exhibition, had been casting around for modern artists in order to create some kind of 'Modern Art' sensation, along the lines of the 'Cubist House', with furniture designs and so on, shown at the Salon d'automne of 1912, and had asked both Lewis and Fry to be responsible for different aspects of the projected installation.[5] Fry had no idea that Lewis had been thus contacted, as he explained in a letter to Gore: 'I did not doubt your word, but had no knowledge of any request that he [Lewis] should do the

c18

98 Mark Gertler, *Merry-Go-Round*, 1916, oil, 142 × 190cm (56 × 74¾in). Ben Uri Art Gallery, London.

decorations as separate from the Omega. We should scarcely have thought of undertaking it if that had been the condition as the Omega produces its work anonymously and would not expect to have the work distributed beforehand amongst the various artists.'[6] Fry concluded: 'I have tried to treat Lewis with every consideration but I fear nothing I can do comes up to his ideal of what is due to him.' Quentin Bell concludes: 'With the wisdom of hindsight of a historian it is easy to see that Fry was mad to have anything to do with Lewis or Lewis with Fry.'[7]

What this sorry tale does illustrate is the determination on Fry's part, like Sickert, to bring together parties who might in the ordinary run of affairs have seemed unlikely allies. It also shows Lewis' equal determination to wreck Fry's Omega co-operative from the outset, just as he seems to have set out to wreck Sickert's circle and in the same way that he was to walk out on the Grafton Group in 1913 soon after it had been reorganised by Fry as a kind of Fine Art equivalent to the Omega, at which members' work was to be shown anonymously, as at the first Exhibition at the Alpine Club Gallery in March.[8] Under such conditions Lewis lacked that power to bind and loose which was apparently so important to him. Hence his takeover tactics throughout this period. Certainly any question of anonymity, so dear to Fry,[9] was totally irreconcilable with Lewis's views on the nature of art and the status of the individual artist.[10]

60

The original members of the Camden Town Group were in a state of some disarray. None of the three Group Exhibitions at the Carfax Gallery had made any money, and in the course of 1913 various members exhibited independently.[11] Throughout 1912, though, 'a London Group' had been meeting at Sickert's 19, Fitzroy Street studio, where the public was invited 'to call in an informal way and become acquainted with its pictures and its members'.[12] All this sounds very much like the situation back in 1908 which had led up to the foundation of the Camden Town Group and, as before, discussion tended to round upon the lethargic state of the NEAC. Thus a decision was made, on 15 November 1913, to form a new association, including women and sculptors, which Jacob Epstein insisted should be called 'The London Group'.[13] The members of the original Camden Town Group may have preferred to see this as an 'enlargement' of their group and its aims, but it was in fact a tacit acknowledgement that the old avant-garde model of a small, closely-defined group was no longer strictly relevant to the situation of artists in England. In this context Wyndham Lewis's 'Vorticist Group', formed in 1914, must have looked somewhat old-fashioned to well-seasoned campaigners such as Sickert, Gore, and Fry. Ezra Pound's claim that 'a school exists when two or three young men agree more or less, to call certain things good'[14] must have smacked to them of a kind of Romantic historicism, rather than the sharp electrical crackle of 'modernity'.

It was this re-constituted version of the Camden Town Group which was responsible for the exhibition held in Brighton at the end of 1913. By this time it must have been apparent to Sickert at least that a change in the rules concerning membership could in no way assuage his fundamental differences with Lewis and his cadre of ex-Omega Workshop members, since it was precisely this opposition which had determined the fate of the Camden Town Group in the first place. To this extent the nominal origins of the London Group constituted a kind of false dawn. Thus it was that Sickert could exhibit

99 J. Epstein, Study for *The Rock Drill* (Front), c.1913, charcoal, 53.5 × 64cm (21 × 25in). The Tate Gallery, London.

with a loose coalition of English artists in October 1913 in London[15] and involve himself with the foundation of the new group. However, early in 1914 he resigned from the London Group, ostensibly out of disgust with the work of Lewis and Epstein which he reportedly found 'pornographic'. Two other important factors may well have contributed, though. Spencer Gore died of pneumonia on 26 March, and with him Sickert lost his closest friend and ally; this friendship must have been particularly important to him since his break with Gilman. And at the same time Sickert's own work was changing. In response to Gore's painting in particular, he was lightening his palette and painting, like Gore in 1912-13, entirely from sketches. From this point Sickert may himself be properly considered a Post-Impressionist, establishing that practice of working from squared-up drawings, with a much more careful regard to the formal lay-out of his pictures, as in *Army and Navy* (1914).[16]

But the picture which most clearly illustrates the change in Sickert's technique is *Ennui* of which there are several versions, the brightest and most

100 W.R. Sickert, *Army and Navy*, 1914,
oil, 50.8 × 40.7cm (20 × 16in). Bristol
City Art Gallery.

fully resolved of which is in the Ashmolean Museum, Oxford. *Ennui* was
effectively a manifesto picture for Sickert. In it he proclaimed both his
continued allegiance to the realist tradition of Degas, whose *L'Absinthe* is an
obvious source, and to the new art of colour harmonies. Having thus arrived as
a Post-Impressionist comparatively late in the day, it is not surprising that he
should have found it impossible to operate in an environment which seemed
less concerned than ever with the problems of painterly technique which he
had at last resolved to his own satisfaction.[17] Thus, whilst Gilman showed his
Eating House at the first London Group Exhibition at the Goupil Gallery in *c23*
March 1914, and his *Leeds Market* in the following year, Sickert did not himself *c22*
rejoin the group, nor exhibit with it, until 1916, by which time Lewis's influence
had considerably diminished, a fact which also opened the door to Roger Fry,
who joined in 1916, followed by Duncan Grant and Vanessa Bell in 1919.

Gore's premature death deprived the London Group of the one man who
could, perhaps, have enabled it to function from its inception as the broad

alliance which it had set out to be. After Gilman's Presidency, from 1914 until his death in 1919, it continued to grow, but only sporadically.[18] This was inevitable given that heterogeneity which was the group's *raison d'être*, and given that, as Quentin Bell puts it, 'there was now a younger generation which viewed the Post-Impressionist Exhibition not as a crisis in its development but as a point of departure.'[19] It is a melancholy reflection on the continued, if inarticulate, factionalism of the period that it took Gilman's tragic death in 1919 fully to achieve that reconciliation of widely differing painterly interests which the London Group had set out to achieve in 1913. Henceforth it was Roger Fry who increasingly gave the Group its lead, a lead which was undoubtedly facilitated by the relative conservatism of Epstein and Roberts' later work, for example, together with the stylistic development of such relatively independent figures as Matthew Smith, and Mark Gertler.

101, 102

There is thus a certain irony which obtains to Fry's comment in 1928 that 'the London Group has done for Post-Impressionism in England what the New English Art Club did, in a previous generation, for Impressionism'.[20] Yet he was perfectly correct to note how 'two currents of artistic tradition' had 'flowed side by side with such mutual adjustments and interactions as became necessary from time to time'.[21] By the time the Bloomsbury painters became actively involved in the group, their own work had ceased to be Post-Impressionist in any useful sense of the term, and once more it seems a sad reflection on the period that Grant and Bell felt unable to work with the London Group in the very years, 1914 to 1919, when their work was at its most innovative and exciting. Fry remarks somewhat laconically that 'as years went on...the tendency became more and more marked to revert to construction in

101 Sir Mathew Smith, *Fruit in a Dish*, 1915, oil, 30.5 × 35.6cm (12 × 14in). The Tate Gallery, London.

depth; to abandon the essentially decorative surface organisation in favour of the more essentially pictorial effects of recession...a feeling for more rigorously planned construction, for a more close-knit unity and coherence in pictorial design, and perhaps a new freedom in the interpretation of natural colour.'[22]

The two 'currents', which had always been divided more by issues of personality than of artistic policy, were finally reconciled, but only at the expense of losing sight of that stress on the unity of the decorative and the observed which had originally characterised both groups. Grant and Bell had always preferred to work from nature. Yet it seems highly unlikely that they would have moved so quickly and so wholeheartedly into the comfortable naturalism of their easel painting in the 1920s had they not been so terribly dependent upon Fry for critical and intellectual support during the sequestered years of the First World War. It was in the early twenties, when their influence was at its greatest in the London Group, that they did indeed look most like minor School of Paris artists. The very use of the word 'decorative' in Fry's 1928 essay signifies a distinction between Fine and Applied art which was literally inconceivable within the more radical discourse of English Post-Impressionism.

103

Fry's lack of sympathy for the entire movement in art which came out of Cubism left him in a position from which he could only respond to those painters whose work most closely corresponded to the increasingly fetishised figure of Cezanne, on whom he was writing throughout the twenties.[23] In a *Burlington Magazine* Review in 1917 Fry stresses his picture of the artist in very traditional Romantic terms, as an individual, completely outside his or her society: 'Where others are shaped, he grows.'[24] For Fry, 'Cezanne realised the type of the artist in its purest most unmitigated form...a character in which everything is due to the compulsion of inner forces.'[25] Cezanne emerges as a kind of admirable synaesthetic, a figure who might have stepped from the pages of Symonds or even Walter Pater. It is impossible to say whether this extreme version of individualistic aesthetics was influenced by Clive Bell, or whether 'Art' in 1914 had simply anticipated a line of argument which was an inevitable structural development from Fry's earlier positions.

Thus, in 1917 Fry could go so far as to reject rationalism itself, in favour of a vague theory of instincts which owed something to Freud, but which also related to contemporary English Behavioural Psychology.[26] As far as his art criticism went, this reaffirmation of the 'universal truths' of European bourgeois thought is apparent in his attitude towards Jean Marchand, who was to be the very model of Fry's 'New Movement' in Art. Indeed, if Marchand had not existed, it seems that Fry could have invented him. A friend of Derain and A. Dunoyer de Segonzac, Marchand had followed the royal road of French art in the period, moving through Fauvism to a very decorative form of Cubism, such that Clive Bell could write of his 1915 Exhibition at the Carfax Gallery: 'No living painter is more concerned with the creation of form, the emotional significance of shapes and colours than Marchand.'[27] Which is only to say that Marchand was the very prototype of a certain kind of academicised, and conceptually bankrupt modernism. His neat geometric houses are painted with all the painstaking technique of Cezanne, on top of which are lain outlines which totally belie that attempt to construct space from related tones which had been Cezanne's greatest single achievement.

Yet for Fry in 1919; 'M. Marchand is a classic artist – one might almost in

102 Mark Gertler, *Self-Portrait with Convex Mirror*, 1918, oil, Leeds City Art Gallery and Temple Newsam House.

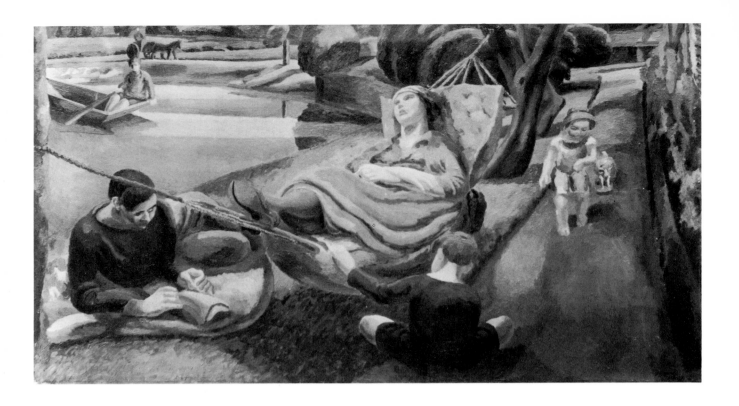

103 Duncan Grant, *The Hammock*, 1921-23, oil, 80.1 × 145cm (31½ × 57¼in). The Laing Art Gallery, Newcastle-upon-Tyne.

these days say a French artist, and count it as synonymous... M. Marchand was handicapped in any competition for notoriety by the very normality and sanity of his vision... He never tries to invent what he has not actually seen. Almost any of the ordinary things of life suffice for his theme...and he paints the objects in all their vulgar everydayness. They do not become excuses for abstract designs; they retain in his pictures all their bleak commonplaceness.'[28] This is an extraordinary and almost complete reversal of Fry's earlier beliefs. In place of the Post-Impressionist who creates form rather than imitating it, here is M. Marchand who 'never tries to invent what he has not actually seen'.

In effect, Fry had gone full circle, from one academicism to another. In a letter of 1919 he wrote of Marchand: 'He possesses that austerity and that solidity of construction which, for me, are the great qualities of the French tradition from Poussin to Cezanne. These are particularly what we lack in England, where fantasy and lyricism are all in favour.'[29] No wonder, then, that Bell and Grant received so little encouragement or support from Fry at the most critical moment in their careers. From 1919 onwards the wit and inventiveness which had so brilliantly informed their Post-Impressionist work was almost exclusively reserved for their careers as interior decorators. This tragic relapse from their previous and intensely serious questioning of the whole Fine–v–Applied Art distinction, denotes both the force and the ultimate narrow-mindedness of Fry's influence over his friends. In 1920 Duncan Grant took over Sickert's old studio at 8, Fitzroy Street, the studio which Sickert himself had taken over from Whistler. This was a move of tremendous symbolic significance. The influence of Grant's technical virtuosity was felt throughout the 1920s and 30s in the London Group, but it is surely a supreme irony that his subsequent reputation should have been made at the expense of that specifically English style of Post-Impressionism for which he, as much as anyone else, had been responsible.

104 Vanessa Bell, *Interior with a Table*, 1912, oil. The Tate Gallery, London.

105 Harold Gilman, *Study for Leeds Market*, c.1913, ink, The Tate Gallery, London.

9. Neo-Realism

Harold Gilman was introduced to Charles Ginner by Frank Rutter in 1910. The experience of his visit to Paris in that year with Ginner, and of Fry's first Post-Impressionist Exhibition, meant that Gilman 'perhaps more than most, found himself faced by a complete reorientation of all his ideas and theories of painting... From an initial admiration of Gauguin he turned finally to Van Gogh, and it is by this artist's standards that he measured all his work for the rest of his life.'[1] As we have seen, Ginner's mature style was completely established by 1911, and the relationship between the two men formed an axis within the Camden Town group which survived its protracted demise. The years 1912-14 were spent by all the ex-Camden Towners in various attempts to forge a style which could assimilate the lessons of Cezanne, Gauguin and Van Gogh without sacrificing that relation of art to lived experience which had been Sickert's great lesson: 'He had two main objects in view. One was to encourage the student to paint without nature in front of him; the other...was to help him become independent of the schools as soon as possible and find his level in the wider world.'[2] In his role as *accoucheur* to an entire generation, it was not to Sickert's discredit that in achieving his pedagogic ends, he lost his followers.

50

In *Leeds Market* and many other pictures from 1912-13, Ginner's influence in clearly apparent, both in the dry ridging and layering of paint, and the highly-organized architecture of the overall pictorial conception. However, in their use of very thick paint, applied directly from the tube, both men appeared to be working towards a style which Sickert had found to be a dead-end in his own work before 1910. The differences between Sickert and Gilman did not centre on the direct issue of colour itself, but on the manner of its application. Sickert's procedure was to add remembered local colour to a canvas which was already largely sketched in, like 'butter into granite' as he described it.[3] On this point he was completely intransigent: 'Using a rotary motion as if he were scrubbing the floor, wearing his brushes down to the ferule and sometimes, in his excitement, scratching away with the tin...he declared that the ideal texture of paint resembled "the side of a matchbox".'[4]

c22

Gilman had exhibited with Spencer Gore at the Carfax Gallery in January 1913, and the founding of the London Group did not prevent him from holding another exhibition, this time with Ginner, in April 1914. The introduction to the Catalogue of this latter exhibition took the form of an essay by Ginner, reprinted from the *New Age*, entitled 'Neo-Realism'.[5] Dr. Malcolm Easton has pointed out that the term itself was used in *The Standard* in July 1913[6] so it is safe to assume that the ideas set out by Ginner on behalf of himself and Gilman had been developed over a considerable period of time. Ginner's central thesis in this essay concerns the relationship between the artist and 'nature', which is simply 'out there'. 'All great painters' he begins 'by direct intercourse with Nature have extracted from her facts which others have not observed before and interpreted them by methods which are personal and expressive of themselves – this is the great tradition of Realism.' This Realism is seen to possess an immanent history, passed down from generation to generation 'through the dark period of the Poussins' and so on, 'and unbroken to this day by Cezanne and Van Gogh'.

Ginner's stress in consistently upon 'continued intercourse with nature' in order to avoid either 'the adoption by weak or commercial painters of the creative artist's personal methods of interpreting nature' or the creation of 'formulae'. It is in this sense that he attacks Post-Impressionism as a new

Academicism, 'disguised under a false cloak' and 'all the more dangerous since it is enveloped in a kind of rose pink halo of interest. Take away the rose-pink and you find the Academic Skeleton.' The further these unnamed artists go, 'the more they see only this formula, and, losing all sight of nature, become formula-machines.' It is hard to see who Ginner is attacking here. Both Gore *c3* and Vanessa Bell made extensive use of pink in their pictures between 1912 *c15* and 1914, but neither may reasonably be seen as formula-painters. For this reason I think Neo-Realism sets up a vague Post-Impressionist straw-man, whom it was only too easy to knock down.

Ginner sees Cezanne 'dividing the object into separate simplified planes of colour which strengthened the feeling of solidity and depth' as means to express 'his feelings of simplified nature'. In his stress on personal expression, Ginner's analysis of Cezanne is much closer to Fry than to Gore. He is hostile to Cubism as a species of 'formula', but is equally critical of Matisse, who 'hunts up formulas in Egypt, in Africa, in the South Seas, like a dog hunting out truffles... The smaller Matisse fry find it even easier, as they have not the trouble of hunting.' Ginner's sarcastic reference to the 'smaller Matisse fry' is much more direct, and clearly signifies his own hostility to Bloomsbury painting, a hostility which one can only suppose was based upon differences of painterly practice. 'The Matisse movement' he writes, 'is a misconception of Gauguin as the rest of the Post-Impressionist movement is a misconception of Cezanne.' Now this was a very easy claim to make in 1914, and at no point was Ginner willing, or perhaps able, to substantiate his criticism. It did however provide him with the semblance of a polemical framework from which he could launch his own concept of Neo-Realism.

Realism for Ginner meant the individual artist's 'personal expression of nature'. Hence the significance of the idea of Neo-Realism, as some kind of return to a 'Great Tradition'. In fact Ginner's position amounts to little more than a thinned-down version of the traditional Romantic Expression theory of art. All questions of sociology or of value are collapsed into the figure of the heroic artist who 'simply', and in some semi-mystical way, 'expresses himself'. He is hostile to Naturalism therefore, in so far as 'the Naturalist, with infinite care...copies the superficial aspects of the object before him. He sees only Nature with a dull and common eye, and has nothing to reveal. He has no personal vision, no individual temperament to express, no power of research... Art then ceases, the decorative interpretation and intimate research of Nature, i.e. Life, are no more.' This is of course very close to Roger Fry's position. It is equally close to Blake.[7] To hold that 'life in art' is to be equated with 'the decorative interpretation and intimate research of nature' was not, finally, to advance from Sickert's position, oft-stated since his return to London in 1905.

As far as Ginner was concerned, it is the function of the artist to 'interpret that which, to us who are of this earth, ought to lie nearest our hearts, i.e. Life in all its aspects, moods, and developments'. Realism, 'loving life...interprets its Epoch by extracting from it the very essence of all it contains of great or weak, of beautiful or of sordid, according to the individual temperament'. In order to achieve this historical documentary status, 'Neo-Realism must be a deliberate and objective transposition of the object (man, woman, tree, apple, light, shade, movement, etc.) under observation, which has for certain specific reasons appealed to the artist's ideal or mood, for self-expression'. Unfortunately he is completely unable to tell us anything whatsoever about these 'certain

specific reasons', and the narrowness of his inventory of objects for potential self-expression suggests the vagueness of his entire theory. There is nothing here that would have puzzled Vasari. What is important is the all-controlling picture of the artist's 'self', his or her 'temperament', magically and unequivocally in touch with its epoch.

Ginner's mystical expressionism begins to make sense however as he goes on to deal with matters of actual technique. The Impressionists, we learn, 'purified the muddy palettes by exchanging colour values for tone values, and thus strangely brought modern painting nearer to the great works of the Primitives... But with their eyes entirely fixed on this scientific study of colour and neglecting to keep themselves in relationships with Nature they began gradually to sink into the Formula Pit.' Out of that 'pit' arose Cezanne, Gauguin, and Van Gogh, 'all three children of Impressionism...with their eyes fixed on the only true spring of Art: Life itself. By this direct intercourse with Nature they brought out of Impressionism a new development by creating a personal Art and self-expression.' What Ginner objects to is an art which possesses only the quality of a sketch: 'An artist who cannot go beyond a sketch is but a poor artist... The good craftsman loves the medium and the tools he uses. The real painter loves his paint as the sculptor his marble... Furthermore, in this matter of medium, it is only out of a sound and solid pigment that good surface and variety can be got, and durability in ages to come... Neo-Realism must oppose itself to slave-ridden formula and be creative.'

This was the heart of the matter. Ginner and Gilman liked thick paint. The bulk of the theory of Neo-Realism amounts to little more than a wholesale ransacking of Romantic art theory, and in particular the letters of Blake and Van Gogh, in order to justify this taste. Sickert, who must have realized that he was the chosen, if unnamed, addressee of this rather straightforward but bulky message, replied in kind: 'Mr. Ginner is a digger. He comes to us with his hands full of honest, strenuous achievement.' Sickert then rehearses the main argument of Neo-Realism as he understood it: 'Art that is based on other art tends to become atrophied, while art that springs from direct contact of the artist with nature at least tends to be alive.' Yet he objects to the prefix 'Neo': 'It is better for a painter not to call himself "new". Time alone will show how his work will wear. He had also better not call himself a realist. Let us leave the labels to those who have little else wherewith to cover their nakedness.'[8]

'Have Mr. Ginner and Mr. Gilman reflected' he asks, 'that when they put their heads between the Sandwich boards of this or any classification, they will have to carry the blasted boards about for another thirty or forty years...?' And in another contemporary notice, entitled 'The Thickest Painters in London' he writes that he is 'inclined to think that, just at present, Mr. Ginner and Mr. Gilman attach a somewhat doctrinaire importance to the virtue of Impasto in itself... Will they look at the Gores in the N.E.A.C., and say whether that skilful, delicate, draughtsmanlike, reticent use of thick paint, that eloquent variety of touch, is not an ideal technique?'[9]

Sickert seems to have hit the nail on the head here, for Ginner and Gilman appear to have been almost self-consciously bidding for the leadership of Sickert's circle, which had fallen vacant with Gore's untimely death. The whole debate around Neo-Realism was extremely narrow. Gore's later work exemplifies the strongest and most characteristic aspects of English Post-Impressionism painting from drawings and oil-sketches: such works as the 1914 *Still-Life*, the *c1*

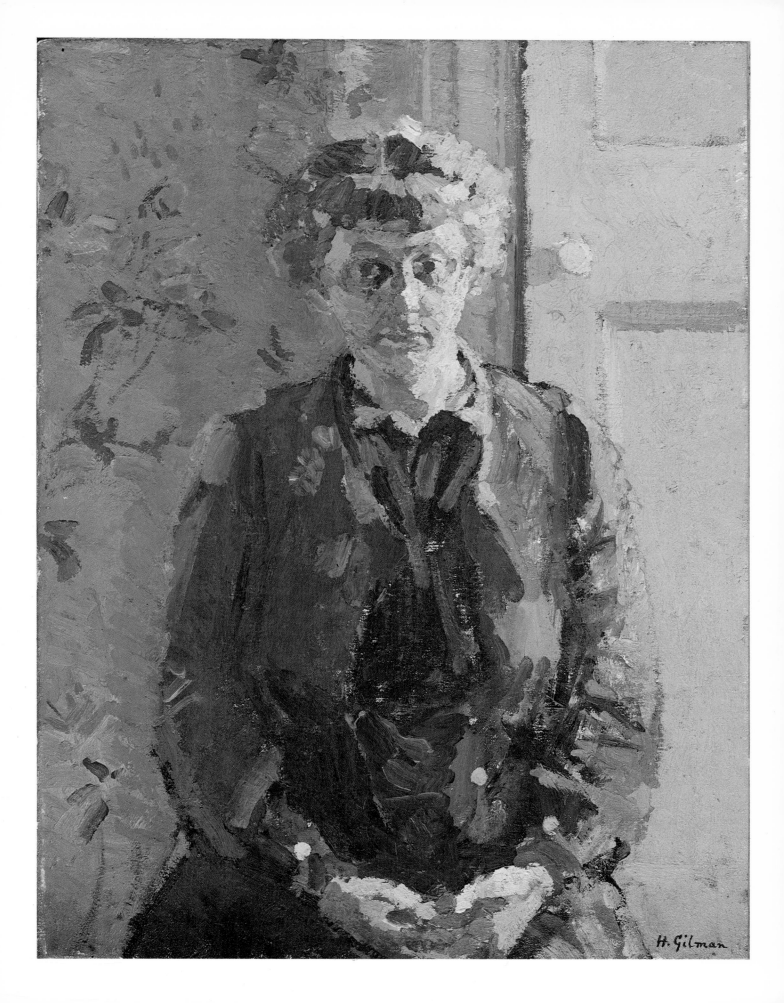

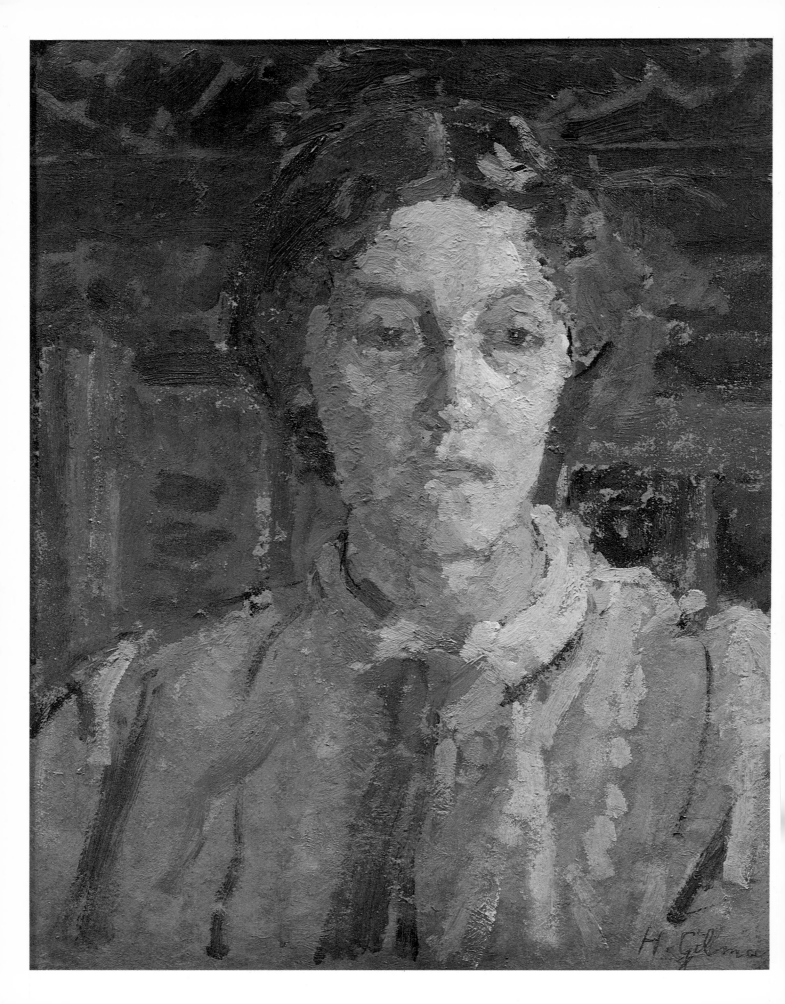

Self-Portrait and *Portrait of Mrs. Gore* and the various Richmond pictures fall 107, 106
almost entirely within the general range of Neo-Realism, save in the one vital
respect – that paint is used thinly, with none of that three-dimensional quality
which offended Sickert's sense of the painterly, the quality of the side of a
matchbox. There is a wonderful sense of continuity about these pictures: just
as in the *West Pier, Brighton* of 1913, the artist employs a technique of cutting-
off a corner in such a way as to emphasise the fundamental flatness of the
canvas, and to hold together the entire design which, as in so many of his earlier 24
works, opens up like a flattened-out fan. At the same time the device defines
us, the audience, in relation to what we are actually seeing. In this sense we may
note a consistent set of pictorial strategies on Gore's part, from the role of the
balcony staircase in *At The Alhambra* to the role of the country track in *The* c4, c3
Cinder Path and the roles of roads and pavements in his *Cambrian Road* 108
paintings. It was this tremendous decorative gift, of simplifying his overall
design without sacrificing any of the subtleties of handling or colour relations
on which his art so depended, that he bequeathed to painters like Robert
Bevan, in whose hands the technique ultimately became a mannerism, to the
extent that the process of simplification tended, especially in his later 109
lithographs, to become mechanical and reductive.

In *The Beanfield* (1912), this process is taken to its logical extreme, a picture 110
which stands to Gore's career rather as Vanessa Bell's 1914 *Abstract* stood to c13
hers. Gore was no more likely to have become a totally non-figurative painter
than was Vanessa Bell. In *The Beanfield* however, we may see Gore separating
out the elements of his art, the infinitely subtle secondary tones of purple,
russet, and olive green, in such a way that the *Still-Life* of 1913 comes as no c1
great surprise in itself. What is perhaps surprising at first sight is the
tremendous similarity between Gore's last few paintings, and the contemporary
work of Vanessa Bell and Duncan Grant. I say 'perhaps' rather carefully, for
such resemblance is only to be expected between painters who have assimilated
similar sources in French art to a shared British background. From the
ravishing technique and colour harmonies – blues, mauves, greens – of Gore's
last Richmond Park paintings[11] one may sense the full extent of the tragedy to
English painting of his death.

In a very moving yet restrained obituary, Sickert noted the power 'of glad
and grateful assimilation...throughout the short years into which he crowded
the sane experiences and ordered achievements that are given to few men of
long life to accumulate.'[11] Anyone who is remotely interested in either Sickert
or Gore should read it in full. 'The artist' he writes 'is he who can take a piece of
flint and wring from out of it drops of attar of roses.'[12] It was Gore's controlled
use of lightly scrumbled paint which survived in the work of Malcolm
Drummond. With its strong emphasis on vertical blocks of colour, Drummond's
work once more recalls Bloomsbury painting, as in *The Doorway, The Desk* and 55, c20
Backs of Houses, Chelsea, all of which date from around 1914 and anticipate his 111
later, more abstract style of the early 1920s. 112

Ironically, it was Ginner himself who became trapped within a 'formula', one
which, with his dogmatic adherence to the mosaic technique of tightly-crusted
brush strokes, had worked very well as long as his subject matter was strong
enough to sustain its laborious fabrication. Yet there was in Ginner some fear
of being led astray, of being 'untrue' to nature, which led to a certain
dehydration of the very craft which he perhaps loved almost too well, losing

facing page
Colour 26
Harold Gilman, *Portrait of Mrs Whelan*,
c.1911, oil on board, 38.7 × 31.8cm
(15¼ × 12½in). The Fine Art Society.

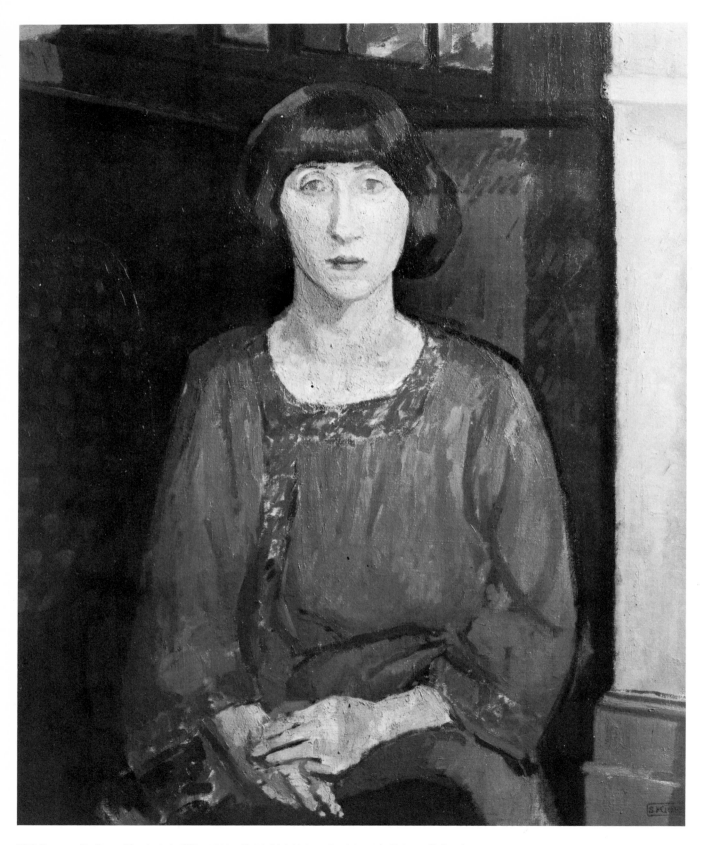

106 Spencer F. Gore, *The Artist's Wife*, 1913, oil, 76.2 × 63.5cm (30 × 25in). Private Collection.

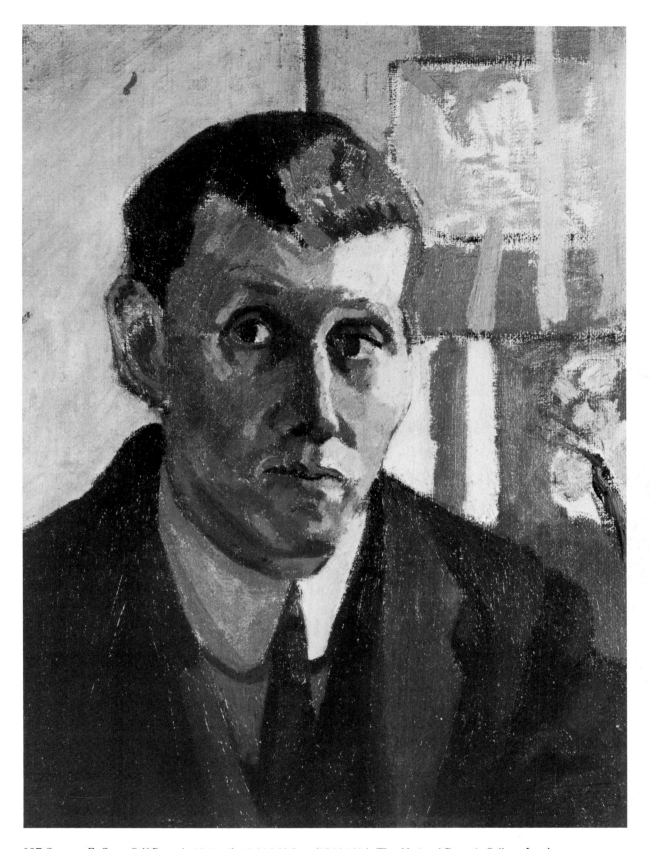

107 Spencer F. Gore, *Self-Portrait*, 1914, oil, 40.6 × 30.5 cm (16 × 12 in). The National Portrait Gallery, London.

108 Spencer F. Gore, *Cambrian Road, Richmond*, 1913, oil, 40.6 × 50.8cm. (16 × 20in). Private Collection.

109 Robert Bevan, *The Plantation*, 1922, lithograph, 30.7 × 35.5cm (12 × 14in). P. and D. Colnaghi and Co. Ltd.

110 Spencer F. Gore, *The Beanfield*,
1912, oil, 30.5 × 40.6cm (12 × 16in).
The Tate Gallery, London.

111 Malcolm Drummond, *Backs of
Houses, Chelsea*, c.1914, oil, 56.5 ×
66.1cm (22½ × 26in). Southampton City
Art Gallery.

112 Malcolm Drummond, *Coconut Shy*, c.1920, oil, 83.9 × 122cm (33 × 48.2in). Leeds City Art Gallery, and Temple Newsam House.

sight of individual objects in a vision where a house became only the sum of its bricks, a roof the sum of its slates. The result, in his later work, is a tendency towards a certain heaviness of texture, which at its worst could be simply pedestrian, as in *The Barges, Leeds* (1916) and at its best possesses a quite 114 magical quality – the result of the sheer doggedness of his determination to express his passionately private sense of reality. 113

Unlike Gilman, Ginner never had to un-learn an earlier style, let alone one in which he had been exceptionally fluent. Yet in a sense Gilman never entirely forsook that abstract pleasure in open brushwork which was the measure of his 28 early debt to Whistler. Throughout his later work, and in particular in his

drawings, one notes the same almost obsessive love of making marks as an end in itself. In these drawings he opens out Van Gogh's example of constructing tonal values within a specific range – by now his own vocabulary – of individual pen-strokes, into an altogether more abstract domain which at the same time is steadfastly attached to a highly singular range of subject matter. This process of strictly tonal construction allowed him that distance from the original motif which was the pre-condition for his particular approach to painting. Sometimes these drawings are filled in to the point of absolute textural saturation, as if he couldn't bear to leave them alone, like many of Giacommetti's sculptures. In the drawing for the Liverpool version of *Mrs. Mounter* from 1916, he has 115
literally scratched through the paper to regain the sense of form which had been lost in the intensity of his attack. Another series of seascape drawings, from 1917, show him in a different light. Here the sea itself exists as only 116
the slenderest of pretexts, on the basis of which he could experiment with the relations of different kinds of marks, very much as Duncan Grant had done in a

113 Charles Ginner, *Early Morning – Surrey (Oxted)*, 1917, oil, 50.8 × 61cm (20 × 24in). Southampton City Art Gallery.

different context altogether in his 1914 scroll. In their exquisite yet exhilarating balance of decorative and descriptive intent, these drawings summarize and exemplify English Post-Impressionism at its best.

In 1914 he took over Gore's classes at the Westminster School of Art, and also, with Ginner, opened a short-lived school of his own in Soho, an enterprise very much along the lines of Sickert's numerous expeditions into art education.[13] All of Gilman's later work reveals the same love of pattern and texture which has been noticed in his drawings. Louis Fergusson told a story of Gore pulling out one of Gilman's still-lives from the rack at 19, Fitzroy Street *c24* and declaring 'Gilman's breakfast!'. Fergusson continues: 'That was what Gilman liked painting – the intimate subject immediately to hand. He surrounded himself with objects that soon took on the character, even in his temporary Camden Town apartments, of household Gods, and then he set himself lovingly to painting them... He gloried in the wall paper of his sitting-room at Maple Street'.[14] This may be seen in *Tea in The Bedsitter*, 1917, *117* painted at Maple Street, in which the brilliant blue and red paper dominates the entire picture, being picked out in the flesh tones of the two women just as in his portrait *Sylva Gosse* (1913) the same type of paper had served an *c25* identical function.

114 Charles Ginner, *The Barges – Leeds*, 1916, oil, 50.8 × 68.6cm (20 × 27in). Southampton City Art Gallery.

115 Harold Gilman, *Mrs. Mounter*, 1916, ink, 28.6 × 18.4cm (11¼ × 7¼in). Ashmolean Museum, Oxford.

In 1916 he painted a series of woodland scenes which seem to relate directly 118 to Gore's 'Richmond Park' series and Letchworth landscapes, in which the 124 painting is much more tightly controlled, individual forms dissolving into one another in a manner which is far closer to Cezanne than any of his previous work. This scaling down of his brush-strokes is also apparent in his most celebrated pictures – the 1916-17 portraits of *Mrs. Mounter*[15]. He confided to c27 Fergusson that 'one of his greatest ambitions was to create a character in painting, or rather to seize the essence of a character in real life and exhibit it on canvas in all its bearings and with all the resources of his technique'.[16] This is

opposite above
116 Harold Gilman, *Seascape, Canada*, 1918, ink. Ashmolean Museum, Oxford.

118 Harold Gilman, *Beechwood, Gloucestershire*, c.1917, oil, 50.8 × 62.4cm (20 × 24½in). City of York Art Gallery.

opposite below
117 Harold Gilman, *Tea in the Bed Sitter*, c.1916, oil, 70.5 × 90.8cm (27¾ × 35¾in). Kirklees Libraries and Museums, Huddersfield.

clearly what Neo-Realism meant to Gilman, a straightforward Expressionist theory of art, which might justify – if justification were necessary – his intense painterly dramatisation of personal experience, working entirely from sketches and memory, and as directly as possible. Mrs. Mounter was Gilman's landlady for several years at the end of his life, and her somewhat truculent features appear in many of his pictures of this period. He may have broken entirely with Sickert's technique, but the majestic portraits of this battered old woman, surrounded by the lares and penates of the tea table provide us with the most eloquent evidence of Sickert's enduring influence on Gilman's outlook as a painter, however much that influence may have been mediated through the letters and portraits of Van Gogh.

One small watercolour in the Ashmolean Museum, again of Mrs. Mounter, shows Gilman seemingly experimenting with what amounts almost to a Vorticist technique. The result is not entirely satisfactory. Gone is all trace of that marvellous strength of line, replaced by a severe geometric patterning which suggests that, had he lived, he might have moved on towards a kind of post-Cubist decorative Expressionism along the lines of Kirchner.[17] But this is

119

mere speculation. However much he and Ginner may have wished to identify themselves as Realists, there is no doubt that their work is only comprehensible within the framework of the English Post-Impressionist movement, of which Gilman remains a central and archetypal representative.

Gilman died as a result of the Spanish Influenza epidemic early in 1919, leaving only Drummond, Bevan and Sickert as central survivors from the original Camden Town Group. In the 1920s William Ratcliffe virtually gave up painting in oils, which only shows the extent of his dependence upon Gilman in particular for support and inspiration. Drummond worked prolifically throughout the twenties, exhibiting regularly with the London Group, but remaining something of an outsider, although he also taught at the Westminster School of Art at the end of the decade. Drummond had no one-man exhibition in his entire lifetime, and the extreme critical neglect into which his work fell until very recently[18] is a strong indication of the dominance of a certain avant-gardist view of English Art History which could not accommodate any of the artists under consideration here. Robert Bevan had briefly formed an exhibiting

119 Harold Gilman, *Interior with Mrs. Mounter*, c.1917, watercolour. Ashmolean Museum, Oxford.

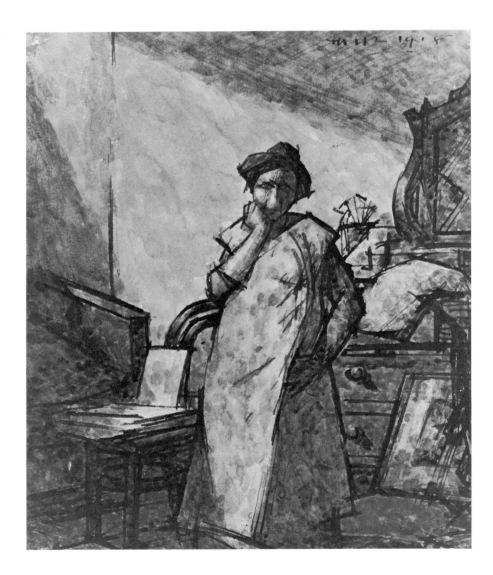

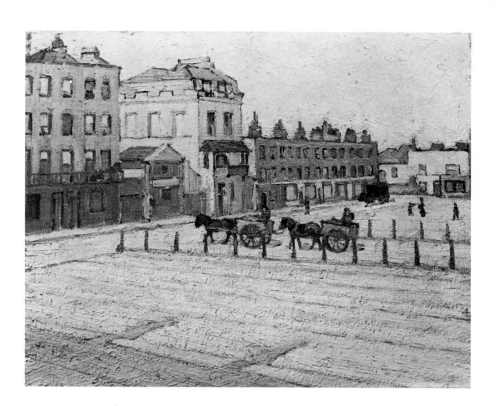

120 Robert Bevan, *Cumberland Market*, 1914, oil, 51.4 × 61.6cm (20¼ × 24½in). Southampton City Art Gallery.

group in 1915, based upon the studio which he had rented in 1914, from which the 'Cumberland Market Group' took its name. This in effect was little more than a private gallery, at which Gilman, Ginner, Nevinson, McKnight-Kauffer, John Nash and others showed their pictures, along the lines of the old Fitzroy Street Group. But Bevan lacked any inclination to lead a 'Group' in Sickert or Gilman's sense of the word, and any such need for a formal organisation was, in any case, already satisfied by the newly-formed London Group. Like Ratcliffe, Bevan does not seem to have been to be able to move forward into the twenties, and his later work, up until his death in 1925, does little more than plagiarise from his 1917-18 style, which itself derived so clearly from Spencer Gore's late street scenes.

120

121
108

It is only too easy to forget that the experience of the First World War was quite as traumatic as that of the Second. The very concept of 'The Great War' – the War to End Wars, marks the decisive symbolic break with the past, effected in the years between 1914 and 1919. In the name of Heartbreak House, Shaw mercilessly exposed the pretentions of 'cultured, leisured Europe before the war', a society in which 'nice people...hated politics. They did not wish to realize Utopia for the common people: they wished to realize their favourite fictions and poems in their own lives', a society in which 'power and culture were in separate compartments'.[19] But then 'nice people' had not wanted to buy Post-Impressionist pictures. English Post-Impressionism had from the outset defined itself as an oppositional tendency, however unclear its sense of its own oppositional standing may have been. But there was no way in which it could maintain its sense of identity and audience at a time when the social order from which it had sprung seemed to have been shaken to its foundations.

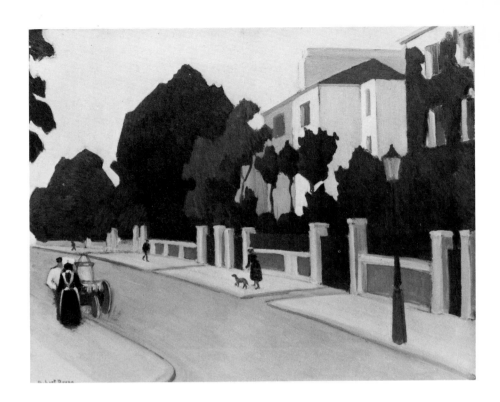

121 Robert Bevan, *Queen's Road, St. John's Wood*, 1918, oil, 50 × 60cm (19½ × 23½in). Ashmolean Museum, Oxford.

122 Duncan Grant, *Self-Portrait*, c.1917, pencil, 26.7 × 23.5cm (10⅝ × 9¼in). Private Collection.

The position of the artists at this time seems to have been much closer to that of Virginia Woolf in the 1930s, recognizing that the necessary radical changes in social structure which she looked forward to, could only be realized at the expense of the very culture within which her own writing had value and meaning, than to men like Lewis or Clive Bell, who simply plunged headlong into reactionary politics. Thus for many painters, including Vanessa Bell and Duncan Grant, a crucial opportunity was lost to adapt Post-Impressionism to what was indeed a new age, together with their own previously clear self-images as artists. Both of them had come to accept Fry's rejection of the importance of subject matter lock, stock, and barrel, together with his rejection of abstraction, to the extent that they denied any relevance to issues of content, and were seemingly unable to see how crucial it had been in their earlier work. This was particularly the case with Vanessa Bell, who, in the darkening of her palette and generally timid approach to matters of subject, appears to have preferred to follow Grant mutely and uncritically into painterly reaction. Her courage failed.[20]

Vanessa Bell came from a very limited cultural background. Like Grant, she was also to some extent the victim of uncritical praise from her immediate circle of friends, whilst remaining at the same time hyper-sensitive to criticism. It seems a terrible irony that Fry, who had done so much for the cause of an independent, catholic, modern English school of painting should have been the man who so decisively misunderstood and misdirected its two ablest exponents. Only in their private decorative projects did the spirit of Post-Impressionism survive, and that at the cost of returning to a rigid distinction between Painting and Design which their finest work always denied.[21]

10. The Iconography of English Post-Impress ionism

'Iconography', wrote Erwin Panofsky, 'is that branch of the history of art which concerns itself with the subject matter or meaning of works of art, as opposed to their forms.[1] This easy distinction which Panofsky draws between 'subject matter or meaning', and 'forms', is a central feature of the methodological orthodoxy of twentieth-century Anglo-American art history. What is less apparent is the full extent to which this methodology is steeped in values which were established and codified during the First World War period by Roger Fry and Clive Bell in the name of Post-Impressionism.

The main thrust of their arguments, as has been shown, took pains to distinguish between the idea of imitative art, and art which conveys and contains some specific autonomous level of meaning, variously described as the 'aesthetic emotion', 'pure form', or, by Bell, 'significant form'. This involved the straightforward collapsing of all issues of subject matter and value into the ancient metaphysical concept of 'form', a distinction which carried over a host of associated ideas from Fry's earlier writings, concerning the function of art in society, and its supposedly intrinsic and historically transcendent, or timeless, value. This theory of art was presented above all in relation to the work of Cezanne. At this point a canonical theory of art history emerges: 'Painting had become in the course of centuries either a more or less photographic record of natural appearances, or a kind of decorative illustration of literary themes. Since Cezanne it has sought to express emotion, not so much by calling up in the spectator's mind the images of actual things, as by the revelation of such fundamental qualities of the visual world as volume, mass, and space. To these it has added a new use of colour.'[2]

This then was the contradiction in Fry's situation. He had developed a theory concerning the idea of a 'pure', 'disinterested' art, which derived largely from the Aestheticism of the 1880s and 1890s. In Cezanne he found the seeming personification of his own polemic against the popular anecdotal painting epitomised by the Royal Academy. From his defence and championing of Cezanne he went on to advocate a freedom of expression which amounted to an attack on figurative painting as such.

It was this second theory of Post-Impressionism which was used to describe the work of Picasso and Matisse – the former appearing to Fry as an 'abstract' artist, and the latter as a kind of formal symbolist, seeking 'equivalents' to life, rather than likeness. It was in this spirit that he conceived of the Omega Workshops, which, as it were, set out to institutionalise his implicit attack on the validity of any absolute distinction between 'Art' and 'Design'. This was the most radical position reached within the framework of the concept of Post-Impressionism, and it was simultaneously achieved by another group of painters altogether, who had followed Sickert's injunctions against any tendency to separate issues of style and subject matter to their logical conclusion.

At this point a broadly-based style of English Post-Impressionism became consolidated, a style which mediated the work of Cezanne, Gauguin and Cezanne, as well as Picasso and Matisse, to a strong local tradition of tonal painting and mildly realist subject matter. This local tradition was itself divided between a concern with the abstract qualities of paint itself, and the problem of producing pictures which might relate to a wider audience than the various secessionary organizations of the day, such as the New English Art Club, could tolerate. The technique of monochrome tonality was exchanged for

c8, c17
c21

a new art of related colour tones, with a greater or lesser degree of formal simplification.

A period of intense experimentation followed, in which painters like Spencer Gore, Harold Gilman, Vanessa Bell and Duncan Grant felt free to separate out the various elements of their craft as painters, sometimes reaching the point of total abstraction. But, as I have stressed, there was no question within the practical or conceptual framework of English Post-Impressionism of a meaningful division being established between figurative and non-figurative painting. For one thing English aesthetics lacked almost entirely that semi-religious aspect which in France or Germany could make an entire universe of an abstract picture. Thus Spencer Gore could write enthusiastically of Kandinsky in 1910: 'The design is almost entirely one of colour, the forms scarcely explaining themselves, and the colour is so gay and bright, pitched in so high a key as to appear positively indecent to the orderly mind of the Britons. Turner must have had some such idea in his head when painting the Interior now in the Tate Gallery.'[3] There was no question here of the 'Spiritual' in art: rather, Kandinsky, like Picasso and Matisse, was accommodated to a specifically English point of view.

Roger Fry's position concerning the role and interpretation of subject matter was, however, deeply ambiguous. His general position implied a total indifference to subject matter, save as a vehicle for expressing 'pure form'. It soon became apparent though, that he could not sustain this theoretical position with regard to his own painterly practice, and representation was gradually re-admitted to his aesthetics by a series of surreptitious moves, which culminated in a direct rejection of Cubism and its subsequent developments, on the grounds that it was literary, concerned with ideas as opposed to 'pure form', and was therefore a new species of 'pseudo-art'. Hence the paradoxical situation in which he became trapped, defending an art of 'formal' values, which could only be actualised through representational means. In the final analysis he was unable to move forward within his own model of history, which was effectively consumated in the projective person of Cezanne, just as Ruskin's model of history had been consumated in the person of Turner.

Representation was thus acceptable, even necessary, for Fry, as a pre-emptive defence against the seeming excesses of modernist art. At the same time, however, he could not allow any attention to be paid to subject matter which might detract from the 'aesthetic emotion'. Thus the issue of subject matter appears as a kind of revolving door, forever vanishing out of sight as it allows one access to 'pure form', of which it is simultaneously the pre-condition and the negation.[4] It was this situation which dominated the main stream of English painting in the twenties through the London Group, whilst in America the more extreme formalism of Bell's 'Art' became a major influence, together with the writings of contemporary French aestheticians and critics such as Apollinaire.[6] By a strange irony however, the very paintings which had both derived from, and stimulated, the most radical phase of English Formalist Criticism, more or less vanished from sight at the very moment at which that school of thought began to gain a clear critical ascendency. The familiar model of modern art history, with its sharply-defined progression of 'movements', which lent canonical status to Fry's taste, possessed a fundamentalist Francophile tendency which guaranteed the suppression of all early twentieth

c13,

c1

123

facing page
Colour 27
Harold Gilman, *Mrs Mounter*, 1916, oil on canvas, 91.7 × 61.6cm (36⅛ × 24¼in). The Walker Art Gallery, Liverpool.

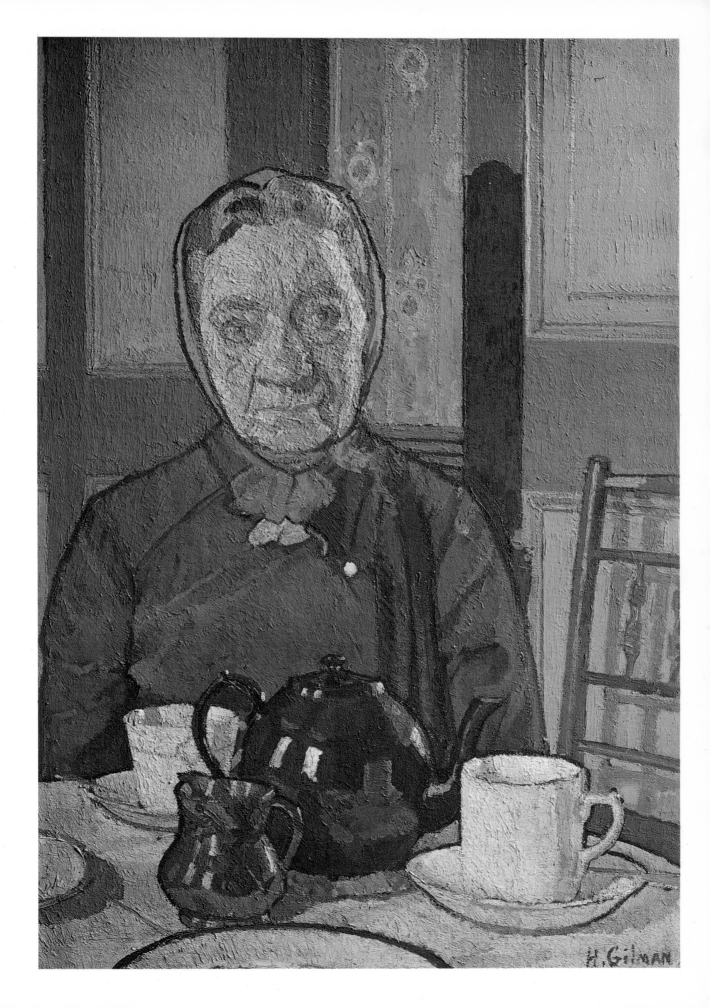

H. Gilman

Colour 28 Charles Ginner, *Leicester Square*, 1912, oil on canvas, 64.2 × 55.9cm (25¼ × 22in). Brighton Art Gallery.

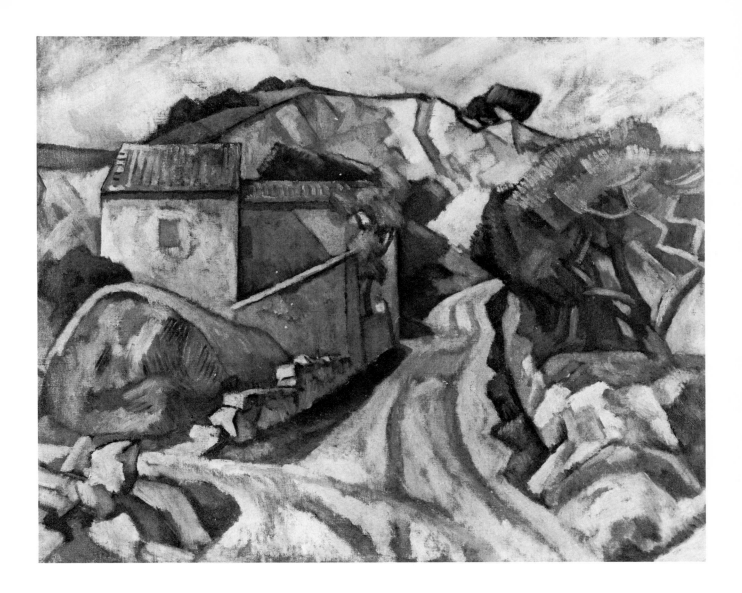

123 Roger Fry, *Landscape*, c.1913, oil, The Courtauld Institute of Art.

century English art which did not slavishly resemble that of France. At the same time this critical model ensured that English Post-Impressionism would henceforth be judged as if it were a provincial school of French painting, thus denying any notion of its own autonomy.[6]

In this way the work of Gore, Gilman, Sickert, Grant, Vanessa Bell and many others was perceived – where it was seen at all – through a conceptual filter which could only legitimate a modern art which was critically soluble in the ideas and values of Cubism, as seemingly championed by Fry before the revision of his 1912-1914 position. In this respect English Post-Impressionism has suffered much the same fate in Anglo-Saxon culture as Matisse suffered until very recently in France. They all appeared 'merely' decorative within the terms of a self-validating critical and evaluative discourse, the values of which, rooted in a crude form-v-content distinction, they themselves had totally rejected. This is nowhere more apparent than in the total inability of this school of criticism to recognise, let alone to analyse, the role of subject matter in the work of such painters. When Fry wrote of Sickert in 1911 as an

artist who 'has steadfastly refused to acknowledge the effect upon the mind of the associated ideas of objects'[7] he was establishing that norm of supposedly 'objective' criticism which has done such grave damage not only to our understanding of the art of the period, but to the possibility of any wide awareness of its very existence.

Dr. Wendy Baron has argued that 'it is on the whole remarkable how little of Sickert's personality can be interpreted from his paintings'.[8] Whilst no artist's precise intentions can ever be revealed in their work in any absolute sense, it seems strange not to comment upon Sickert's preferred range of subject matter. I do not myself believe that Sickert cared to think very much about what he painted or why he painted it. His claim that 'if the subject of a picture could be stated in words there had been no need to paint it'[9] is no more than a piece of characteristic evasion on this very topic. What mattered to Sickert throughout his career was that concern with subject matter should not override concern with technique. In his own writings his casual attitude towards painterly themes is often reminiscent of Fry, an attitude which is totally belied in his actual paintings and prints. The virtue he detected in the practice of painting anonymous paid models rather than friends would seem to suggest that his more spontaneous inclinations lay a long way from the ideal painter/model relationship of professional distance. Indeed, Sickert's passionate concern with his own subject matter is the final measure of his differences with Whistler.[10] Why, for example, should he have gone out of his way to employ the actual man who had been tried for and acquitted of the Camden Town Murder in 1907, as a model in several pictures of the same name, if he had not at some point felt the need for a peculiar kind of authenticity? The Sickert literature is full of examples of his personal friendship with his sitters.[12]

By the same token I do not agree with Dr. Baron that Sickert's titles are merely 'capricious'. On the contrary, they are indispensible guides to our understanding of his art, and his own guarded attitudes towards life. They are anything but arbitrary. Culled from newspapers, popular song, classical literature and so on, they signify a desired angle of viewing which ranges from the ironic – e.g. *Amantium Irae* and *Noctes Ambrosianae* to the frankly quotidian – e.g. *A Weak Defense, My Awful Dad, Off to the Pub*, and so on. These titles suggest that 'Dandyism *à rebours*' which William Rothenstein[12] detected in his personality, as well as his own singular *nostalgie de la boue*.

After a conversation with George Moore and Max Beerbohm he reported: 'They asked me what I liked best and I said, my own particular brand of frump.' I think it is also clear from these titles that Sickert valued ambiguity as an end in itself, hence the freedom with which he would re-name individual pictures. This cannot simply have stemmed from a desire to bewilder the scholarly art historian, but is aspective of his sensitivity to the resonances of contemporary associated meanings – what was 'in the news' – which is precisely what Fry failed to grasp.

It was this searching regard for the truth of the world as he experienced it, that Sickert communicated to his followers, in whose work the almost obsessive emphasis on sexual tension and emotional stress becomes transmuted into a less complex iconography of everyday urban life, from Bevan's fascination and love of the London horse-markets, and Ginner's sense of urban picturesque, to Gilman and Gore's more subtle evaluations.

There is, however, a certain risk attached to any attempt to portray the

100, 1

49, 53
c2

124 Spencer F. Gore, *Letchworth*, 1912, oil, 50.8 × 61cm (20 × 24in). The Tate Gallery, London.

Camden Towners as painters of modern life. Undoubtedly they wished to break decisively with the iconography of 'daintiness' from the 1890s, and the urban-pastoral mood of so much contemporary literature. Unlike Eliot's, theirs was not an 'Unreal City'. But neither was it a Realist interpretation of class struggle. Their social vision seems to have been defined by a tension of attraction and repulsion which accurately reflected their own situation as middle-class artists attempting to expand both their audience and the range of acceptable subject matter, at a time when any such attempt was interpreted as profoundly subversive.

Hence the Garden City modernism of so much of their work. It should be remembered that these artists spent much of their lives in the New Towns and Model Villages which were the early twentieth century's romantic solution to the problems of mass unemployment and gross economic exploitation.[13]

Certainly Gore painted commuters waiting on the toy-town platform at Letchworth in 1912, factories in Camden Town, and Bleriot's Monoplane in

108

125 Spencer F. Gore, *Flying at Hendon*, 1912, oil, 50.8 × 61cm (20 × 24in). Private Collection.

Flying at Hendon. Yet this in itself is hardly surprising. What should be noted is the extraordinary thematic aridity of both the English and French landscape traditions of the late nineteenth century, an aridity which the English did not import with Fauvism, as they had with Impressionism. Gore showed no interest in an ideology of modernity for its own sake. This is the decisive difference between the Post Impressionists and the Vorticists. His airmen are wealthy amateurs at their chosen pastime, and as such may be related to the conventional genre of Sporting Art rather than to fiery intoxication with machine technology per se. There is all the difference in the world between this picture and, for example, Robert Delaunay's image of the same aeroplane a year later in *The Cardiff Team*. Gore's landscape is not threatened by the grass runways. There is no sense of heroic technological achievement, let alone of technology at odds with nature. His attitude seems to have been one of mild wonder, which is utterly in keeping with the gently fantastical themes he selected from the English music-hall stage, and the many city paintings which celebrate such mundane yet pictorially fanciful subjects as the delivery of mail, and the clockwork life of London's late Victorian suburbs.[14]

This concern with the 'contemporary' as opposed to the 'modern', was tempered above all by their use of colour. It was colour which most decisively separated the English Post-Impressionist movement from anything which

125

19

c2

immediately preceded or followed it. Colour had meaning in 1910. It was simultaneously the pre-condition for the iconography of English Post-Impressionism, and a part of that iconography in itself. This much is clear from almost any writing in the period 1910-1919. Frank Rutter provides us with a useful insight into the significance of Post-Impressionist techniques at this time: 'RHYTHM was the magic word of the moment. What it meant exactly nobody knew, and the numerous attempts made at defining it were not very convincing. But it sounded well, one accepted it, one "knew what it meant", and did not press the matter further. When we liked the design in a painting or drawing, we said it had Rhythm. The pictures of Matisse had lots of Rhythm.'[15] In 1914, with colour as with rhythm, one 'knew what it meant'.

The construction of space and volume from pure colour relations allowed artists a freedom of design and of actual painterly function, which were unimaginable within the tonal conventions taught at the Slade and elsewhere. But this does not support Fry's over-simplified picture of an art based on the principles of single-point perspectival illusionism being replaced overnight by an art of free expression. What possible meaning could the word 'art' possess in these two situations, beyond an ideological imperative to regard certain objects in a certain way?

What is uniformly evident in the careers of all the individual English Post-Impressionists is the cautious and gradual assimilation of modern French painting to a local tradition which was already noticeably sensitive to issues of design and of technique considered for its own sake. The result was a compromise formation, something new. Victor Burgin has pointed out that 'in the historicist view, there is some "thing", Art, which changes while yet retaining its essential identity, these changes having a direction which may be historically charted.'[16] This was Fry's opinion, and remains an article of faith for most art historians. What should be noted in the context of English Post-Impressionism, though, is that an entirely new art practice was evolved, a practice which was at least as taken up with matters of painterly means as with those of descriptive pictorial ends. This took place with scarcely any of that sliding into closed private symbolic codes which was the fate of so much contemporary European painting.

Thus the entire conventional and technical structure of traditional oil painting was systematically dismantled and then carefully re-assembled in such a way that the artist's means of signification – paints, colour, line, tone, canvas – were no longer completely exhausted in their descriptive functions. *c11, c14 c5*
They were allowed to remain present as things in themselves, thereby stalling that taken-for-grantedness of the plastic means of painterly production which had been the dominant mode of all systems of visual representation since the Renaissance.

This is what Fry himself seems to have been struggling to articulate. He was, however, held back by his historicist model of art history which continually forced him into an analytic distinction between form and content in which he was irresistibly obliged to favour one side of this ancient metaphysical dualism against the other. Ultimately for Fry, the 'aesthetic emotion' signified a void, an absence of all other emotions, a respite from the demanding energies of consciousness. Subject matter constantly threatened to interrupt this semi-religious state of mind. Hence his censorious attitude to this aspect of his friends' work, without which it would have lacked any capacity for public

meaning. Hence his taste for an intellectually empty range of subjects – still-lives, straightforward portraiture, and so on. Subject matter was tolerated as a kind of stretcher through which 'pure form' might be materialized. As soon as it took up any traces of iconography it became 'impure'. The world might exist for the artist as far as Fry was concerned, but only as the object for a contemplative attitude which was incompatible with any degree of social meaning.

Since the work of both Vanessa Bell and Duncan Grant was particularly rich in iconographic significance this meant that he was unable to support them at the very point at which they were most themselves, in their intimate relating of a view of the world to a view of painting. It is hard to imagine how anyone could have regarded Vanessa Bell's *Bedroom, Gordon Square* or *The Tub* as mere 72, 92 exercises in 'pure form', let alone the lost *Nativity*, with a black child, which she painted in 1914.[17] Duncan Grant's early career is still more saturated with complex cultural references and symbols, ranging across an extraordinarily wide field of social experience and sexual politics. His best work always combined observation and imagination in a highly personal and often fragile dialectic. His earliest Art Nouveau-influenced drawings reveal a personality 74 which was already strongly defined by its unique iconography and formal inventiveness in the late 1890s whilst he was still at school. The concept of pure painting could only serve to impoverish the image of an artist whose work combined such a diverse variety of sources and personal experience, just as conventional criticism could never have come to terms with the 1914 Scroll.[18]

Fry's dogmatic hostility to any tendency to regard works of art as 'crystallized history'[19] confused the values placed upon them as commodities in a bourgeois society, with the idea of art as a medium of communication. His dislike of the former led him to deny the validity of the latter. As such he was unable to recognize the vital continuity of English art in this period, let alone the significance of Grant's iconographic innovations, together with the full practical consequences of his refusal to operate any absolute distinction between the traditional categories of Art and Design. In other words Fry was unable to comprehend that passionately serious attitude towards the concept and practice of decoration which so distinguishes Grant's work in this period, together with that of Sickert, Gore, Gilman, and the whole of the English Post-Impressionist movement.

No art can exist without an audience, be it real or imaginary. English Post-Impressionism was played out before an 'audience' which consisted of a concrete, if unspecific, sense of the future. When the future failed to materialize the artists were obliged, in the absence of any alternative support, to return to the surviving critical and institutional framework of the past. This phenomenon may be observed in differing degrees throughout Europe and the Soviet Union in the immediate post-war period. At a time when so much discussion is once more concentrating on the sterile distinction between figurative and abstract art, as if these were fixed and immutable categories between which, finally, choice must be made, it is salutary to think back to the implications of the one English movement in this century which dared to suggest that things might be otherwise. When, many years later, Duncan Grant asked himself[20] whether Picasso's desire to amuse and to comprehend were not perhaps aspects of the same thing, he was thinking from the very heart of those principles which determined the short but not inglorious history of English Post-Impressionism.

Notes

Introduction

1 F. Rutter, 'Modern Movements in Art', Part One, *The Art News*, 7 February 1912.

2 R. Cork, Introduction, 'Vorticism and its Allies', Arts Council Catalogue, 1974.

1. The Concept of Post-Impressionism

1 Duncan Grant. Taped interview with Professor Quentin Bell, 1960s. University of Sussex Library.

2 R. Fry to G.L. Dickinson, 15 October 1910. *The Letters of Roger Fry*, ed. Denys Sutton, 2 vols, (Chatto and Windus, 1973). Afterwards referred to as Sutton.

3 R. Fry to M. Mauron, 1 January 1921, (Sutton).

4 Q. Bell. *Roger Fry*, (Leeds University Press, 1964).

5 R. Fry to M. Mauron, 23 November 1920. (Sutton).

6 See W. Sickert's review of the First Post-Impressionist Exhibition, in the *Fortnightly Review*, January 1911. Reprinted in *A Free House, the writings of W. Sickert*, ed. Osbert Sitwell (1940). Afterwards referred to as Sitwell.

7 R. Fry, 'The French Post-Impressionists'. Preface to Catalogue of the Second Post-Impressionist Exhibition. Reprinted in *Vision and Design*, (The Hogarth Press, 1921).

8 R. Fry to M. Mauron, December 1919, (Sutton).

9 The *Athenaeum*, 1919, (*Vision and Design*).

10 G. Apollinaire, 'The Three Plastic Virtues', 1908. Reprinted in *Apollinaire on Art*, ed. L.C. Breunig, (London, 1968).

11 R. Fry, *The Art News*, 15 December 1911.

12 R. Fry to G.L. Dickinson, 18 February 1913. (Sutton).

13 Sickert, from an altogether different position, was nonetheless able, in 1910, to question the putative opposition between the words 'subject' and 'treatment'. 'Is it not possible' he asks, 'that this antithesis is meaningless, and that the two things are one, and that an idea does not exist apart from its exact expression?' 'The Language of Art', *The New Age*, 28 July 1910. (Sitwell).

14 J. Rewald, Introduction to *Post-Impressionism from Van Gogh to Gauguin*, M.O.M.A., New york, 1956.

15 W. Sickert, 'Degas', obituary essay in the *Burlington Magazine*, December 1917. (Sitwell).

16 Ford Madox Ford, *The Good Soldier*, (The Bodley Head, 1915).

17 Fry had translated Maurice Denis' famous article on Cezanne from *L'Occident* of September 1907, for the *Burlington Magazine* in January 1910. In his introductory Note, Fry observes a new tendency in French art, 'the direct contrary of the Impressionist conception'. He also observes 'a new courage to attempt in painting that direct expression of imagined states of consciousness which has for long been relegated to music and poetry.' At this time he was still toying with the idea of describing this new movement as he saw it 'Expressionism'. The analogies with music, and the use of the term 'synthesis' illustrate the development of his thinking towards the full notion of Post-Impressionism later in the same year.

18 F.S. Gore, review of the First Post-Impressionist Exhibition, *The Art News*, 15 December 1910.

19 C. Ginner, 'Neo-Realism', *The New Age*, 1 January 1914.

2. English Impressionism

1 The Impressionists' dealer, Paul Durand-Ruel, had fled the Paris Commune in the autumn of 1870 and rented 'The German Gallery' at 168, New Bond St. See Alan Bowness' Introduction to 'The Impressionists in London' Arts Council of Great Britain Catalogue, 1973.

2 'Il n'y a que la peinture qui compte.' Camille Pissarro, quoted by Sickert in a review of an exhibition of his pictures at the Stafford Gallery. Sickert adds: 'This sentence would be his complete epitaph.'

3 I am referring to Russian Formalist theories of 'making strange' or 'de-familiarising', developed by artists and poets such as Malevich and Mayakovsky, and transformed into a method of literary criticism by members of the OPAYAZ group of linguistic scholars in Moscow in 1915. The idea was also crucial to Berthold Brecht and Walter Benjamin in the twenties and thirties. The germ of their concept of 'complex seeing' is in fact already present in Oscar Wilde's observation in 'The Critic as Artist' (1891), that 'beauty is dimmed to us by the mist of familiarity'.

4 Lionel Johnson, 'The Cultural Faun', published in *The Anti-Jacobin* in 1891, and partially reprinted in R.K.R. Thornton's Introduction to *Poetry of the Nineties*, (Penguin Books, 1970).

5 T.J. Clark, *Image of the People. Gustave Courbet and the 1848 Revolution*, (Thames and Hudson, 1973) chapter one.

6 See Ralph Miliband, *Parliamentary Socialism*, 2nd Edition, (Merlin Press, 1975).

7 Oscar Wilde, *The Critic as Artist*, (1891).

8 Ibid.

9 Fry himself explains in a letter of 1927 that he 'always admired the "Soul of Man under Socialism"... [Wilde] was an exhibitionist but how infinitely nearer to some kind of truth than all the noble rhetoricians, the Carlyles, Ruskins, etc., of the day. He has a way of being right, which is astonishing at that time, or any for that matter'. R. Fry to Helen Anrep, 1927, (Sutton 595).

Fry had met John Adington Symonds in Venice in May 1891, and was undoubtedly influenced by that Aestheticism which was so much the current of his society at the time, as is apparent in many of his early paintings.

10 Sickert, 'Impressionism', *The New Age*, 30 June 1910, (Sitwell, pp. 25-28).

11 Sickert, 'The New English and After', *The New Age*, 2 June 1910, (Sitwell, pp.

57-60).

12 Sickert, Introduction to the Catalogue of the 'London Impressionists' Exhibition at the Goupil Gallery, December 1889.

13 Sir George Clausen, *Six Lectures on Painting. Delivered to the students of the Royal Academy of Arts, January 1904*, (Elliot Stock, 1904).

14 Jules Lafargue, *Oevres Complets*, 3 vols, (Paris, 1903–17).

15 R.A.M. Stevenson, *Velasquez*, (London, 1895). 'It is no exaggeration to say that for art students in the late nineties Stevenson's book on Velasquez, and particularly his chapters on Technique, became as much a Bible for the aspirant as Ruskin's writings had been for an earlier generation.' Frank Rutter, *Art in My Time*, (London, 1940).

3. The New English Art Club and the Slade

1 Sickert, 'Sargentolatry', *The New Age*, 9 May 1910. (Sitwell, pp 78-82).

2 'Saki' (H.H. Munro), 'Reginald on the Academy', *Reginald*, (Bodley Head, 1904).

3 Sickert, op. cit.

4 Vanessa Bell, letter to Margery Snowden, Spring (?) 1902.

5 Vanessa Bell, 'Memories of Roger Fry'

6 Owen Jones, *The Grammar of Ornament*, (London, 1856).

7 George du Maurier, *Trilby* (London, 1894).

8 Sickert, 'Legros' from 'A Critical Gallery', *The English Review*, March 1912. (Sitwell, pp. 238-239). The strength of Sickert's uncharacteristically direct criticism here might relate to memories of his own portrait style in the late 1890s, which seemed to have been painted directly from the model, at speed, in a manner close to Legros' Slade prescriptions. See, for example, the *Self-Portrait*, and *Portrait of Miss Ellen Heath*, Leeds City Art Gallery, (Baron, 60 and 61).

9 Quoted in Joseph Hone's *The Life of Henry Tonks* (Heinemann, 1939).

10 John Fothergill, 'The Principles of Teaching Drawing at The Slade', in *The Slade 1893–1907*, (London, 1907). Fothergill taught drawing at the Slade, and was the founder of the Carfax Gallery in 1898.

11 Ibid.

12 Andrew Forge, 'The Slade II' *Motif*, Autumn 1960.

13 D.S. MacColl, 'Augustus John', in *The Slade 1893–1907*, (London, 1907). MacColl was art critic for the *Spectator* in the 90s and a staunch supporter of the N.E.A.C. and, in particular, the work of John. John himself observed, perhaps somewhat ungenerously: 'pawky and didactic, this accomplished writer's perceptions appeared to be somewhat limited, except where Wilson Steer was concerned. When they became boundless.' (*Chiaroscuro*, 1952)

14 Augustus John, *Chiaroscuro: Fragments of Autobiography*, (Jonathan Cape, 1952).

15 George Moore, letter to Henry Tonks, quote in Hone. op. cit. (9).

16 Henry Tonks, quoted in Hone. op. cit. (9).

17 Vanessa Bell, op. cit. (5).

18 Alfred Thornton, *50 Years of the New English Art Club 1886–1935*, (Curwen Press, 1935).

19 Andrew Forge, 'The Slade I' *Motif*, March 1960.

20 Sickert, 'The Whistler Exhibition,' the *Burlington Magazine*, July 1915. (Sitwell pp.33-36).

21 W.J. Laidlay, *The Origin and First Two Years of The New English Art Club*, (The Bodley Head, 1907).

22 Sickert, 'Impressionism', Introduction to the catalogue of the 'London Impressionists' exhibition at the Goupil Gallery, December 1889.

23 Fry had entitled his first exhibition 'Manet and the Post-Impressionists', presumably to attract an audience familiar with 'respectable' French painting.

24 Sickert, 'The New English and After', *The New Age*, 2 June 1910.

25 Sickert, 'La Thangue's Paintings', *The New Age*, 7 May 1914. (Sitwell pp.270-273).

4. The Fitzroy Street Group and Others

1 Vanessa Bell, letter to Margery Snowden, January 11 1905.

2 Quentin Bell, Virginia Woolf: A Biography, (The Hogarth Press, 1972) Volume 1. p.105.

3 Virginia Woolf, 'Old Bloomsbury' (1921), in *Moments of Being*, ed. Jeanne Schulkind, (Sussex, 1976).

4 Ibid.

5 Ibid.

6 Ibid

7 Marjorie Lilly, *Sickert, The Painter and His Circle*, (Noyes, 1973).

8 Sickert 'Impressionism' *The New Age*, 30 June 1910. (Sitwell pp. 25–28).

9 Sickert, 'The Whistler Exhibition' the *Burlington Magazine*, July 1915. (Sitwell pp. 33-36).

10 Sickert, 'Where Paul and I differ', *The Art News*, 10 February 1910. (Sitwell pp. 21–22).

11 Ibid.

12 Sickert, 'The New Life of Whistler' the *Fortnightly Review*, December 1908. (Sitwell pp. 6-20).

13 Ibid.

14 'The butterfly role must be very tiring. I prefer to play the old ox myself, eh?' Degas, quoted by Sickert in an obituary notice in the *Burlington Magazine*, December 1917, (Sitwell, pp. 144-154).

15 Whistler, The Ten O'Clock Lecture, 1885.

16 Sickert, op. cit. (12).

17 See Baron, 164 – 167. (These and following references are to catalogue numbers in Dr. Wendy Baron's *Sickert*, Phaidon, 1973).

18 See Baron, 198/199/208.

19 See Baron, 181/183.

20 Sickert, Introduction to the Catalogue of the 'London Impressionists' Exhibition at the Goupil Gallery, December 1889.

21 Marjorie Lilly, op. cit.

22 John Davidson, 'Thirty Bob a Week' *Ballads and Songs*, (London, 1894).

23 Degas, quoted by Sickert in 1915 obituary notice, op. cit.

24 Marjorie Lilly, op. cit.

25 Marjorie Lilly, op. cit.

26 Sickert, letter to Nan Hudson, quoted in 'Camden Town Recalled' by Wendy Baron. Fine Art Society Catalogue, 1976.

27 Sickert, letter to Ethel Sands and Nan Hudson, ibid. The Sickert literature is littered with anecdotes and quotations concerning Sickert's desire to find a wider public for his art. 'Painters, my brothers, Codlin is the friend, not Short. Cease to look for the super-goose, for your bread. To begin with she is always overdrawn. Look in the chop-houses of the city for some pearl of an elderly businessman, florid and whiskered by preference. It is he who, in defiance of all decorative and sanitary laws, will pack the walls of his suburban villa with your works. He will deny himself a better house. He will travel second class to buy you. Four or five of him will keep you in comfort. If I may slip in a word of advice, don't offer to paint his portrait, and don't try to introduce your short-haired, aggressive and tongue-tied mistress to his wife.' Sickert, 'The Whistler Exhibition', op. cit. Unfortunately, what little evidence there is suggests that Sickert himself remained financially dependent upon affluent middle-class patrons, hence the reference to Codlin from Dickens' *Old Curiosity Shop*.

28 Walter Bayes, 'A Table at the Cafe Royal', Preface to 'The Artist and the Cafe Royal' Catalogue, July 1955.

29 Walter Bayes, 'The Camden Town Group', the *Saturday Review*, 25 January, 1930.

30 The figure on the right in this drawing is Albert Rutherston (né Rothenstein).

31 Spencer Gore, quoted by John Woodeson in his Introduction to an exhibition at The Minories, Colchester, 1970.

32 Frank Rutter, Editorial to *The Art News* no. 1. Thursday October 21 1909. *The Art News* advertised itself to be 'The only Art Newspaper in the United Kingdom'. It became the official journal of the A.A.A. in December 1909, and in this respect resembled *The New Age* which was founded by A.R. Orage as a voice for the Fabian Society on an advance of £500 from George Bernard Shaw. Both journals sold for one penny each.

33 Sickert, *The Art News*, 24 March 1910.

34 Sickert, Review of 1910 A.A.A. Exhibition, *The New Age*, 14 July 1910.

35 Spencer Gore, *The Art News*, 4 August 1910.

36 Vanessa Bell, letter to Margery Snowden, August 14 1905: 'Trevose View, Carbis Bay ...I think that my kind of painting must be done more or less directly partly because of its being thick – but also because (this is the important point) it seems to me almost impossible to get good colours by putting one layer of say grey over another layer of grey. But you can get good colour by putting one layer of grey over another of red or brown – I believe this is true and not only an idea of mine. Therefore you see as I want to have thick paint in the end my method would be this – prepare a canvas with a red ground. Sketch in the drawing in any neutral colour, then paint quite directly and leave it. If I paint the whole thing in rather quickly on a new canvas and then want, in order to get a good surface, to go over it again (for I am sure that a good surface can only be got either by quite direct and very thick paint, right at once as to drawing tone and colour, like Sargent – or by a greater or smaller number of layers) I should, by putting more or less the same colours on the top of the first painting, lose the freshness entirely. You see, my method is the same as Whistler's – only he used many more layers than I should because he painted very thinly – which I can't, nor at any rate, get myself to do. But the important thing which I believe I hadn't realised before, is that he didn't put the right colour on at once – it was probably almost a monochrome to start with, and I suppose he only got the right colour at the end.' I have slightly altered the punctuation in this letter to aid its meaning. In her closing comments Vanessa Bell could almost be describing Sickert's mature working practice.

37 Sickert, quoted by Ronald Pickvance in 'Vanessa Bell, a Memorial Exhibition of Paintings', Arts Council, 1964.

38 This picture was exhibited at the New English Art Club in 1910 as *London Morning*. It is one of only four pictures exhibited at the N.E.A.C. and the A.A.A. between 1908 and 1910. This is as close as she was to come to what one might think of as 'Camden Town School' painting.

5. The Camden Town Group

1 Louis Fergusson, 'Souvenir of Camden Town', *The Studio*, February 1930.

2 Letter from Sickert to Miss Sands and Miss Hudson, quoted in Wendy Baron's 'Camden Town Recalled' op. cit. (2).

3 Vanessa Bell, MS. 'Memories of Roger Fry', October 1934.

4 Ibid.

5 Ibid.

6 Sickert, 'The Post-Impressionists', the *Fortnightly Review*, January 1911. (Sitwell, pp. 97-108).

7 Ibid

8 Ibid

9 Vanessa Bell, op. cit.

10 Charles Ginner, 'The Camden Town Group' *The Studio*, November 1945.

11 Ibid.

12 Spencer Gore, Review of the First Post-Impressionist Exhibition, *The Art News*, 15 December 1910.

13 Ibid.

14 F. Rutter, *Revolution in Art*, (The Art News Press, 1910).

15 Sickert, op. cit.

16 Quoted in Sir William Rothenstein, *Men and Memories Vol. II.*, (1932).

17 Sickert, 'Whitechapel' *The New Age*, 28 May 1914, (Sitwell, pp. 278-280).

18 Sickert, 'Camille Pissarro' Preface to an Exhibition at the Stafford Gallery, (Sitwell, pp. 139-142).

19 Camille Pissarro, *Letters to His Son Lucien*, ed. J. Rewald, (London, 1944).

20 F. Gore, Introduction to catalogue of 'The Camden Town Group' Exhibition, Hampstead Artists' Association, June 1965.

21 Sickert, 'Whitechapel' op. cit.

22 Ibid.

23 Ibid.

24 F. Gore, 'The Camden Town Group' op. cit.

25 P. Wyndham Lewis, in *Harold Gilman: An Appreciation*, (Chatto & Windus, 1919).

26 H. Gilman, 'Note on Technique' *The Art News*, 28 April 1910.

27 F. Rutter, 'The Work of Harold Gilman and Spencer Gore', *The Studio*, March 1931.

28 P. Wyndham Lewis, op. cit.

29 P. Wyndham Lewis, op. cit.

30 F. Rutter, 'The Work of Harold Gilman and Spencer Gore', op. cit.

31 F. Gore, op. cit.

32 Showing The Alhambra music-hall, so often painted by Gore.

33 H. Gilman, op. cit.

34 *Victoria Embankment Gardens* (1912). Collection Anton Lock. Here the spontaneity of Van Gogh's giddy free-wheeling forms is uncomfortably locked within heavy outlines which relate to Art Nouveau sources and, perhaps, to Kandinsky.

35 F. Rutter, the *Sunday Times*, 9 July 1911.

36 See Dr. Malcolm Easton's 'Charles Ginner: Viewing and Finding', *Appollo*, March 1970, and Richard Morphet's 'Modernity in Late Sickert', *Studio International*, July/August, 1975.

37 Wendy Baron, 'Camden Town Recalled' op. cit. (2).

38 Baron, 382.

39 These two pictures were perhaps painted at the same time?

40 One should not forget that the Camden Town Group set out to represent 'within a fixed and limited circle those painters whom they considered to be the best and most promising of the day'. Charles Ginner, op. cit. (10).

41 Conversation with the author, 1976. Richard Shone has informed me that 'Tulips' was actually begun before Grant was elected to the Camden Town Group.

42 '...he was at that period touching the fringe of cubism, anathema to certain of the members.' Charles Ginner, op. cit.

43 There was a long review by Michael Sadler of Kandinsky's 'Concerning The Spiritual in Art' in *The Art News*,

February 7 1912, relating Kandinsky's Expressionist theories to Cezanne and the Fauves with extended quotations.

44 The Contemporary Art Society had been founded in 1909 by Roger Fry and Lady Ottoline Morrel 'to encourage by purchase and exhibition the more remarkable examples of painters who in any other country would enjoy a certain official patronage,' from the conviction that 'some of the finer artistic talent of our time is imperfectly or not at all represented in the National and Municipal Galleries'. 'Objects of The Society', 1920 Report for the years 1914 to 1919.

45 Roger Fry, Prefatory Note to Contemporary Art Society exhibition at the Manchester Corporation Art Gallery, reprinted in *The Art News*, 15 December 1911.

46 H.D. Roberts, Director of the Public Art Galleries, Brighton, 'Notice' in catalogue to an 'Exhibition by the Camden Town Group and others', 6 December 1913 to 14 January 1914.

47 J.B. Manson, Introduction to Rooms I and II at the 'Exhibition by the Camden Town Group and others'. Manson argues 'Eight years ago the then revolutionaries, the new English Art Club, had already found its respectable level; it had reached a point of safety. It was too tired or too wise to venture further. But self-complacency, whether New English or old, has never won the respect of tumultuous youth; nor have brain and brawn been bred on sponge cakes even distinguished in the pink and chocolate of the officially distinguished.'

6. Bloomsbury

1 Sickert's mother.

2 Marjorie Lilly, *Sickert, The Painter and His Circle* (Noyes, 1973).

3 Quoted in Lilly, ibid.

4 Vanessa Bell had met Duncan Grant at The Friday Club in 1905 but they did not become real friends until 1907.

5 Edward Carpenter, pioneer socialist and early champion of homosexual rights. Virginia Woolf describes Carpenter's visits to Cambridge where he 'discussed the universe with the undergraduates, made them read Walt Whitman and turned Roger Fry's thoughts to democracy and the future of England'. *Roger Fry, A Biography* (The Hogarth Press, 1940). She also quotes a letter from Fry to Goldie Lowes Dickinson describing a visit to Carpenter at Millthorpe: 'I had rather expected that he might be a somewhat rampant and sensational Bohemian. But I am most agreeably disappointed, for he seems a most delightful man and absolutely free from all affectation. The manner of life here is very curious and quite unlike anything I ever saw before, but I have not seen enough yet to form an opinion...he is quite one of the best men I have ever met, although he has given up so much for an ideal.'

25 July 1886. The portrait was shown at the N.E.A.C. Spring Exhibition in 1894 and, by special invitation, at the Autumn Exhibition of the Liverpool Art Gallery later that year.

6 Roger Fry, letter to Sir Edward Fry, 24 May 1897. (Sutton)

7 In 1894 Fry designed some furniture for J.E. McTaggart's rooms in Cambridge and in 1895 decorated Hubert Crackenthorpe's house in London.

8 The aim of the Guild, wrote Ashbee, is to 'promote good standards of workmanship and a good life for the producer...', applying 'principles of co-operation, of Trade Unionism, to the modern revival of Art and Craft'.

9 Roger Fry, letter to C.R. Ashbee, 22 October 1886. (Sutton)

10 Quentin Bell, 'The Omega Revisited', the *Listener*, 30 January 1964.

11 e.g. W.C. Lipke, 'The Omega Workshops and Vorticism', *Apollo*, March 1970.

12 Quentin Bell, op. cit.

13 William Morris, 1877 Address to the Trades Guild of Learning in London. Elsewhere he attacks the notion of Art for Art's Sake. 'A piece of slang that does not mean the harmless thing it seems to mean... An art cultivated professedly by a few, and for a few, who would consider it necessary – a duty, if they could admit duties – to despise the common herd...to guard carefully every approach to their palace of art...' *The Art of the People.*

14 Hence Fry could write: 'Despairing of the conditions due to modern commercialism it is not unnatural that lovers of beauty should look back with nostalgia to an age when society was controlled by a landed aristocracy.' *Art and Socialism* 1912. For Fry aristocracy and plutocracy amount to the same thing in so far as both may sustain patronage. The category of 'taste', however, which Fry finds an aristocratic virtue, is one measure of his own tendency to aestheticise and thus de-politicise history.

15 Roger Fry, undated Omega Workshop publication, probably 1913. Tate Gallery Library.

16 Ibid.

17 Richard le Gallienne, *The Romantic 90's* (London, 1926).

18 Roger Fry, to The Editor of the *Burlington Magazine*, March 1908.

19 E.P. Thompson, 'Romanticism, Utopianism and Moralism: the case of William Morris', *New Left Review* 99, September–October 1976.

20 Ashbee met Wright whilst on a lecture tour of the United States in 1901. In 'Should we stop teaching art?' he challenged any idea that 'there cannot be beautiful machine products, or that the beauty of the mechanical object lies in conforming to the standard of the hand-made piece'. Fry's own critique of machine technology is much more subtle than, for example, Sickert's, but nonetheless begins and ends with the question of the relation between design and social symbolism which he recognises, laments, and cannot finally comprehend, witness the celebrated description of a railway station refreshment room. Of this he can only conclude that 'one must remember that public places of this kind merely reflect the average citizen's soul, as expressed in his home'. *Art and Socialism* op. cit. Fry is completely

incapable of going beyond this crude 'reflective' sociology, which is perilously close at times to just that Palace of Art mentality which Morris detected in the Aestheticism of the 1870s and 80s.

21 Roger Fry, 'An Essay in Aesthetics' the *New Quarterly*, 1909.

22 Vanessa Bell, 'Memoir of Roger Fry', 1934.

23 For Picasso's early influences see A. Blunt and P. Pool, *Picasso, The Formative Years*, (London, 1962).

24 Sickert, 'The Post-Impressionists', the *Fortnightly Review*, January 1911. (Sitwell, pp. 97-108.)

25 Virginia Woolf, Preface to Catalogue of 'Recent Paintings by Vanessa Bell' at the London Artists Association, 1930: 'If portraits there are, they are pictures of flesh which happens from its texture or its modelling to be on equality with the China pot or the Chrysanthemum.' Compare this with Fry's 1909 'Essay in Aesthetics': 'It is only when an object exists in our lives for no other purpose than to be seen that we really look at it, as for instance at a China ornament or a precious stone, and towards such even the most ordinary person adopts to some extent the artistic attitude of pure vision.'

26 Virginia Woolf, *To The Lighthouse* (Hogarth Press, 1927).

27 Grant told the author in 1976 that he had recognised the relationship between the two pictures at first sight, adding that the Dresden Venus was the only painting ever to have moved him spontaneously to tears. 'Not', he added, 'that that is necessarily any guarantee of anything.'

28 Simon Bussy had come to England in 1901, living for a time in the house of Lady Strachey, to whom he had been given an introduction. It was there that he met the young Duncan Grant, whom he tutored, accompanying him to the National Gallery to copy the work of Piero di Cosimo and Piero della Francesca.

29 Duncan Grant, 'M. Simon Bussy's Pastels', the *Spectator*, 1908. Review of an Exhibition at 'The New Gallery'.

30 'Mobbling'. This was a term used by Duncan Grant and Vanessa Bell to refer to the rich decorative marbling technique which, in particular, he exploited so often between 1911 and 1920.

31 Grant visited Greece and Turkey with Maynard Keynes in 1910, and Tunisia in 1911. The large and colourful decorative panels beneath the frescoes by Piero della Francesca in Arezzo may have also been an important source for Grant's 'mobbling', since they are worked in a very painterly yet highly illusionistic marbling technique. Piero's loving use of such abstract painterly techniques – the effect of wood-grain, embroidered fabrics and marble – in the frescoes themselves must also have struck him on his first visit to S. Francesco in 1904.

32 These decorations are now covered by a later series in Maynard Kenyes rooms at King's College, Cambridge, completed by Grant and Vanessa Bell in 1922.

33 Vanessa Bell used the phrase in a letter to Clive Bell in January 1912.

34 The *Spectator's* Reviewer, 11 November 1911, draws his readers' attention to the influence of Signorelli: 'It makes one want to swim – even in water like an early Christian mosaic.' In the *Morning Post* Robert Ross contrasted the 'postulates of Mr. Roger Fry' to 'the archaicism of Rossetti and his followers with its abstract desire for beauty, its overcharged literary impulse, its intellectualism and aloof contempt for modernity...'. The scene 'might be recognised for "Washing Greek Vases of the Sixth Century B.C. in the Illisos"... The nude figures set you thinking of Puvis and Signorelli, not of Van Gogh or M. Matisse. The water is symbolised by wavy streaks of paint and strata of streaks such as you see in Christian Fifth Century mosaics...' Frank Rutter in his 'Round the Galleries' column in *The Art News*, also singled out *Bathing in the Serpentine*, which, 'for sheer beauty of line and colour [is] hard to equal anywhere'.

35 Matisse visited Italy with his wife early in the Summer of 1907. He, too, was particularly impressed by Piero della Francesca and Duccio. This journey stands between the two versions of *Le Luxe*.

36 In this respect it anticipates Duchamp's *Nude Descending a Staircase* of 1912.

37 In a short essay written much later in his life Duncan Grant described Picasso as an '*actor*'; 'He wants to amuse or to comprehend – the same thing? He is very much an *illustrator*. He does not have one manner. He takes all manners, even the bad, to achieve his end... He is almost never what one calls serious – except in the sense purely of "design"...' From an undated essay on Picasso in a sketchbook containing designs for the 1956 Aldeburgh Festival Production of John Blow's *Venus and Adonis*. Grant's perceptive comments on his friend's work seem singularly appropriate to his own particular genius.

7. Bloomsbury Abstraction

1 Roger Fry, 'The French Post-Impressionists' Preface to the catalogue of the Second Post-Impressionist Exhibition, held at the Grafton Galleries, 5 October – 31 December 1912.

2 Ibid.

3 Henri Doucet, 1883–1915. Fry had met Doucet in Paris in 1911 and persuaded him to come to England, where he worked for the Omega Workshops and became a close friend of both Vanessa Bell and Duncan Grant. He was killed in action in 1915.

4 See F. Rutter, 'Modern Movements in Art', Part One, *The Art News*, 7 February 1912.

5 Clive Bell, *Art*, (Chatto & Windus, 1914).

6 In this respect 'Art' prefigures many of the more dubious sentiments expressed in Bell's later 'Civilisation' of 1927, in which he carefully defends social inequality on the curious grounds that 'on inequality all civilisations have stood'. Inequality may be justified 'because to be

civilised society must be permeated and, what is more, continually nourished by the unconscious influence of this civilised elite; a leisure class is necessary. The majority must be told that the world of thought and feeling exists; must be shown, lying just behind the drab world of practical utility, a world of emotional significance. To point the road is the task of the few.'

7 Clive Bell, op. cit.

8 G. Apollinaire, 'Toujours' from *Calligrammes*, 1913: 'Who then will know how to make us forget this or that part of /the world/where is the Christopher Columbus to whom we shall owe the/Forgetting of a continent? The precise relations between the art criticism of Apollinaire, Salmon and their circle, and that of Fry and Bell, remains to be studied.

9 'I think it was William Morris who said that poetry should be something that a man could invent and sing to his fellows as he worked at the loom. Too much of what Morris wrote may well have been so invented.' Clive Bell, op. cit.

10 Neither Fry nor Bell seem to have been aware of the irony of this situation, in which they attacked the products of the one Mandarin theory of culture with yet another. In neither case is the critical concept of 'taste' related to ideology.

11 The most widespread defence of abstract art in this period tended to favour vague metaphysical concepts of 'Higher Reality' or 'Fourth Dimension' to which abstraction supposedly referred.

12 The Omega Workshops at 33, Fitzroy Square in London were co-directed by Fry, Bell and Grant from 1913 to 1919. A wide range of decorated schemes and household products were made and/or decorated by a host of young artists including William Roberts, Frederick Etchells, Paul Nash and so on, who were employed on a day-to-day basis. The Workshops thus aimed to resolve two problems – the unemployment of young painters, and the cause of modern decorative art in England.

13 The Scroll was not painted with any particular musical accompaniment in mind, although the artist was familiar with Scriabin's experimental combinations of sound and colour. The most important single source, however, is an article by Gabrielle Buffet in *Les Soirées de Paris*, 15 March 1914, in which she writes of the possibility of installing a cinema screen on which a literary text would appear simultaneously with music. 'Perhaps' she writes, 'this might be the point of departure for a completely new form of art which would no longer have any resemblance to what we have up until now called music and musical composition... We should be able to see painting abandon objective representation in order to break free into the domain of pure speculation.' Grant doodled on the cover of his copy of this edition of *Les Soirées de Paris* with surrounding designs which pre-figure some aspects of the Scroll.

Apollinaire also wrote in the *Paris-Journal* of July 15 1914, of the paintings of Survage, whose work fulfilled Apollinaire's earlier predictions of 'an art

that would be to painting what music is to literature... coloured rhythm may be compared to music, but the similarities between them are superficial; we are dealing rather, with an autonomous art having an infinite variety of resources that are peculiar to it alone...independent both of static painting and cinematographic representation... An art that...will have an infinite appeal for those who are sensitive to the movement of colours, their interpretation, their sudden and slow transformations, their juxtaposition or their separation, etc.' Grant's Scroll is the only European work I know of which so entirely fulfills Apollinaire's dream.

14 Dr. David Brown has discovered a review in the *Glasgow Herald* from 11 June 1915, of the 'First Vorticist Exhibition' in which Grant was invited to participate. 'It is intended that we take seriously Mr. Grant's two "paintings" composed of pieces of firewood stuck on the canvas and left uncoloured together with smears of paint upright in shape, put on all haphazard so far as can be judged.' Allowing for the Reviewer's prejudice one can only conclude that these were related to Picasso's constructions of the period which he had seen in Paris. At least two surviving works include (or included) three-dimensional additions – a painted bedhead now at Charleston, and a Portrait of Lady Ottoline Morrell, from which a wooden chin and a string of beads have since been removed.

15 See D-H. Kahnweiller, *Juan Gris*, (London, 1947), referred to in S.D. Lawder, *The Cubist Cinema*, (New York, 1975).

16 See, 'Robert and Sonya Delaunay', Inventaire des Collections Publiques Francaises: Paris-Musée National D'Art Moderne, 1967.

17 The artist told the author some years ago that this picture was occasioned by the death of Rupert Brooke's younger brother, with whom he shared a closer relationship.

18 Fry's distinction between two types of modern painting is closely related to Apollinaire's various typologies of Cubism throughout this period. In 1912 he wrote an article 'On the Subject in Modern Painting' in which he argued on behalf of a new kind of art 'that will be to painting as painting has hitherto been envisaged, what music is to literature... An entirely new plastic art...only at its beginnings...not yet as abstract as it would be.'

19 I am grateful to Judith Collins for pointing out to me that at least part of these decorations appear to consist of cut-out paper glued to the wall. Vanessa Bell made several collaged abstract pictures at this time.

20 See Richard Morphet, 'The Significance of Charleston', *Apollo*, November 1967.

21 In her diary entry for 2 March 1918, Virginia Woolf describes a Saturday morning at Charleston: 'Nessa, Duncan and I sat in the studio and gossiped. Part of the time we discussed art. This is what I like doing best with them. They say that there is no-one worth considering as a painter in England today...even with whom its worth discussing one's business.'

In France this is reversed.' *The Diary of Virginia Woolf, Volume One, 1915–1919* ed. A.O. Bell, (The Hogarth Press, 1977).

Vanessa Bell had also accompanied Grant and Fry to the enormous 'Sonderbund' Exhibition at Cologne in the summer of 1912, in itself a comprehensive retrospective of Post-Impressionism, grouping together the Blaue Reiter artists, the Brücke group, and most French tendencies since Cezanne, together with a special subsidiary selection of paintings by El Greco. It proved to be a direct example both for the Armory Show and Fry's own Second Post-Impressionist Exhibition. She also exhibited six pictures of her own at the 'Exposition de quelques Independants Anglais' at the Galerie Barbazanges in Paris in July of the same year.

22 Both Ginner and Gore decorated Frida Strindberg's London cabaret club, the Cave of the Golden Calf at 9, Heddon Street, Soho, in 1912. Gore had also participated in ephemeral decorative projects with Wyndham Lewis.

23 e.g. *Triple Alliance* (1915), Wentworth Hall, Leeds.

24 Charleston – the country house, a few miles from Lewes in Sussex, she moved into together with two children and David Garnet and Duncan Grant, both of whom were conscientious objectors to the War. See Quentin Bell, 'Clive Bell at Charleston', Gallery Edward Harvane Catalogue, 1972.

25 *The Tub* was painted for the sitting-room at Charleston. The model was Mrs. Mary St. John Hutchinson, who appears partially dressed in an early photograph, although it is unclear quite how she stood in relation to the finished painting. In a letter to Roger Fry of September 1917 Vanessa Bell describes the standing figure as being 'rather too like Mary' which, given Mrs. Hutchinson's close relationship with Clive Bell, may begin to explain something of the air of apprehension possessed by this picture.

26 This is a copy painted c. 1940 of the original of 1917 which was destroyed in a fire.

27 In her diary entry of 22 November 1917, Virginia Woolf describes a conversation over dinner between Clive Bell and Roger Fry at Fry's 21, Fitzroy Street studio: 'D'you know, Clive, I've made out a little more about the thing which is essential to all art: you see, all art is representative' etc., *The Diary of Virginia Woolf, Vol. I*, op. cit. In a review in *The Birmingham Gazette* of Wednesday 18 July 1917, entitled 'Artists in Revolt', a reporter summarised an address given by Fry at an exhibition of 'The New Movement in Art' which he had selected and arranged for the Royal Birmingham Society of Artists: 'Mr. Fry somewhat startled his audience by admitting a great admiration for certain aspects of the Pre-Raphaelite "decorative poetical conception of art" as reposes in Burne-Jones. But he went on to point out that the Post-Impressionist – a term which he invented but which died out after a short vogue – differed from the Impressionist of the nineteenth century inasmuch as he did not rely on suggested associations often

vague and indefinite but nonetheless potent.' By 1917, then, Fry was prepared to place the entire concept of Post-Impressionism behind him as a thing of the past.

I am very grateful to Judith Collins for showing me this Review.

28 Max Jacob, 1910. 'Cornet à Des'.

29 William Carlos Williams, 'Tribute to the Painters'.

30 *The White Jug*, Private collection, 1914 and 1918.

8. The London Group

1 J.B. Manson, Introduction to Rooms I-II of the 'Exhibition of the Camden Town Group and others' at the Public Art Galleries, Brighton, 6 December 1913 to 14 January 1914.

2 P. Wyndham Lewis in *Harold Gilman: An Appreciation*, (Chatto & Windus, 1919).

3 Ibid.

4 See Quentin Bell and Stephen Chaplin, 'The Ideal Home Rumpus' *Apollo*, October 1964, and 'Rumpus Revisited', *Apollo*, January 1966.

5 In a letter to Vanessa Bell, Mr. F.G. Bussy, the Secretary of the Ideal Home Exhibition, denied his representative had ever met or contacted either Gore or Lewis: 'The commission to furnish and decorate a room at Olympia was given by the Daily Mail to Mr. Roger Fry, without any condition as to the artists he would employ.' Bell and Chaplin conclude that 'while one official approached the Omega, another approached Gore and that Gore did indeed visit the Omega and leave a message and a book with Duncan Grant. Mr. Grant, who fifty years after the event was amazed to hear that Spencer Gore was in any way involved in the business, supposed that he might well have received and forgotten such a message.' From 'The Ideal Home Rumpus', op. cit.

6 Roger Fry to Spencer Gore, 5 October 1913. In another letter to Gore, Fry writes: 'If you believe the fantastic and gross nonsense that Lewis and co. have written about me you will not believe a word of this. But ask yourself honestly which theory is more likely, that I am an almost incredible monster not only of iniquity but of folly (for what the Devil have I to gain by it), or that there has been a quite absurd misunderstanding produced by Lewis's predisposition to believe himself the object of subtle antagonistic plots.' Roger Fry to Spencer Gore, 18 October 1913. Quoted from 'The Ideal Home Rumpus', op. cit.

7 Quentin Bell and Stephen Chaplin, op. cit.

8 At this exhibition there was a special section of pictures by Kandinsky and the American Max Weber, although neither Fry, Bell, Grant nor Etchells included paintings then or after 1914. Vanessa Bell showed five pictures and a screen at the second Grafton Group Exhibition, at which Duncan Grant also showed his *Adam and Eve*, commissioned by the Contemporary Art Society, and since destroyed.

9 In an interview with the *Pall Mall Gazette* in 1913, Fry describes his intention at the Omega: 'To get a group of young artists to work together, freely criticising one another and using one another's ideas without stint.' Referring back to the Borough Polytechnic decorations of 1911, Fry spoke of how 'they all worked together, taking their ideas from one another...and feeling so thoroughly all the time that the work was a common effort that they refused to sign the pictures...'. In fact, Duncan Grant did sign his *Bathing*, though the signature is so treated as to be practically invisible amongst the waves. Anonymity was a fundamental tenet of that idealism which stimulated the entire Omega project, as was implicit in its very name. There was no question of secrecy, along the lines of the Pre-Raphaelite Brotherhood; the whole idea related rather to an ethic of non-specialisation.

10 '...the modern world is due almost entirely to Anglo-Saxon genius – its appearance and its spirit... The nearest thing in England to a great French artist is a great Revolutionary English one.' P. Wyndham Lewis, *Blast no. 1* July 1914. And again; 'Vorticism, in fact, was what I, personally did and said, at a certain period. This may be expanded into a certain theory regarding visual art', P. Wyndham Lewis, Introduction to the 'Wyndham Lewis and Vorticism Exhibition', Tate Gallery, 1956.

11 e.g. Gilman and Gore Exhibition at the Carfax Gallery in January 1913, and a one-man Robert Bevan exhibition at the same gallery that summer.

12 Quoted in Quentin Bell, 'An Unlikely Alliance', The Sunday Times Colour Supplement, 12 July 1964.

13 Ibid.

14 Ezra Pound, *Status Rerum*, 1913.

15 Sickert contributed to the 'Exhibition of Post-Impressionist and Futurist Art' held at the Doré Gallery in October 1913, including work by Delaunay and various German Expressionists. Frank Rutter, who organised this exhibition, wrote: 'I flatter myself that I went further than Mr. Fry did in either of his exhibitions. It is not for me to speak of the quality of the exhibition, but its range was far wider than any similar preceding or following show.' *Art in My Time* (Lund Humphries, 1940). The work shown here by Lewis, Nevinson and others was the first public evidence of what was formally to become the Vorticist Group in 1914. Sickert himself appears to have been rather perversely taken with some aspects of Italian Futurism: 'One thing the Futurist Movement certainly is not, and that is immoral. Austere, bracing, patriotic, nationalistic, postive, anti-anarchistic, anti-sentimental, anti-feminist...the movement is one from which we in England have a good deal to learn.' The tone here must surely be ironic but he nonetheless goes on to argue that 'the root of the Futurist movement is health itself. It aims at creating "a contagion of courage". It would teach us that a healthy intellectual life, a healthy political life is based on active concern with the present, and the future, and not a hypnotism by the past.' 'The Futurist "Devil Among the Tailors" ', *The English Review*, April 1912 (Sitwell, pp. 108-114).

16 Quentin Bell has described the various ways which Sickert recommended to him for painting a picture in the 1930s: 'Then he told me how to paint a picture. It seemed very simple. First you discovered a nineteenth century print – not too well known or the critics will nab you. Then square it up; then paint it in monochrome. Then let it dry completely and rub it down with linseed oil and a silk rag. Then you just touch in the colour, like a girl using her lipstick.' Another way was to 'find your subject, say a house in a street. Take a taxi and drive past it, as you go memorise your subject. Of course, if you are a novice, and not good at memorising images, you can tap on the glass as you approach your motif and ask the cabbie to drive slow. Alternatively, he suggested taking a photograph and squaring it up.' Quentin Bell, 'A Short Pose', unpublished recollections of Sickert. Whilst Sickert presumably enjoyed shocking his young visitor, it seems clear that this is in fact a fairly close description of his actual working procedures. A strong case can be made that Sickert's later work, including the photo-based 'Echoes' series, exemplifies one extreme of English Post-Impressionism as it has been understood in this book. A major study of these paintings is long overdue.

17 See Wendy Baron, *Sickert*, Phaidon, 1973, especially Chapter XV: '1913–1914, Sickert's Problems with Paint – and their Solution'.

18 Elected Founder Members were Bernard Adeney, Walter Bayes, Robert Bevan, David Bomberg, Henri Gaudier-Brzeska, Malcolm Drummond, Jacob Epstein, Frederick Etchells, Jesse Etchells, Renée Finch, Harold Gilman, Spencer Gore, Sylvia Gosse, C.F. Hamilton, A.H. Hudson, Therese Lessore, Wyndham Lewis, J.B. Manson, John Nash, C.R.W. Nevinson, William Ratcliffe, Ethel Sands, Harold Squire, Harald Sund, Walter Taylor and Edward Wadsworth. Duncan Grant attended the first meeting but did not join the group. Other members in the next few years included Paul Nash and William Roberts, 1914; Mark Gertler 1915; E. McKnight Kauffer and Sickert, 1916; Roger Fry and Nina Hamnett, 1917; Boris Anrep, Vanessa Bell and Duncan Grant, 1919; F.J. Porter and Matthew Smith, 1920; Richard Carline, 1921; and so on. For a full list of membership, see 'London Group 1914–1964' catalogue, the Tate Gallery, 1964.

19 Quentin Bell, 'An Unlikely Alliance', op. cit.
In this context Mark Gertler wrote to Carrington in November 1915: '...I went to the private view of the London Group yesterday. What a rubbishy show! All the pictures except my own, were composed of washed out purples and greens, and they matched so well that it seemed almost as if the artists all collaborated in order to create harmony at the show. In reality it means simply that they all paint alike and equally badly!' *Mark Gertler: Selected Letters*, ed. Noel Carrington, (Rupert Hart-Davis, 1965).

Gertler's *Merry-Go-Round*, (plate 98) which was exhibited in 1917 might be seen as a younger painter's response, within the overall framework of English Post-Impressionism, to the Camden Town Group style as it had survived. His letter also shows how easy it was, as early as 1915, to take the original crisis period of Post-Impressionism 1910–1912 for granted.

20 Roger Fry, 'The Modern Movement in England', Catalogue essay for the 'London Group Retrospective Exhibition: 1914–1928' New Burlington Galleries, 1928.

21 Ibid.

22 Ibid.

23 Fry published his major book on the artist, *Cezanne*, in 1927.

24 Roger Fry, 'Paul Cezanne by Ambroise Vollard: Paris 1915' the *Burlington Magazine*, August 1917 (review).

25 Ibid.

26 Fry was reading Ernest Jones' biography of Freud in March 1919. On November 22 1917 Virginia Woolf observed in her Diary: 'Roger takes a gloomy view not of our life, but of the world's future; but I think I detected the influence of Trotter and the herd, and so I distrusted him.' *The Diary of Virginia Woolf: Volume One, 1915–1919* ed. Anne Olivier Bell, (The Hogarth Press, 1977). In a footnote to this letter, Anne Olivier Bell calls attention to ' "Instincts of the Herd in Peace and War" (1916) a study of individual and social psychology by Wilfred Trotter, MD, FRCS, [which] had been the basis of an article by Leonard Woolf in the *New Statesman* 8 July 1916.'

27 Clive Bell, reviewing Marchand's one-man exhibition at the Carfax Gallery, 1915. Quoted in 'Jean Marchand: 1882–1941', O'Hara Gallery catalogue. No date.

28 Roger Fry, 'Jean Marchand', the *Athenaeum*, 1919. Reprinted in *Vision and Design*, 1920.

29 Roger Fry to Marie Mauron, December 1919 (Sutton).

9. Neo-Realism

1 J. Wood Palmer, 'Harold Gilman, 1876–1919, *The Studio*, June 1955.

2 Marjorie Lilly, *Sickert, The Painter and his Circle*, (Noyes, 1973).

3 Sickert, quoted in Lilly, ibid.

4 Ibid.

5 The essay was first published in the *New Age*, 1 January 1914 and reprinted in the Catalogue to Ginner's joint exhibition with Gilman at the Goupil Gallery in April 1914.

6 Malcolm Easton, 'Charles Ginner: Viewing and Finding,' *Apollo*, March 1970.

7 I am thinking of Blake's letters to the Revd. Dr. Trusler, in particular that of August 23 1799 in which he wrote: 'The tree which moves some to tears of joy is in the eyes of others only a green thing that stands in the way... But to the eyes of the Man of Imagination, Nature is Imagination itself. As a man is, So he

Sees.' There is more than a trace of Blakean intensity in 'Neo-Realism', as there is in much of Ginner's actual painting, an influence he shared with Duncan Grant.

8 Sickert, 'Mr. Ginner's Preface', the *New Age*, 30 April 1914, (Sitwell pp. 179-183).

9 Sickert, 'The Thickest Painters in London', the *New Age*, 18 June 1914, (Sitwell. pp. 183–186).

10 The finest of these Richmond Park paintings is in the Manchester City Art Gallery.

11 Sickert, 'A Perfect Modern', the *New Age*, 9 April 1914. (Sitwell, pp. 274-278).

12 Ibid.

13 Their school was held at 16, Little Pulteney Street, Soho.

14 Louis Fergusson, *Harold Gilman: An Appreciation*, (Chatto and Windus, 1919).

15 Two versions of this portrait were shown in the 1916 'London Group' Exhibition. A third, now in the Tate Gallery, was probably executed a little later, being still more dramatically simplified yet somehow less radiant than the Liverpool version.

16 Louis Fergusson, op. cit.

17 E.L. Kirchner, 1880–1935, German Expressionist painter and founder member of the Brücke Group.

18 Drummond is perhaps the most neglected of all the English Post-Impressionist painters. Apart from one Arts Council catalogue Introduction by Quentin Bell in 1963, and another by Charlotte Heinlein for the Maltzahn Gallery in 1974, almost nothing has been written about him.

19 Bernard Shaw, 'Heartbreak House and Horseback Hall', Preface to *Heartbreak House*, (London, 1919).

20 The reasons for this joint 'failure of courage' lie outside the scope of this work. I hope to explore this topic in much greater detail in a forthcoming study of the career of Duncan Grant.

21 This distinction seems gradually to have been relaxed once more from the early 1930s, as is apparent from Vanessa Bell's magnificent *The Other Room* of 1930–35. In this large painting elements from various rooms at Charleston are combined in a single ideal interior, inhabited by three women, one lying down, one burying her head in her hands and one staring out of a window. *The Other Room* also marks a return to Vanessa Bell's most complex and fascinating earlier iconographic preoccupations.

10. The Iconography of English Post-Impressionism

1 E. Panofsky, *Meaning in The Visual Arts*, (New York, 1955).

2 Roger Fry, Preface to catalogue of 'The New Movement in Art' Exhibition, selected and arranged by him for the Royal Birmingham Society of Artists, July 17 – September 17, 1917.

3 Spencer Gore, Review of the third annual Allied Artists' Association Exhibition, *The Art News*, 4 August 1910.

4 'Modern art, contrary to a common misapprehension, does not alienate itself from life, but seeks a closer connection with life than did the art that preceded it.' Anonymous Preface to catalogue of 'Twentieth Century Art' Exhibition at the Whitechapel Gallery, May 8 – June 20 1914, almost certainly written from notes by Fry, if not by Fry himself. This Preface seems to be a direct answer to Ginner's 'Neo-Realism' manifesto published earlier in the year. What is significant is that both documents differ only in the degree to which they use the concept of 'Life' as an abstraction.

5 Particularly through the influence of Alfred Stieglitz's '291' Gallery, and his magazine, *Camerawork*, which appears at times to have been more or less a New York version of *Les Soirées de Paris*.

6 This same process has operated with equal efficiency to suppress other nations' schools equivalent to English Post-Impressionism. How was Matisse received in Budapest, or Cezanne in Oslo? Formalist art history does not tell us.

7 Roger Fry, Prefatory note to catalogue of Contemporary Art Society exhibition at Manchester Corporation Art Gallery, December 1911, reprinted in *The Art News*, December 15 1911.

8 Wendy Baron, 'Sickert's Attitude to his Subject Matter'. Appendix to *Sickert*, (Phaidon, 1973).

9 Sickert, 'The Language of Art'. 28 July 1910, (Sitwell, pp. 88–93).

10 'The Whistlerian mise-en-scene! Hangings and overpowering frames, frames, frames, out of all proportion to the matter enclosed in them, are more and more obviously an insufficient defence for the result of dissipation of effort and confusion of aim...' Sickert, Review of the Whistler Exhibition at Colnaghi's, in aid of the Professional Classes War Relief Fund. The *Burlington Magazine*, July 1915.

11 e.g. Marjorie Lilly's story of 'Joe': 'A special protegé of Sickert's was a boy called Joe... An ex-pupil from the Westminster he was now a soldier, waiting to be sent to France. There was something very moving about Joe with his round, candid face, his shock of fair hair and his shy friendly smile. Whenever he could get leave he would be present on Wednesdays with his girl; sitting side by side, they seldom spoke, and he had no eyes for anyone but the Master. He worshipped Sickert. I suppose no distinguished man had ever taken such an interest in him before... But Joe was sent to France and in a few weeks he was lying dead with a bullet through his brain... After Sickert heard of the death of Joe he shut himself up for three days and would not open his door. When he emerged, he never spoke of Joe and no one dared to mention his name.' *Sickert, The Painter and His Circle*, (Noyes, 1973). Sickert knew many of his working class models extremely well, e.g. Hubby and Marie.

12 W. Rothenstein, *Men and Memories*, (London, 1932).

13 Lucien Pissarro lived in Bedford Park, whilst Gilman and Ratcliffe both lived at Letchworth for much of the period, and Gore often painted there.

14 This attitude is exemplified by Robert Bevan's 1916–1917 paintings of St. John's Wood and Belsize Park, where he lived.

15 Frank Rutter, *Art in My Time*, (Lund Humphries, 1940).

16 Victor Burgin, *Commentary Part I*, (Latimer, 1973).

17 Exhibited at the Grafton Group Exhibition, January 1913.

18 In a letter to Lady Ottoline Morrell, 27 January 1915, D.H. Lawrence wrote: 'We like Duncan Grant very much, I really like him. Tell him not to make silly experiments in the futuristic line with lots of colour on moving paper. Other Johnnies can do that... But to seek all the terms in which he shall state his whole. He is after stating the Absolute like Fr Angelico in The Last Judgement – a whole conception of the existence of man...'. David Garnett's *The Flowers of the Forest*, (Chatto and Windus, 1956).

19 Roger Fry, 'Art and Life', a lecture to the Fabian Society, 1917.

20 Duncan Grant, unpublished notes on Picasso, 1956, written in French. 'The most unexpected always comes as a shock. He never looks for the essence. It is always the particular which makes up his work... He always envisages a public – large or small. He is an *actor*. He wants to amuse or to comprehend – the same thing? He is very much an *illustrator*. He does not have one manner. He takes all manners, even the bad, to achieve his end... He is almost never what one calls serious – except in the sense purely of "design". His arabesques – what delicious sensuality! – as arabesques are serious – but they are always also commentaries, Hogarth? Goya? Chardin. Matisse. Velasquez. In using all these styles and all those beauties he remains Picasso, man of spirit!'

Selected Bibliography

Apollinaire, G., *Apollinaire on Art*, ed. L.C. Bruinig, Thames and Hudson.

Bayes, Walter, 'The Camden Town Group', the *Saturday Review*, 25 January 1930. 'A Table at the Café Royal', Café Royal Catalogue, 1955.

Baron, Wendy, 'Sickert's links with French painting', *Apollo*, March 1970. *Sickert*, Phaidon, 1973. 'Sickert', Fine Art Society Catalogue, 1973. 'Camden Town Recalled', Fine Art Society Catalogue 1976.

Barr, Alfred H, *Matisse*, M.O.M.A. New York, 1951. *Art*, Chatto and Windus, 1914. 'Civilisation – an essay', Chatto and Windus, 1928.

Bell, Quentin, 'The Camden Town Group I: Sickert and the Post-Impressionists', *Motif 10*, 1962. 'The Camden Town Group II: opposition and composition', *Motif II*, 1963. 'Malcolm Drummond 1880-1945', Arts Council catalogue, 1963. *Roger Fry*, Leeds University Press, 1964. 'The Omega Revisited', the *Listener*, 30 January 1964. 'An Unlikely Alliance', the *Sunday Times* colour supplement, 12 July 1964. 'Vision and Design – The Life, work and influence of Roger Fry', Arts Council catalogue, 1966. *Bloomsbury*, Weidenfeld and Nicolson, 1968. *Virginia Woolf, A Biography*, 2 vols, Hogarth Press, 1972.

Bell, Quentin, and Stephen Chaplin, 'The Ideal Home Rumpus', *Apollo*, October 1964. 'Rumpus Revisited', *Apollo*, January 1966.

Bevan, R.A. *Robert Bevan 1865-1925: A memoir by his son*, Studio Vista, 1965.

Blanch, Jaques Emile, *Portraits of a Lifetime*, Dent, 1940.

Bowness, Alun, 'The Impressionists in London', Arts Council Catalogue, 1973.

Brown, David, 'Duncan Grant' Introduction to catalogue of an exhibition organized by the Scottish National Gallery of Modern Art 1975.

Clark, T.J., *Image of The People, Gustave Courbet and the 1848 Revolution*, Thames and Hudson, 1973.

Clausen, G., *Six Lectures on Painting*, Elliot Stock, 1904.

P. and D. Colnaghi and Co. Ltd., *Robert Bevan, The Complete Graphic Works* Catalogue, 1975.

Cork, Richard, 'Vorticism and its Allies', Arts Council Catalogue, 1974.

Cross, T.A., 'The Slade 1871-1921', Fine Art Society Catalogue, 1971.

Davie, Donald, *Pound*, Fontana, 1975.

Eastern, Malcolm, *Artists and Writers in Paris, The Bohemian Ideal 1803-1867*, Edward Arnold, 1964. 'Charles Ginner: Viewing and Finding', *Apollo*, March 1970.

Emmans, Robert, *The Life and Opinions of Walter Richard Sickert*, 1941.

Farr, Dennis, and Alan Bowness, ' "Historical Note" on the London Group', London Group 1914-1964, Tate Gallery catalogue, 1964 (also essays by Andrew Forge and Claude Rogers).

Fegusson, Louis F., *Harold Gilman: an appreciation*. (Also essay by P. Wyndham Lewis.) Chatto and Windus 1919. 'Souvenir of Camden Town' *The Studio*, February 1930.

Forge, Andrew, 'The Slade I' *Motif 4*, 1960. 'The Slade II' *Motif 5*, 1960.

Fry, Roger, *Vision and Design*, Chatto and Windus, 1920. *Cezanne*, Hogarth Press, 1927. *Letters of Roger Fry*, edited by Denys Sutton, Chatto and Windus, 1972.

Garnett, David, *The Golden Echo*, Chatto and Windus, 1954. *The Flowers of the Forest*, Chatto and Windus, 1956.

Gertler, Mark, Selected Letters, Noel Carrington, with introduction by Quentin Bell, Hart-Davies, 1965.

Ginner, Charles, 'Neo Realism', *The New Age*, 1 January 1914. 'The Camden Town Group', the *Studio*, November 1945.

Golding, John, *Cubism, a history and analysis 1907-1914*, 2nd edition, Faber, 1968.

Gore, Frederick, Introduction to 'The Camden Town Group' exhibition catalogue Hampstead Artists Association June 1965. 'Spencer Gore; a Memoir by his Son', introduction to Spencer Frederick Gore 1878-1914 exhibition catalogue, Anthony D'Offay Gallery 1974.

Gore, Spencer F., Review of the First Post-Impressionist Exhibition, the *Art News*, 15 December 1910.

Hone, Joseph, *The Life of Henry Tonks*, Heinemann, 1939.

John, Augustus, Chiaroscuro, Fragments of Autobiography, Jonathan Cape, 1952.

Laidlay, W.J. *The Origin and First Two Years of the New English Art Club*, Bodley Head, 1907.

Laughton, Bruce, 'Steer and French Painting', *Apollo*, March 1970.

Lilly, Marjorie, *Sickert, The Painter and his Circle*, Noyes, 1973.

Morphet, Richard, 'The Significance of Charleston', *Apollo*, November 1967. 'The Art of Vanessa Bell', catalogue essay, Anthony D'Offay Gallery, 1973.

Pickvance, Ronald, 'Vanessa Bell', introduction to Memorial Exhibition catalogue, the Arts Council, 1964.

Pool, Phoebe, *Impressionism*, Thames and Hudson, 1967.

Rewald, John, *Post-Impressionism from Van Gogh to Gauguin*, M.O.M.A. New York, 1956.

Rothenstein, John, *Modern English Painters: Sickert to Grant, Innes to Moore*, 2 vols, Arrow Books, 1962.

Rothenstein, William, *Men and Memories 1872-1900*, Faber, 1931. *Men and Memories 1900-1922*, Faber, 1932.

Rutter, Frank, *Revolution in Art*, The Art News Press, 1910. 'The Work of Harold Gilman and Spencer Gore', the *Studio*, March 1931. *Art in My Time*, Lund Humphries, 1940.

Rubin, William, *Picasso in the Collection of The Museum of Modern Art*, M.O.M.A., New York, 1972.

Shone, Richard, Introduction to Duncan Grant Portraits exhibition catalogue, the Arts Council, 1969. 'The Friday Club', The *Burlington Magazine*, May 1975. *Bloomsbury Portraits*, Phaidon, 1976.

Sickert, Walter R., *A Free House! or the Artist as Craftsman*, ed. Osbert Sitwell, Macmillan, 1947.

Spencer, Robin, *The Aesthetic Movement*, Studio Vista, 1972.

Stevenson, R.A.M., *Velasquez*, London, 1895.

Thornton, Alfred, *Fifty Years of the New English Art Club 1886-1935*, Curwen Press, 1935.

Westbrook, Eric, 'The Camden Town Group', Introduction to exhibition catalogue, the Arts Council 1951.

Williams, Raymond, *The Country and The City*, Paladin, 1975.

Wooderson, John, Introduction to Spencer Gore exhibition catalogue, The Minories, Colchester, 1970.

Wood, Palmer J., Introduction to Spencer Frederick Gore exhibition catalogue, the Arts Council, 1955. 'Harold Gilman 1876-1919', the *Studio*, June 1955.

Woolf, Virginia, *To the Lighthouse*, Hogarth Press, 1927. Foreword to 'Recent paintings by Vanessa Bell' exhibition, the Cooling Galleries, 1930. *Walter Sickert: a conversation*, Hogarth Press, 1934. *Roger Fry: A Biography*, Hogarth Press, 1940. *Moments of Being:* Unpublished Autobiographical Writings of Virginia Woolf, ed. Jeanne Schulkind, Sussex University Press, 1976. *The Diary of Virginia Woolf Volume One, 1915-1919*, ed. Anne Oliver Bell, Hogarth Press, 1977.

English Post Impressionism a brief chronology

1886 Formation of the New English Art Club.

1871 Foundation of the Slade School of Fine Art.

1889 The London Impressionists exhibition at the Goupil Gallery, December.

1893-4 Robert Bevan at Pont-Aven in Brittany.

1903 Roger Fry one-man exhibition at the Carfax Gallery, April.

1904 Spencer Gore introduced to Sickert in Dieppe.

1905 Vanessa Bell briefly a student at the Slade: forms the Friday Club.
Sickert returns to London, taking studios at 6 Mornington Crescent and 8 Fitzroy Street.

1906 Duncan Grant a student at La Palette in Paris.
Sickert and independent artists exhibit at Agnews.

1907 Formation of the Fitzroy Street Group.

1908 Foundation of the Allied Artists Association. Annual exhibitions until 1919.
Bevan meets Gilman and Gore through A.A.A. and joins the Fitzroy Street Group.

1909 Spencer Gore elected to the N.E.A.C.
Drummond attending Sickert's etching class at Rowlandson House; joins the Fitzroy Street Group.
Vanessa Bell exhibits *Iceland Poppies* at N.E.A.C.
Duncan Grant exhibits two works at N.E.A.C.; visits Matisse.
Foundation of *The Art News*. First issue Thursday October 21.
Ginner comes to London, meets Gilman and Gore through A.A.A. and joins Fitzroy Street Group.

1910 Friday Club becomes an exhibiting group, March.
Sickert opens painting classes at Rowlandson House, continuing until 1914.
Roger Fry organizes 'Manet and the Post-Impressionists' exhibition at the Grafton Galleries, November.

1911 Camden Town Group formed in the spring, first group exhibition at the Carfax Gallery, June.
Roger Fry supervises the Borough Polytechnic Murals, Summer.
Second Camden Town Group exhibition at the Carfax Gallery, December, Duncan Grant replacing M.G. Lightfoot.

1912 'Exposition de Quelques Artists Anglais' at the Galleries Barbazanges, Paris, July.
Fry's 'Second Post-Impressionist Exhibition' at the Grafton Galleries, October – December.
Third Camden Town Group exhibition at the Carfax Gallery, December.

1913 Fry re-organizes the Friday Club as The Grafton Group, first exhibition at the Alpine Club Gallery, March.
Gore and Gilman exhibit at the Carfax Gallery, January.
Robert Bevan one-man exhibition at the Carfax Gallery, Summer.
Omega workshops open, July.
Frank Rutter's 'Post-Impressionist and Futurist' Exhibition at the Doré Gallery, October.
Formation of the London Group, November.
'Exhibition by the Camden Town Group

Index